Step·by·Step
WATERCOLOR PAINTING

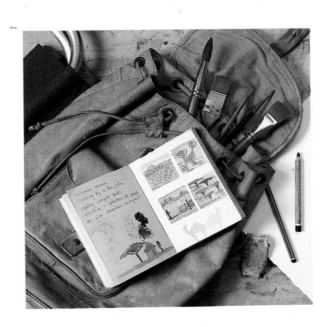

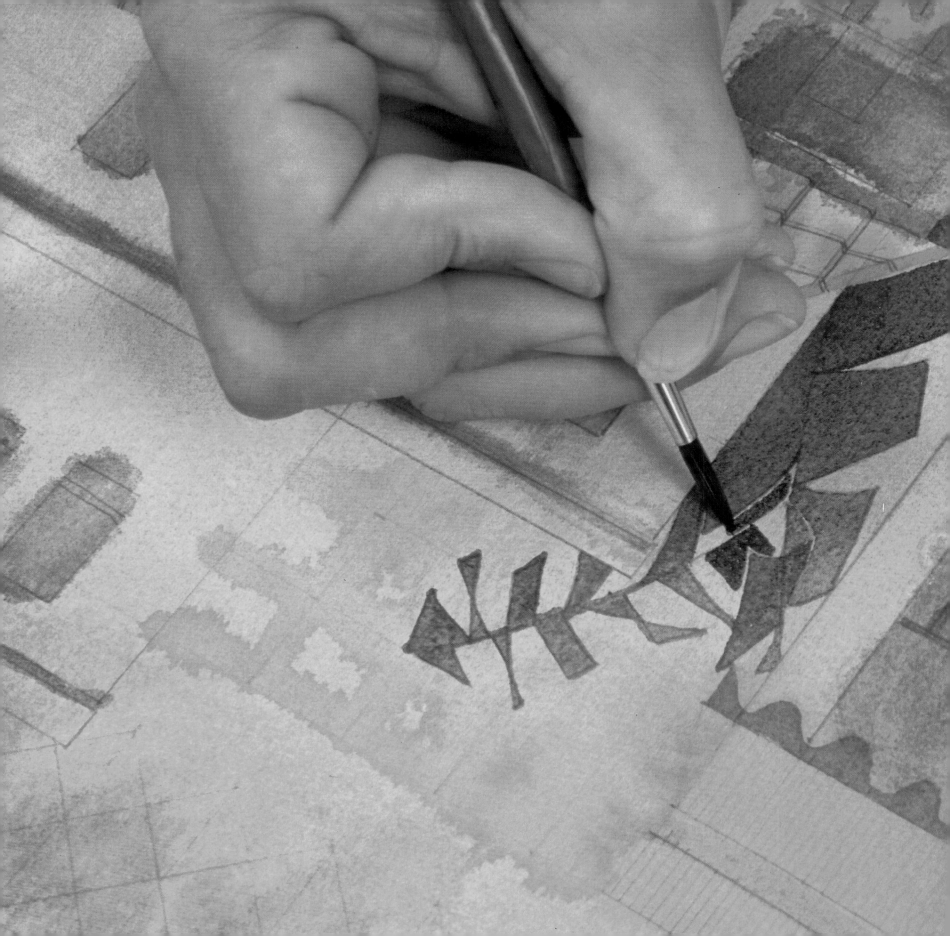

Step·by·Step
WATERCOLOR PAINTING

A Complete Guide to Mastering Techniques with
THE ALEXANDER BROTHERS

PHOTOGRAPHS BY ROSE JONES

 STERLING PUBLISHING CO., INC NEW YORK

Library of Congress Cataloging-in-
Publication Data Avaiable

10 9 8 7 6 5 4 3 2
First Paperback Edition
Published in 1997 by
Sterling Publishing Company, Inc
387 Park Avenue South, New York,
N.Y. 10016
Originally published in 1994 by
George Weidenfeld & Nicolson Ltd
Orion House
5 Upper St Martin's Lane
London WC2H 9EA

Text ©1994 by Gregory and Matthew
Alexander
Photographs ©1994 George Weidenfeld
& Nicolson Ltd

c/o Canadian Manda Group,
One Atlantic Avenue, Suite 105,
Toronto, Ontario, Canada MK6 3E7

Edited by Tessa Clark
Designed by Graham Davis
Jacket designed by the Senate
Colour separations by Newsele Litho Ltd
Printed in Mexico

ISBN 0-8069-1332-0 Hardcover

ISBN 0-8069-1333-9 Paperback

DEDICATION
To the memory of our father Chris Alexander,
whose teachings were inspirational.

ACKNOWLEDGEMENTS
We would like to thank Gill Catto of the Catto
Gallery for her continued support 'looking out for
the boys'; Michael Dover and Suzannah Gough of
Weidenfeld & Nicolson for their faith in our
abilities; Tessa Clark for keeping the project on
track and creating fluent text from our verbal
ramblings; Rose Jones for her fine photography;
and Graham Davis for creating visual coherence
combined with exciting design.
 Finally, a special thanks to our better halves,
Trish and Fran, for their unerring support (only an
artist's wife would know what they have to put up
with !)
 The painting on pages 16/17 is reproduced by
kind permission of Mr and Mrs J. B. Tomlinson.

CONTENTS

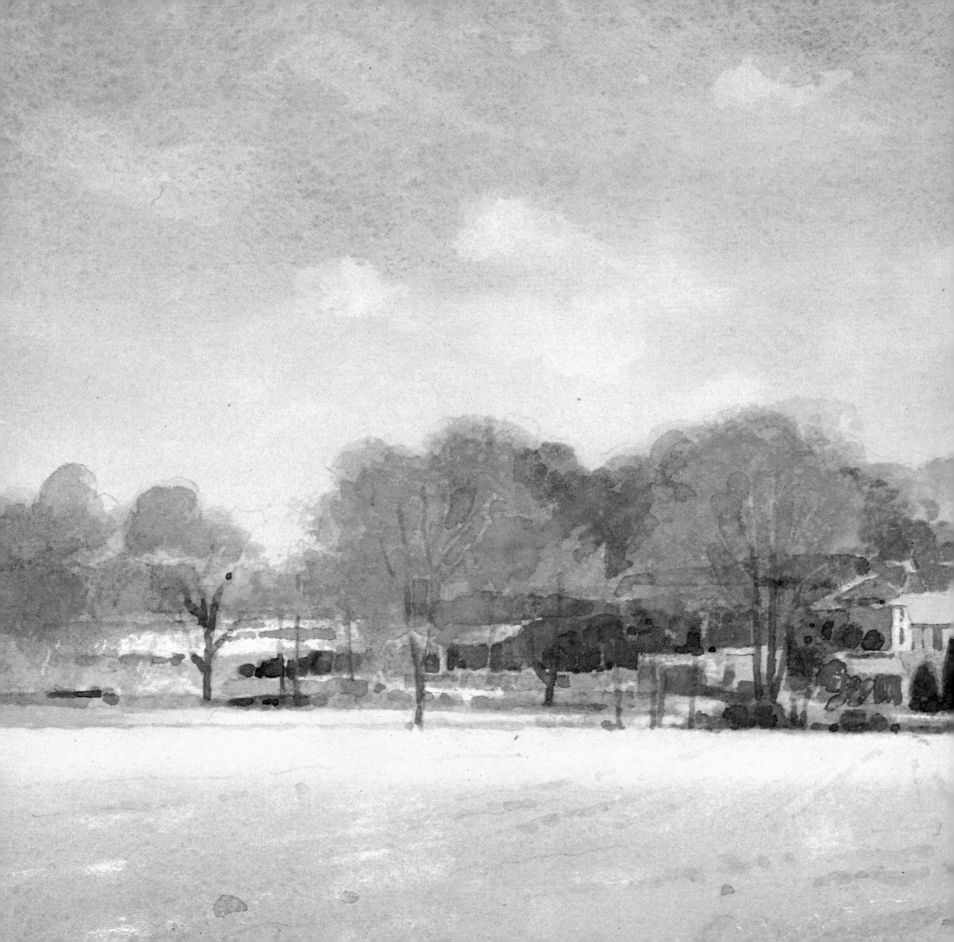

INTRODUCTION

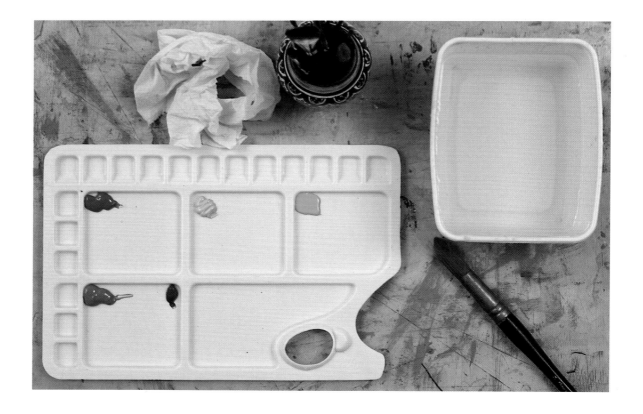

Matthew and Gregory Alexander share a lifelong commitment to painting. Their father Chris Alexander, a talented artist and teacher, was the main influence on their early development and imbued them with the desire, dedication and discipline that he knew they would need to sustain them as they pursued their rewarding — and challenging — careers as painters.

Although their commitment to painting is shared, the ways in which they express it are very different and the styles they have developed are singularly individual. Matthew developed a passionate interest in landscape painting and focused his attention on the English countryside and the seascapes of his native Kent. In more recent years, he has widened this interest to include subjects throughout Britain and further afield in Europe. Gregory has searched for more exotic subject matter in Africa, India and the Middle East. He has lived in France and Cyprus, spent long periods of time in Africa and now lives in Australia.

These differences apart, they both believe that how a painting is approached is the all-important factor in creating a work that encapsulates the subject that inspires them. This is

the basis of the teaching method in this book.

Their attitude to painting, and particularly to the teaching of painting, is based on their belief that to make any worthwhile statement requires a deep-seated commitment. This does not necessarily call for total immersion every hour of the day; it does call for total concentration during the times you are painting. To give a new twist to an old saying: ' Painting is 99 per cent perspiration and one per cent inspiration — but 100 per cent enjoyable.'

WHY WATERCOLOR ?

Why not watercolor ? This may seem a rather flippant reply to a searching question, but all painting requires a medium and every medium, whether it is oils, acrylic — or watercolor — has qualities that are unique to itself. The differences between the media are fundamental and each has its own unique 'pluses'. Listed below are some that determine the use of watercolor.

Familiarity: Most people have painted at some stage during their lives, generally at school when they were very young. And more often than not these first experiences would have involved the use of a water-based medium similar to watercolor.

Portability: Watercolor is probably the easiest painting material to transport and can be used simply — to add color notes to what would otherwise be a sketch-like drawing — or more ambitiously to produce larger and more complicated paintings. Whatever the purpose, the use of watercolor involves the minimum of equipment.

Effects: The medium's transparent spontaneity allows painters to create beautiful effects with great speed and enables him or her to indicate intricate subtleties with the minimal amount of working.

Handling: Watercolor must be treated differently from other, more plastic media, and anyone whose previous experience has been with oils or acrylics will find that the contrast between the different techniques involved will enrich their response to, and the way they approach, their subjects.

Gregory has been painting in watercolor since his college days: he has always been interested in the effects created with two-dimensional shapes and color and the medium suited his flat, patterned work. Matthew's use of watercolor for his landscapes and other studies is more recent: although he had always drawn in wash his primary interest was painting in oils.

Both agree that watercolor is a marvellous medium for any artist. The transparency of the pigments allows the paper to shine through to ethereal effect and the beauty of fresh colors applied with fluid strokes can create some of the most beautiful, instant and subtle images in painting.

THE ALEXANDER METHOD

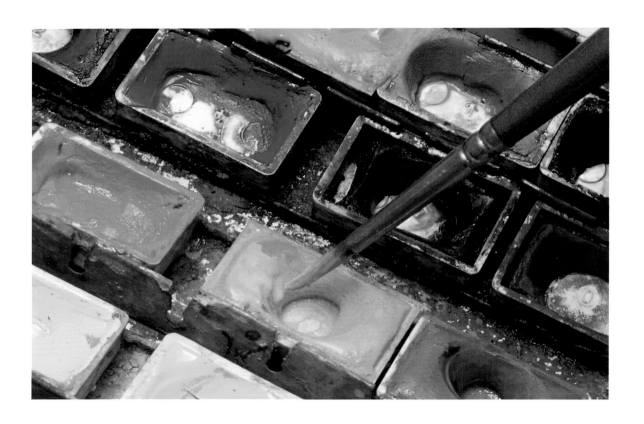

Over the years we have identified three questions that we advise our students to ask before they so much as take up a pencil or brush and apply it to paper: What do I want to paint ? How will I paint it ? What materials will I need ? The answers — the three Ms — define three distinct but inter-related stages in the development of a painting: motivation; method; materials.

MOTIVATION

'Motivation is vision; it is the marriage of a need to create a painting and the inspiration of the subject, seen in terms of the potential realization in a specific medium — in this case watercolor.'

This definition may seem daunting, but can easily be broken down into its component parts.

The need to create can come from a variety of sources. It may be as simple as just wanting to paint in watercolor; in other words, the medium itself has created the need. It may be the result of visiting an exhibition and being inspired to do a painting like the ones you have just seen. It could be that you have just looked out of your window at a dramatic landscape with clouds almost dribbling down the sky and want to get that effect in watercolor. You may want to capture the way objects are arranged on a window sill or in the corner of a room or the ephemeral beauty of a bunch of flowers. You may be introduced to — or notice in the street — someone who has a particularly beautiful or characterful head. You may be inspired by a photograph or a visit to the cinema. Or you may have an interesting and subtly colored

watercolor paper that you want to paint on. Even reading this book could inspire the need to create !

Vision is a dangerous word because it infers being overcome or 'blasted' by a concept that springs full-blown and clearly seen into your mind's eye. Not necessarily so. 'Vision', in our terms, is a concept of what you want to create — an idea, even the germ of an idea, of what you want to accomplish finally. All kinds of things can influence your vision. Scale is one. You may have a big wall and want a painting to fill it — or an empty niche that cries out for something small and jewel-like. The image of what you want to create will also be inspired by the subject you choose. It may be a portrait, a landscape or a still-life but, depending on the personality of the person you are painting, the play of light and shadow in a landscape or the glint of light on pewter in a still-life. You may visualize a painting that uses a limited range of colors or a great variety of them, thin or thick paint, large or small brush strokes. The effect you want to create may be detailed — or it may be ethereal.

What is important is to see these subjects in terms of painting; you must have an idea of the kind of image you want to create.

METHOD

'Method is the means by which your vision is achieved; it is an amalgamation of techniques where the individual technique does not make up the method — the whole is greater than the sum of its parts.'

Method is basically the process of selecting the medium — in this case watercolor — to realize your vision, the colors you will choose and the tech-

niques you will choose from the many that are available. We describe the ones we use most often in the next chapter and include them in projects later in the book. You will notice, though, that none of these is used in isolation. Nor are all the techniques used in one painting. Method, therefore, involves both selecting and amalgamating techniques.

It also involves deciding whether to work indoors or outside, whether to paint in a sketch-book or prepare a large sheet of stretched paper, and whether the effect you are looking for — your vision — calls for you to work loosely or tightly. Do you want the finished painting to be loose and ethereal or tight and topographically correct ? Do you visualize it as being large or small, colorful or monochromatic ? Do you want to paint in the manner of Cotman or Picasso ? Will you use white or colored paper ? And will you introduce gouache or use just watercolors. Your decisions must be based on what inspires and interests you. Make sure, though, that you set your sights as high as possible. Don't copy or refer to indifferent or weak works.

The answers to many of these questions will already be determined by your motivation. If your inspiration and your vision — the painting you see in your mind's eye — is like Gregory's *Venetian Façade* (page 94) you will require a wider range of colors than if your inspiration were similar to Matthew's *Scotney Castle* (page 130).

The method you use may also be influenced by other artists. Don't be

afraid to refer to the great masters of the past. Art grows out of art and if you are inspired to do a landscape in the manner of Turner look in a reference book and see how he achieved his effects. If he used beige paper and a limited palette, follow his example. Perhaps you love the way the German artist Emil Nolde used watercolor, soaking the paper with pigment and working wet-into-wet. Or you may like the pure colors used by Paul Klee or August Macke. Try to re-create their effects. The extent to which you adopt — or decide not to adopt — elements of the way in which an artist you admire works will help you to evolve your own style.

MATERIALS

'Materials are the vehicle used, determined by the choice of method.'

In other words, materials are tools. What you use will be determined by the method you have selected which, in turn, is determined by your motivation.

If you decide the best method for achieving your vision is by using a limited palette, the decision might dictate that you use Prussian blue and burnt sienna. However, if you want to create a feeling of intense heat because you are painting a subject in a tropical setting, you might well start with a wash of orange, followed by other intense colors.

An analogy could be with writing a book, in which the materials — the tools — are the words, the method is the style of writing, the way the words

are used, and the motivation is the initial idea for the book.

To put our three Ms into context, here are two examples of how they work, one from each of us.

Matthew witnessed a beautiful, stormy landscape with a racking light that was reminiscent of a painting he had seen by Turner or Cotman sometime in the past. He felt he would like to paint it (motivation) and decided to work it using only a limited palette and working from dark to light on toned paper (method), a decision that dictated his choice of paints and equipment (materials): three earth colors, Chinese white and toned paper.

While Gregory was travelling in Spain he came across a wonderful hilltop village and was inspired to paint it (motivation). He decided to draw it carefully and then flood it with wet and intense color washes (method). This decision and the fact that he was travelling determined his choice of materials: a travel palette with pan colors and a block of paper.

These are examples of how we both reacted to the kinds of landscapes that appeal to us. The paintings of back streets in Lisbon (opposite and overleaf) show how the same townscape inspired us to create two different paintings. Although the scene was the same, our motivation and the methods and materials we used were totally personal: an example of how the three Ms are interpreted in ways that are unique to the individual artist.

Gregory's inspiration was emotively based and grew from a direct response to the location and the spirit of the place. Using his travelling palette and a block of watercolor paper he chose to make a careful pencil drawing and then flood the paper with oranges, yellows, ochres, etc. He allowed them to bleed and merge to represent crumbling masonry and decay, but retained the overall warm glow to create a feeling of heat and southern European light.

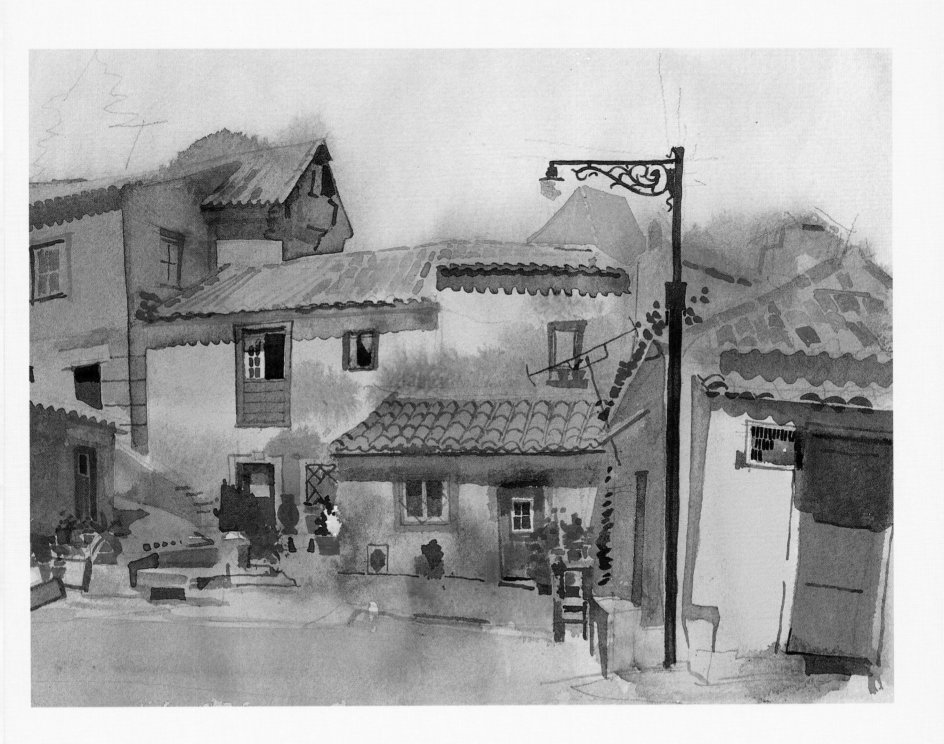

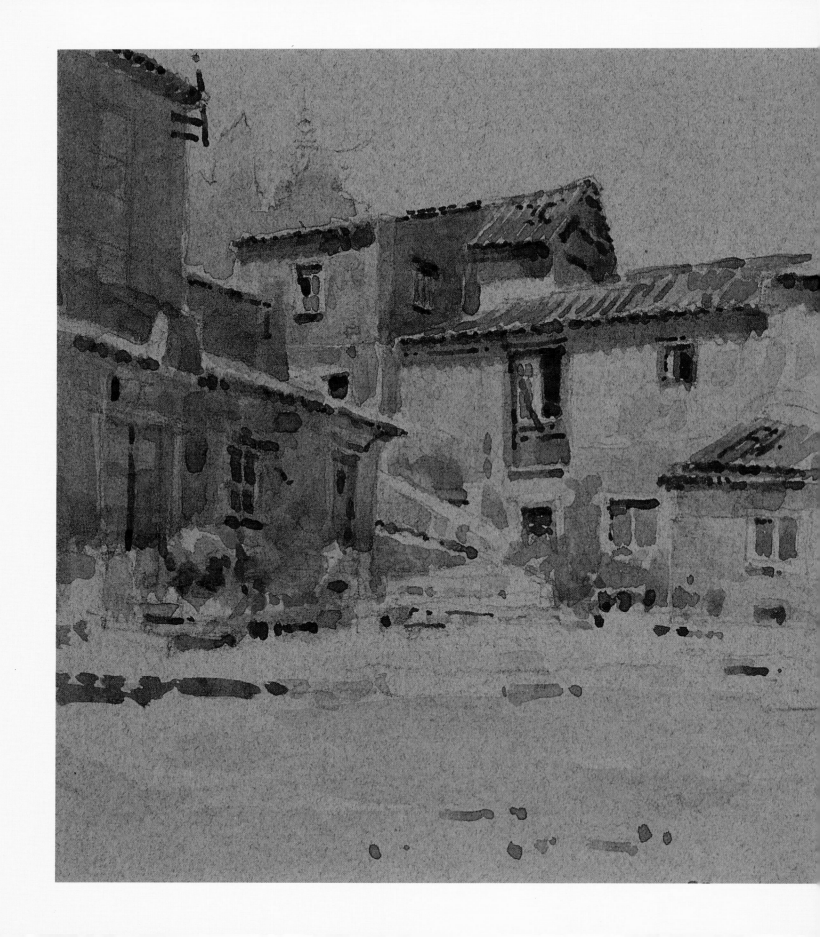

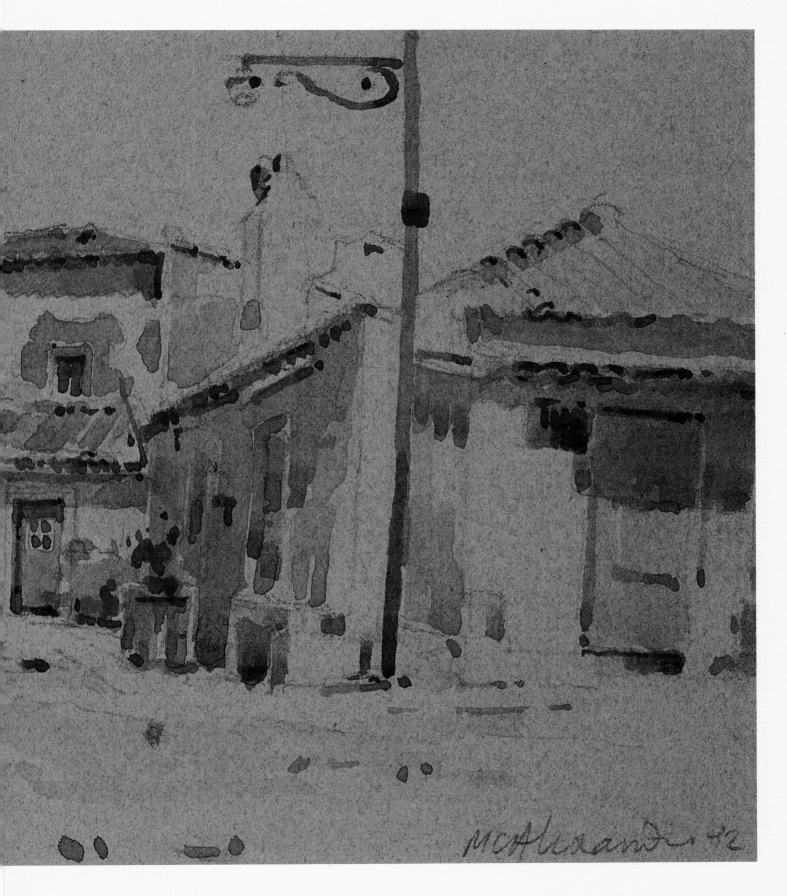

McAlexander 42

Matthew's inspiration for painting this Lisbon scene was a small pocket-book he had made, based on some small studies by Turner. He had prepared a blue paper with a stain of brown watercolor and felt that the dilapidated state of the buildings and the colors of the decaying doors would harmonize with this base color. The pigments he used developed this color relationship and throughout the painting he retained the sense of dilapidation and decay by using short, separate brush strokes that echoed the disjointed quality of the subject.

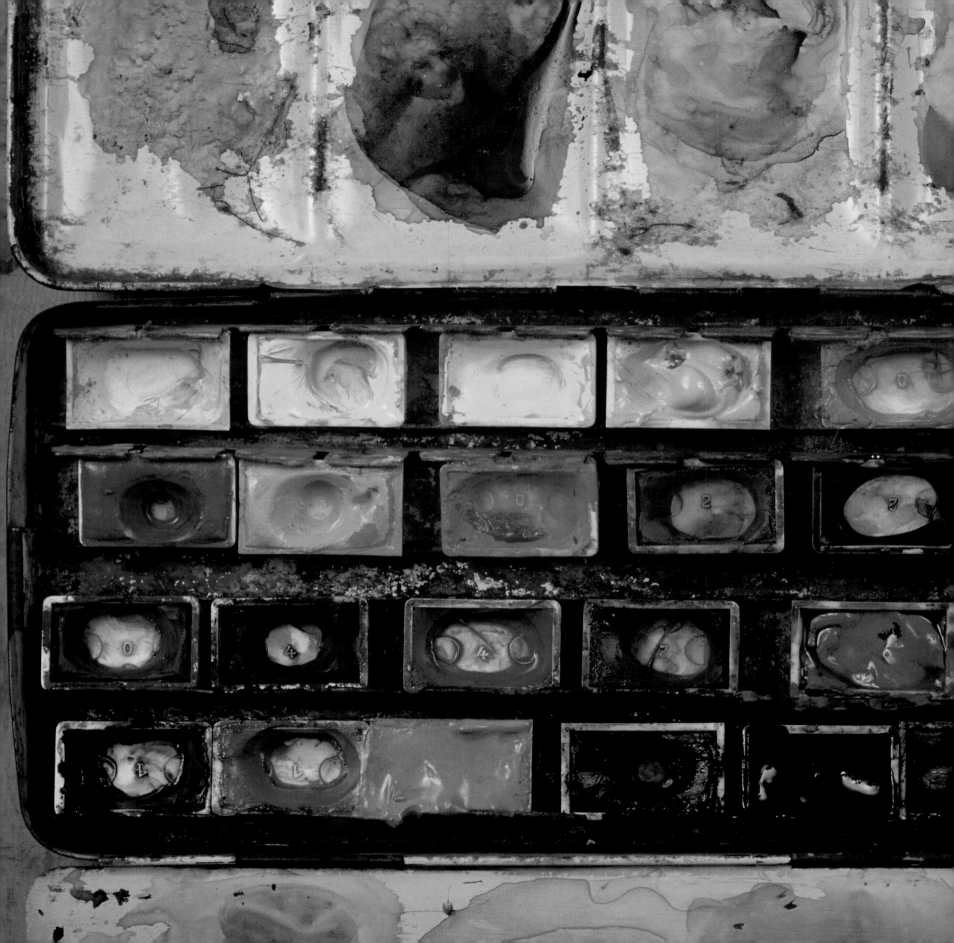

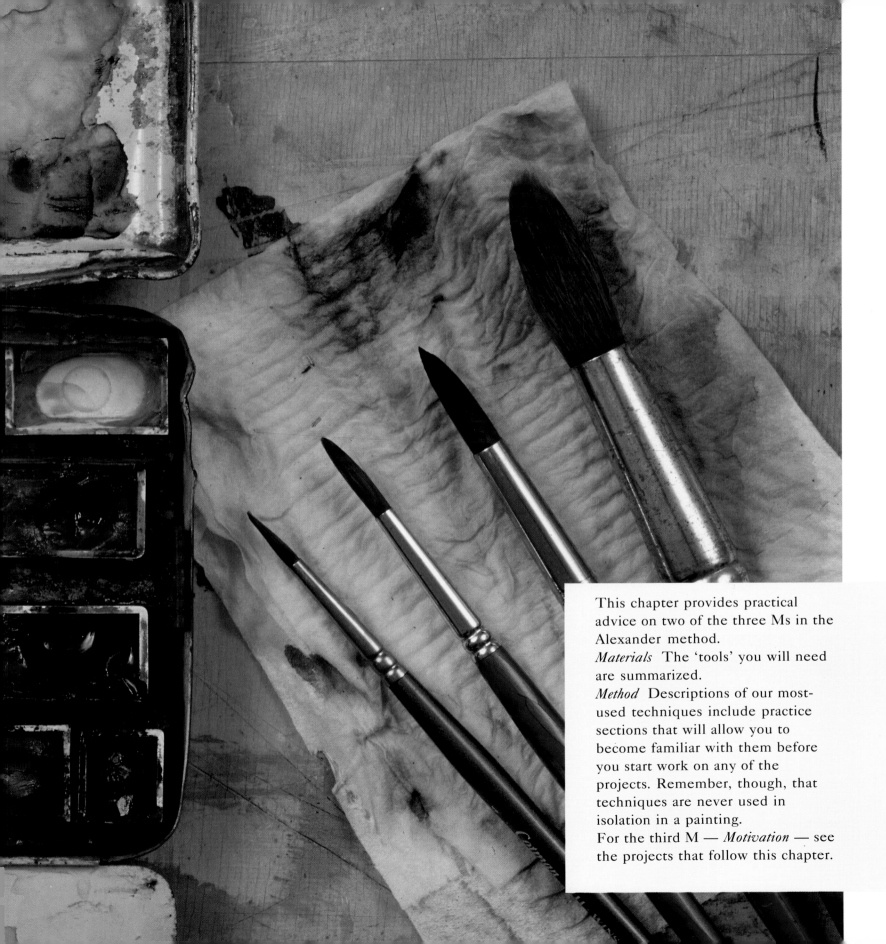

This chapter provides practical advice on two of the three Ms in the Alexander method.

Materials The 'tools' you will need are summarized.

Method Descriptions of our most-used techniques include practice sections that will allow you to become familiar with them before you start work on any of the projects. Remember, though, that techniques are never used in isolation in a painting.

For the third M — *Motivation* — see the projects that follow this chapter.

MATERIALS

Watercolors are available in pans and tubes. Both types are widely used by artists and practical experience is the best way to get to know how they differ. The differences between them are subtle; the main one is that tube paints are wetter than pans which means that it is easier to mix them with water as there is less need to worry them with a brush. They can also be mixed to a thicker and rougher consistency than pan paints, especially when they are mixed with a medium like aquapasto as they are in *African Townscape* (page 138) and *Tiger* (page 124). The consistency of pan colors, on the other hand, tends to be more like that of dried tube paints so more working and worrying with the brush is required when you mix them with water. However, they are easily transported and slot neatly into a palette so we find them ideal for working on the spot.

Both tube and pan paints come in a wide range of colors and are available either preselected, in watercolor boxes, or as single pans or tubes that can be slotted into your box. The colors you choose

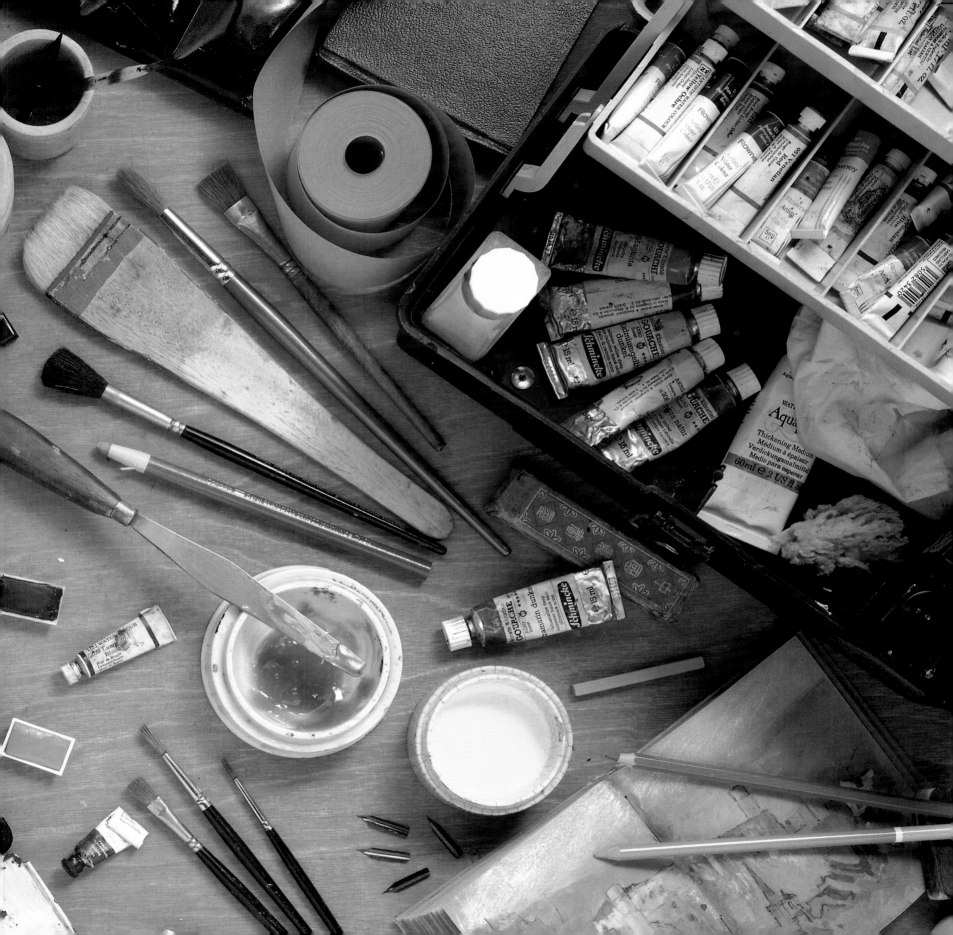

MATERIALS

will be dictated by the method you employ. Gregory likes to use a variety of colors including three or four yellows, three reds, three blues and two greens. Matthew often uses only four colors: burnt sienna, Prussian blue, magenta and sepia.

Tube and pan watercolors both come in artists' quality and the less expensive but lower grade students' quality. Although the latter often produce very satisfying results, it is sensible to buy the best paints you can afford — good materials lead to good results.

PALETTES

Watercolor boxes, either empty or pre-filled, come with ready-made palettes — the lid has wells for mixing colors in. Larger palettes are available and it is also possible to use a plain white plate. The three criteria are that the surface should be smooth, white and waterproof. Again, your final choice will depend on how you want to work. If you enjoy working indoors — and if you are planning a large painting — you will probably want to use a larger palette with more mixing areas. If you prefer painting on location and want a small and compact palette a folding one is probably best.

BRUSHES

Brushes come in a variety of shapes and sizes, from round and hairline thin to flat and 2 ½ inch wide — or bigger. Three or four brushes, ranging from small to big, are useful. If money is no object, buy sable hair brushes. They are the best there are and will last for ages. However, the less expensive squirrel and ox hair brushes, even ones made from man-made fibre, are perfectly adequate.

PAPERS

Your choice of paper, like all your materials, will be determined by your motivation and the method by which you decide to realize it. But it is unwise to use anything other than a good-quality paper suitable for watercolors. These come with three different surfaces: Rough, with a rough surface; Hot-pressed (HP) with a very smooth surface; and NOT (also called Cold-pressed or CP) which has a medium-rough surface. The papers are also graded according to how much a ream (500 sheets) would weigh. This indicates the thickness of the paper - the higher the weight, the thicker the sheet.

Gregory generally uses a medium-weight (140 lb) paper with a rough surface (Rough) while Matthew usually prefers the smooth surface of Hot-pressed paper. However, the choice of paper, like other materials, is dictated by the method. In *Tiger* Gregory used a rough, 300 lb handmade paper — and tore it so that the shape was irregular to realize his vision of the painting which had been partly inspired by seeing very old Indian manuscripts.

If you do use a light paper (up to l40 lb) it is advisable to stretch it before starting to work (see opposite) to prevent it cockling when water is applied.

Paper is available in single sheets and pads, and also in blocks which are particularly useful for working outdoors. Gregory has used blocks in several of his projects; typically the weight is l40 lb — the upper limit at which paper should be stretched — but the fact that the paper is glued on all four sides and is based on a hard card support cuts down on wrinkling and cockling even though it doesn't entirely eliminate them.

PENCILS

Pencils range from very hard (9H) to very soft (6B). We find that a grade 2B pencil is good to draw with as it is neither too hard nor too soft. Watercolor pencils are used in *Outdoor Market* (page 102). These are basically watercolors in pencil form and have the advantage of merging with the water and colors that are applied over them.

OTHER MATERIALS

You will also need jam jars or other large pots for water; plenty of tissues for blotting; a putty eraser that can be moulded to a point to rub out pencil lines or correct a drawing; and a sponge to get rid of excess water or lift out color. Natural sponges are available from suppliers of artists' materials. Pastels are used in *Landscape in Snow* (page 114) and both this and *Woman on a Beach* (page 80) require a Stanley blade for scratching out pigment to create sparkling highlights. Aquapasto is mixed with pigments in *Tiger* and *African Townscape* and a palette knife is called for in *Tiger*.

A drawing-board on which to pin or stretch your sheets of paper will be necessary if you are not using a pad or block. An easel is not essential because watercolors are generally painted at an angle of 10-20 degrees — which will help you lay a wash — or less, not vertically. When working outdoors you can simply rest the board on your knees; indoors it can be propped up on a table.

Finally, if you are working outdoors a folding chair and a bag for carrying your equipment are useful.

STRETCHING THE PAPER

Paper up to 140 lb in weight should be soaked in water and then dried under tension or it will wrinkle and cockle when you start painting. Alternatively, you can use watercolor blocks with the sheets glued on all four sides as Gregory does in several of his 'on the spot' projects.

To stretch paper you will need a bath or other receptacle filled with water and a thick — about 5 ply — drawing board. The board must be rigid so don't use hardboard which might bend or break when the paper stretches.

You will also need some 1 - 1 ½ inch wide gummed paper.

Soak the paper in the bath for about 5 minutes. The exact time will depend on its thickness — if it is very heavy, leave it for longer.

While this is happening, cut strips of gummed paper to the same lengths as the side of the paper.

■ The paper is only stretched while it is attached to the drawing board so keep the gummed paper on while you are painting. We have found that a number of our students are under the impression that stretched paper remains stretched even after it has been removed from the board.

■ There is no right or wrong side to the paper. Each feels different when you are painting and it is up to you to experiment and decide which surface you prefer.

I Trim a sheet of paper to the right size for the board. You will need to leave a good margin so that the gummed paper can be stuck to the board.

Lay the paper flat in a bath or basin of water. Make sure that the paper is thoroughly soaked before you remove it; and remember to handle it very gently throughout the stretching process. Hold the sheet of paper up to drain off excess water.

2 Lay the paper on the board and smooth out the wrinkles with a damp cloth or sponge, working from the centre to the edges until it is flat and smooth.

Encourage it to stretch as you do this. Remove the excess moisture from the edges with a tissue and then stick the sheet of paper to the board with the gummed paper.

3 When the gummed paper has been applied to all four sides of the paper dry the gummed strip and the edges of the paper with a tissue so that these areas dry first. Leave the paper to dry flat. This is important: if you allow it to dry at angle the water will drain to one side and the paper will dry unevenly and may pull out from the gum strip.

4 Just before you leave the paper to dry, re-dampen the centre of the sheet with a large brush to ensure that it is the last area to dry.

The edges must dry first so that the stretch from the centre is maintained throughout the drying process.

LAYING FLAT AND GRADATED WASHES

Laying flat and gradated washes are basic techniques that are used in the initial stages of many watercolor paintings. These large washes are then broken down into smaller — and even smaller — areas using a variety of methods. It is important to prepare enough pigment to cover the area you intend to paint; if you run out of color before you have finished and stop to mix more the paint will dry and the dried edge will be evident.

A flat wash uses one color and can be applied to the entire background of a painting or to selected areas. The size of the brush will depend on the area to be covered: a flat wash can be laid on a 1 inch square or over a 30 inch x 20 inch sheet of paper. Just use the largest brush that is suitable for the area; the wash should be applied with as few sweeps as possible.

The simplest gradated wash is one where a strong color at the top of the painting is gradually diluted with water so that it gradates away to nothing — the paper — at the bottom. A variation, which is used in a number of projects in this book, is to apply two colors and encourage them to merge.

Technique practice

■ Lay flat washes on a variety of areas using different-sized brushes.

■ Lay a gradated wash with one color: load your brush with saturated pigment for the first stroke at the top of the paper, then dip it in water to dilute the color. Repeat this with subsequent strokes until you reach the bottom of the paper.

■ Lay gradated washes using various combinations of two colors.

To lay a flat wash: Position your board at an angle of 10-20 degrees and dampen the paper with clean water. Load your brush with pigment and lay the wash with broad, sweeping strokes. Start at the top and work from lef t to right then right to left. Add more pigment between each stroke and pick up the wet edge of the previous line. Pinch out your brush when you reach the bottom of the paper and remove any excess paint.

To lay a gradated wash: Tilt your board at angle of 10-20 degrees and dampen the paper. Load a brush with pigment and lay the wash over the paper from the top to halfway down. Work from left to right then right to left, in broad, sweeping strokes. Now clean your brush and load it with another color. Apply this with broad, sweeping strokes as before and work towards the bottom of the paper. Work the two colors gently with your brush where they meet, encouraging them to merge and create a seamless gradation.

CREATING A GRANULATED EFFECT

Granulation is used to create interesting variety and texture in a painting. Some pigments granulate more effectively than others. Examples are ultramarine blue, burnt umber, light red, sepia and indigo. They can be used as pure colors or may be mixed with each other or with other pigments. They must be very wet when they are applied. The effect becomes more pronounced with rough paper.

The technique is normally applied to large areas of a painting with a large brush. The board must be flat while the colors dry; and applying them while the painting is flat will also encourage granulation.

Matthew includes granulation in three of his projects: *Clouds at Sunset* (page 62), *Landscape in Snow* (page 114) and *Woman on a Beach* (page 80).

Technique practice

■ Mix one of the granulating pigments mentioned on the left with plenty of water. Make sure the density is strong and lay the wash with broad, sweeping strokes using a large brush. Do the same with the granulating pigments you didn't use and experiment with different combinations of color. Allow to dry flat; tapping the edge of the board may enhance granulation.

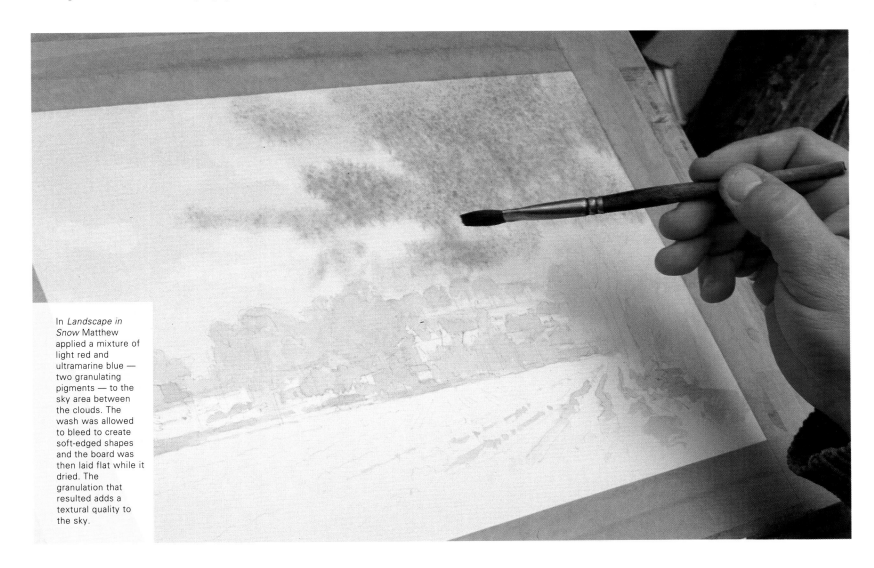

In *Landscape in Snow* Matthew applied a mixture of light red and ultramarine blue — two granulating pigments — to the sky area between the clouds. The wash was allowed to bleed to create soft-edged shapes and the board was then laid flat while it dried. The granulation that resulted adds a textural quality to the sky.

LEARNING TO MIX PAINTS

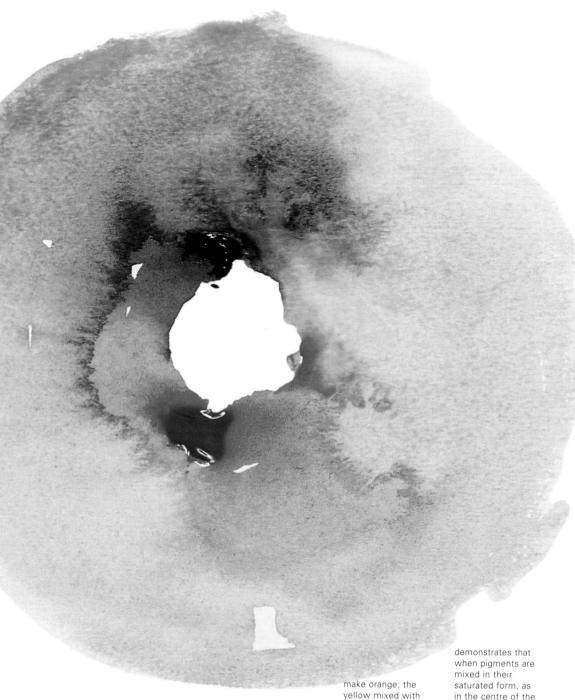

The theory behind mixing colors is simple. As the color wheel shows, there are three primary colors — red, yellow and blue — and when two of these are mixed they will produce secondary colors. Yellow and blue make green; yellow and red create orange; and blue and red result in purple. By mixing the primaries with secondaries, yet more colors can be produced: the tertiaries.

But these are basic, theoretical mixtures. One of the excitements of working with watercolors is to discover for yourself the vast array of colors that can be created. Black and yellow can be mixed to make olive green; Prussian blue and burnt sienna produce sensitive and neutral greens. If you mix ultramarine blue with light red the result is a neutral grey granulating pigment that will be warm if the red is predominant and cool with more blue.

Colors can be mixed on a painting as well as on the palette. Just put two pigments next to each other and touch them together with the point of your brush so that they blend and merge.

Technique practice

■ Set out a variety of colors and mix them. Make sure you have plenty of clean water, and clean your brushes regularly. Remember, if there are too many pigments in a mixture the result will be a dirty brown.

■ Produce your own color wheel. Put a blob of each of the primaries in the centre of a piece of paper and, using the point of your brush, mix them to produce secondaries. Use a larger brush to add water at the edge of the circle and encourage the colors to gradate out as lighter tints.

This simple color wheel shows the effect of mixing variations of the three primary colors. Yellow ochre and magenta make orange; the yellow mixed with Prussian blue gives an intermediate green; and blue with magenta, itself a purple-red, creates an even deeper purple.

This illustration demonstrates that when pigments are mixed in their saturated form, as in the centre of the wheel, they produce very strong and vivid variations of color. It also shows how they lighten when they are diluted with water.

OVERLAYING PAINTS

Because watercolor is a transparent medium it is possible to overpaint an area of dried pigment with another color to create an effect rather like laying a piece of colored acetate over a different-colored background. This is demonstrated very clearly in Gregory's *Flower Study* (page 56) in which a mixture of magenta and ultramarine blue is applied over a dry yellow-green wash to create a pearl-colored background. Overlaying produces exciting and interesting colors and can also be used to orchestrate temperatures within a painting: warm colors are laid over cool ones and cool over warm to create warm-cool relationships.

Certain colors are more, or less, transparent or opaque. Cerulean blue is opaque, as is lemon yellow which, even when it is diluted and used as a wash color, tends to look opaque. Prussian blue is nicely transparent.

It is important to keep the colors pure, so try to use a different brush for each one and make sure you have plenty of water for cleaning.

Technique practice

■ Lay stripes of different colors in different directions, as shown in the illustration, using a 1 inch brush. You will see that opaque pigments tend to obliterate the first color when they are used as overlays. However, this is inherent in the pigments and the effects can be interesting. It is well worth experimenting to see whether you like them.

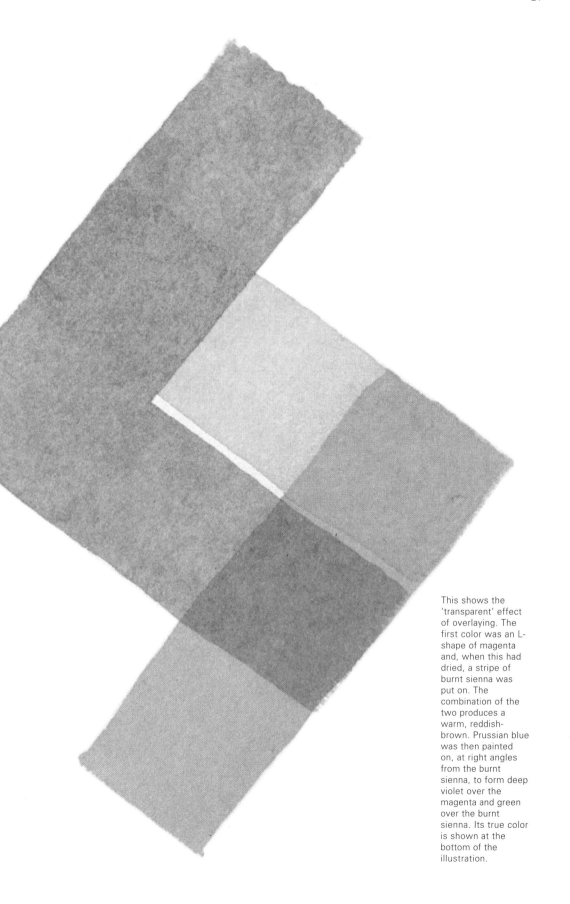

This shows the 'transparent' effect of overlaying. The first color was an L-shape of magenta and, when this had dried, a stripe of burnt sienna was put on. The combination of the two produces a warm, reddish-brown. Prussian blue was then painted on, at right angles from the burnt sienna, to form deep violet over the magenta and green over the burnt sienna. Its true color is shown at the bottom of the illustration.

EXTENDING AND BLENDING COLOR

White is very seldom used to reduce color values or tone. Instead, the pigment is extended with water. This technique is particularly useful for giving the impression of distance in landscapes — faraway views are almost always lighter in tone than those in the foreground. Reducing tone also creates a sense of depth and form as you will see in the two monochrome projects, Matthew's *Outdoor Market* (page 102) and Gregory's *A Simple Portrait* (page 76), both of which emphasize tonal relationships.

The technique of blending colors, or shades of the same color, brings life and vitality to an image and is used in many watercolor paintings. If a leaf in a plant study is painted in one green it could look bland and boring, rather like a paper cut-out. Mixing variations of greens, from cool blue greens to warmer yellow ones, and encouraging delicate transitions between the shades suggests that the leaf is reflecting the various colors that surround it and immediately brings it to life.

Technique practice

■ Creating delicate gradations from pure color through to white paper requires dexterity in handling your brush. Practise this technique by following the examples in the illustration on the right.

■ Put two colours side by side and use your brush to encourage them to merge so that they fuse together. Do this with a variety of colors, and with shades of the same color.

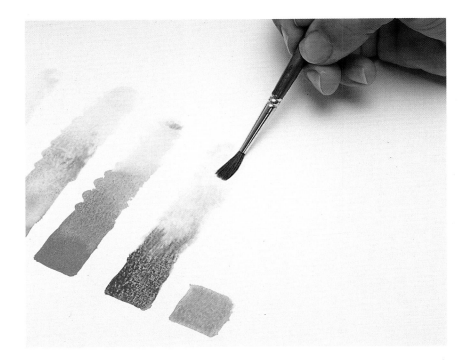

Start by painting areas of strong color, then, using a small brush, add more water to extend the color. Continue to add more water and apply it to the color area until you have created a gradated tonal strip. Try to get the gradations running smoothly from pure pigment to white paper.

In *Landscape with Houses* Gregory used Winsor green and ultramarine blue to create the impression of distant hills and a mixture of yellow ochre and a little Winsor green for vegetation. Once both washes had been laid he wet a clean brush with water and blended them together to create a delicate transition that adds life and vitality to that part of the painting.

WET-INTO-WET

Working wet-into-wet allows the bulk of a painting — usually the first 50-60 per cent — to be developed very quickly and broadly, starting from the general and moving on to the specific. Because washes and pigments are never applied to dry paper during the process, there are no hard edges and colors tend to bleed and blend into each other, creating the loose, spontaneous effects that you will see in Gregory's *Venetian Façade* (page 94) and *Tiger* (page 124) and Matthew's *Outdoor Market* (page 102).

As the painting progresses the wet-into-wet washes are allowed to dry and more defined, hard-edged washes can be added to give value and to contrast with the initial effect. Even so, the early spontaneity created by the original washes remains integral to the painting.

Technique practice

■ Lay a color wash and, while it is still wet, load your brush and drop the paint on to it. You will see how the color spreads. Continue to add color — it will spread less as the paper becomes drier.

■ Experiment with this technique. It never allows total control; the skill is in reacting to what is happening or has happened.

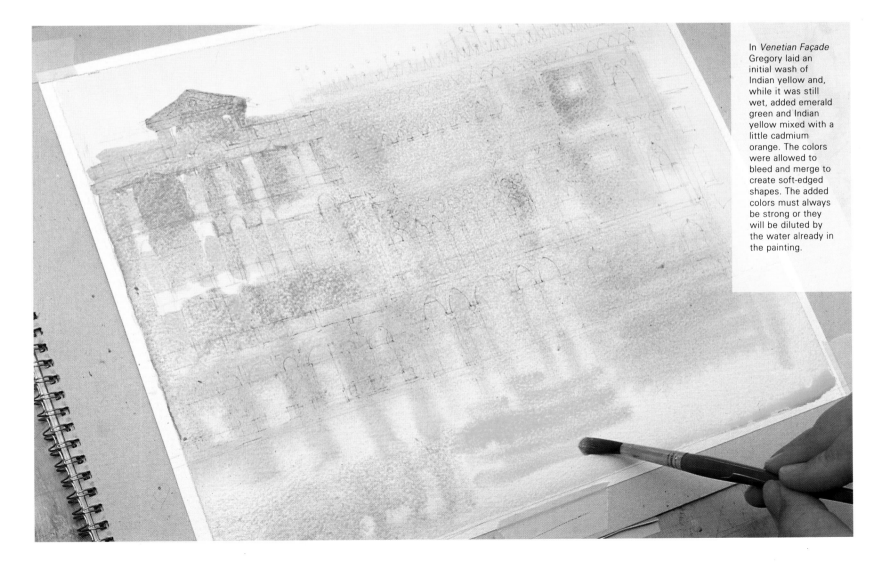

In *Venetian Façade* Gregory laid an initial wash of Indian yellow and, while it was still wet, added emerald green and Indian yellow mixed with a little cadmium orange. The colors were allowed to bleed and merge to create soft-edged shapes. The added colors must always be strong or they will be diluted by the water already in the painting.

LIFTING-OUT WITH A BRUSH

This technique can be used at any time during the development of a painting but is usually applied early on to re-establish the tone — usually white — of the paper after the initial washes have been laid.

Make sure your brush is completely dry by pinching it out between your fingers or wiping it on blotting paper, then use it to paint back into the still-wet surface of the painting. The pigment will be soaked up by the brush and the paper surface will be revealed. If the paper is still wet the color will creep in again and you may have to repeat the process several times. You can lift out small as well as large areas of pigment by using different-sized brushes: Gregory used a No. 10 brush to lift out the petal shapes in his *Flower Study* (right and page 56) while Matthew used a ¾ inch flat brush in the early stages of *Scotney Castle* (page 130) to lift out the castle and its reflections.

This same technique can also be used in an emergency to correct mistakes that become apparent when a wash has dried. Dampen the surface and, using a clean brush, gently rub the area that needs changing with clean water. When the wash is liquid again just pinch the brush to get rid of the color it has absorbed and lift the pigment out of the wash.

Technique practice

■ Prepare a color wash — it should be fairly saturated or it will dry before you start your practice — and lay it on your paper. Pinch the excess water out of a brush and lift out a variety of shapes. Repeat this using different brushes.

In *Flower Study* Gregory used lifting-out to create soft-edged shapes that reflected the delicacy of the lilies he was painting. He had to dry and re-dry his brush several times before he was satisfied that he had achieved the flowerlike effect he was looking for.

In *Outdoor Market* Matthew was concerned to keep the light areas in the painting linked together. Where necessary, he lifted them out of darker areas using a clean, dry brush. The initial wash was still wet when he did this and he was able to create light areas without losing spontaneity.

BLOTTING-OUT AND USING A SPONGE

Blotting-out — using absorbent tissues to soak up pigment from large, washed areas or smaller, more detailed, ones while the colors are still wet — can be done at any stage during the development of a painting. If previous washes have been applied they must be dry before this technique is used. Matthew uses blotting-out to establish the shapes of clouds in three of his landscapes: *Clouds at Sunset* (page 62), *Landscape in Snow* (page 114) and *Scotney Castle* (page 130).

Use a clean tissue and crumple it up to form a ball or roll it into a strip depending on the shapes you want to achieve. Then use the tissue to soak up the pigments. Tissues absorb colors when they blot them, so remember to change them frequently or you will return the pigment to another part of the painting.

It is also possible to 'blot on' color using tissues or a sponge. Small natural sponges about 1 - 1 ½ inches across are available from art suppliers and can be used to suggest foliage on bushes and trees and to create interesting textural effects. They are generally preferable to tissues as the effects they create are more varied. Matthew uses this technique as well as blotting-out in *Clouds at Sunset* and *Landscape in Snow*.

Technique practice

■ Crumple or roll tissues into different shapes and experiment to see the variety of shapes these will produce.
■ Prepare a color wash in a saucer, then dip a watercolor sponge into it and blot or drag the sponge across the surface of your paper. Experiment to see the variety of shapes and textures that can be created.

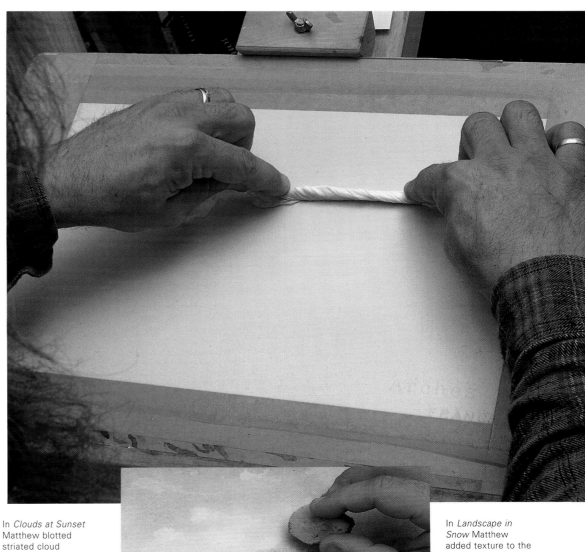

In *Clouds at Sunset* Matthew blotted striated cloud shapes out of a gradated wash of raw and burnt sienna that had been applied over a dry, raw sienna wash. He used rolled tissues to reveal the original warm color of the initial wash.

In *Landscape in Snow* Matthew added texture to the trees in the middle ground of the painting by using a watercolor sponge. He dipped it into burnt sienna and applied the color to the trees to give the impression of foliage.

MASKING-OUT AND SCRATCHING-OUT

Two techniques — masking-out and scratching-out — enable you to use the white (or colored) paper surface as an integral part of the finished painting.

Masking-out involves using masking fluid at the outset, before any washes are laid. Use a small or medium brush and apply it to all the areas that are to remain uncolored. Allow the fluid to dry and then apply colors to the entire paper surface. The rubberized fluid acts literally as a mask and protects the areas it covers from the pigments. Wait for the washes to dry then remove the 'mask' by gently rubbing it off with a piece of dried fluid or with your finger or a soft eraser.

Wash your brush out with hot, soapy water immediately after applying the fluid; it is virtually impossible to remove it when it has dried.

Scratching-out creates texture and sparkle and can be applied with the blade or point of a Stanley knife. Matthew uses a Stanley blade to create sparkle in *Landscape in Snow* (page 114) and combines scratching-out with masking-out in *Woman on a Beach* (page 80). In *Scotney Castle* (page 130) he uses a hard eraser to create small detailed areas.

Technique practice

■ Pour a small quantity of masking fluid into a saucer and, using different-sized brushes, paint marks and shapes on to your paper. Allow to dry and then cover the entire surface with a color wash. Gently rub the fluid off.

■ Lay a wash and, when it is dry, use the edge and point of a Stanley blade to create different textural effects.

In *Woman on a Beach* Matthew masked out all the areas that would be white in the finished painting. This technique was especially suitable for this seaside scene where the foam on the crests of the waves and the reflection of the woman's dress had to be delicate and transitory.

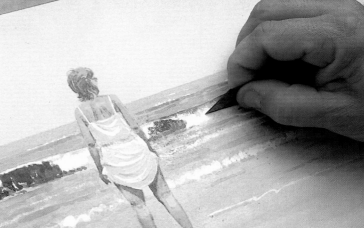

Matthew also used scratching-out in *Woman on a Beach*. When the painting was dry he scraped the edges of the white areas left by the masking fluid with the flat edge of a Stanley blade in order to soften them.

The point of the blade can be used to 'dig out' small areas like pebbles on a beach.

USING AQUAPASTO AND SPATTERING

Aquapasto is a comparatively recent innovation, a creamy medium that can be used with or without water to add textural variation in watercolor painting. Watercolors, even when the pigment is saturated, are normally thin and watery. Mixing the colors with aquapasto gives them an added body and consistency that makes them more like oil paints.

In *Tiger* (page 124) Gregory has thickened watercolor pigments with aquapasto to create a soft layer of color and then scribbled back into this with the back of a brush to create a sgraffito effect. He uses the medium again in *African Townscape* (page 138) and, in both projects, he combines it with yet another technique for introducing texture: spattering or flicking pigments on to the surface of a painting to create a textural basis from which the image develops apparently haphazardly. This requires a very wet wash which is spattered from a brush or toothbrush. Another method is to hold the brush over the painting and allow the wash to drop off. Whichever method you use it is wise to practise first on a spare piece of paper.

Technique practice

■ Mix a wet, dark wash in a saucer. Dip a toothbrush into the mixture, hold it over your paper and run your finger along the brush.
■ Pick the wash up on a brush and tap the brush on your index finger so that the paint spatters down.
■ Hold the brush over the paper and allow the paint to drip on to it.

In *Tiger* Gregory used aquapasto to create a thick base for the background to the main image. He applied it with a palette knife and then spattered and dropped Winsor red into it.
 The result is richly textured and apparently haphazard. In fact, the technique of spattering requires judgement and control.

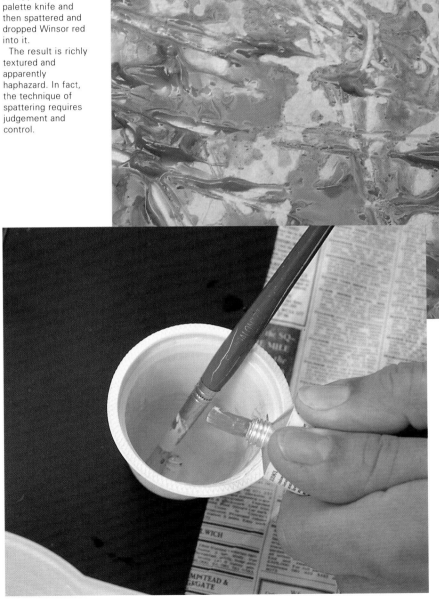

In *African Townscape* Gregory mixed aquapasto with white gouache, cobalt blue and water to create a dense blue that provides a striking contrast with the surrounding washes.

CHOOSING YOUR PALETTE

Literally hundreds of colors are available from art suppliers and it is always difficult for anyone who is starting to paint watercolors for the first time to decide which ones to include and what to leave out. In this book we list the colors that are needed for each project — this way the choice is taken out of your hands until you feel more confident and decide what you want to do with color.

Matthew's projects generally require a palette of no more than seven or eight colors ranging from warm yellows through orange-reds to purple-blues and blue-blacks. Gregory likes to use many more, and often starts with at least two yellows, at least two red, two blues and some greens together with a purple and orange.

Before starting to paint, squeeze out your tubes or set out your pans according to a basic arrangement of color. Put the warmer ones — yellows through orange-reds to warm browns — on the left of your palette, for example, or at the top, and the cool colors from violet through blues to indigo and black opposite them. Greens come somewhere in between.

WARMS AND COOLS

Colors that suggest heat are referred to as warm ones and those that do the opposite are cools and between them there is a range of other temperatures. However, it is difficult to identify the temperature of a color when it is seen on its own: its relative warmth or coolness depends on what is next to it. For example, lemon yellow — a very bright yellow — could be considered a very hot color but, alongside cadmium yellow, which contains more orange, it appears relatively cool. Similarly

Prussian blue is generally thought to be cool but when it is put next to ultramarine blue it immediately seems slightly warmer because it is moving towards the green of the blue spectrum. Temperature in painting terms therefore refers to the warmness or coolness of a particular range of colors. A painting can be keyed towards the warm or cool spectrum by using colors that co-ordinate within one end of the temperature scale. It is not necessary — and often not desirable — to use colors from both ends and the middle of the scale.

One of the beauties of watercolor is that the pigments can be used to overlay each other so that it is possible to achieve a wide range of temperatures using only two or three basic pigments. A cooler color will appear less cold if it is overpainted with a warm one; a warm color will seem cooler if it is overlaid with a cool one.

This way of controlling temperature within a painting can create quiet, calm and harmonious effects.

DEVELOPING YOUR RANGE

It is always advisable to develop your range of colors slowly — too many pigments can lead to confusion. Although Gregory's palette is very wide it is the result of many years of experience of adding and taking away colors.

Similarly, Matthew's limited palette of earth colors — browns and yellow ochres — has been selected and developed over a number of years.

The colors you use will be determined by your motivation and your method. And the chances are that you already know the types of painting — and the colors within them — that you respond

to. You may admire a particular artist's work. On visits to museums and galleries you may be drawn towards paintings filled with saturated color. Or possibly you are more interested in the calmer, more muted tones that are characteristic of early nineteenth-century artists.

All these factors will influence your initial choice of colors.

It is unwise, however, to become too dogmatic in your approach. Particularly in the early stages of developing your color range you may find that experimenting with colors that do not normally interest you could lead to exciting and unexpected results.

Never be afraid of experimentation — and never be afraid to respond directly to what you are painting.

■ As a practical experiment in temperature values it is useful to put out colors from one end of the scale, from a cool brown such as sepia through warmer browns like burnt sienna and raw and burnt umber to raw sienna and yellow ochre, and try to paint a picture using just these pigments.

The painting will have an overall warm harmony but the range of temperatures between the hottest and coolest colors will be obvious.

There is no need to choose a subject that only has these browns. You can translate blues, greens and purples into the colors you are using by matching their relative temperatures.

Several of the projects in this book use a limited palette, some use only one color and others require a whole range of pigments. But any of these projects could have been painted using a few or several colors. The choice is up to the individual artist.

**Matthew
Alexander's
palette**

Matthew uses tubes of
watercolor and his
relatively limited palette
consists of yellow ochre,
burnt umber, burnt
sienna, light red, sepia,
magenta, Prussian blue,
ultramarine blue and
indigo. He may use only
three of them or he may,
occasionally, use all
nine. When necessary he
adds other colors.

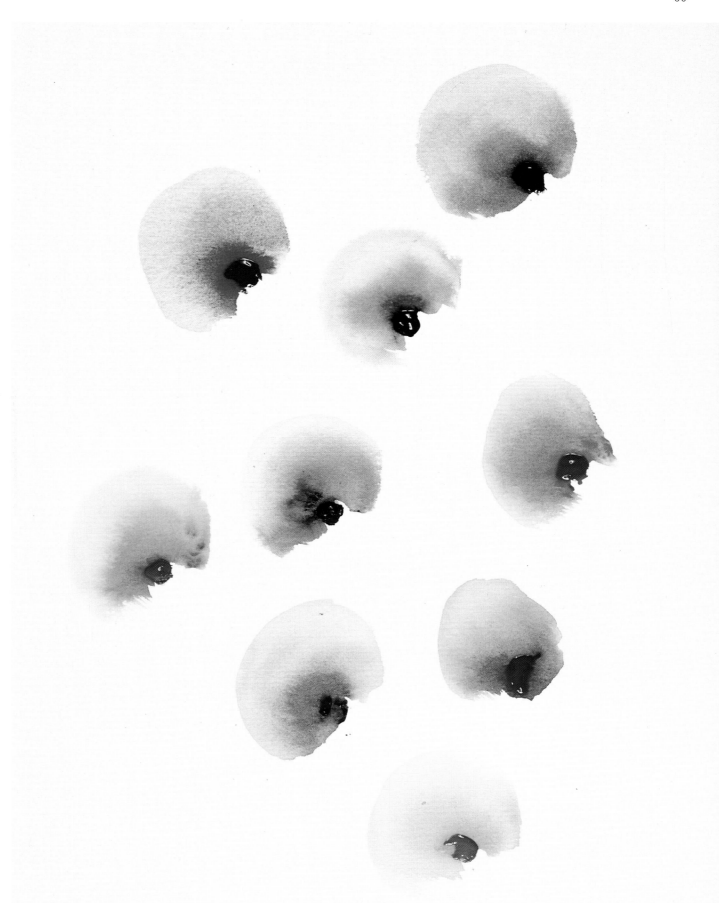

**Gregory
Alexander's
palette**

Gregory's colors are organized
within his travelling paint-box
from warm colors through to
the cooler ones. Yellow,
oranges and reds are lined up
on one side and the blues and
greens on the other. He uses
pans and mixes the colors in
the lid of his watercolor box.
Although there are 25 colors in
his palette he would never use
all of them. However, they give
him the opportunity to select
from a range of pigments that
suit his needs and allow him to
respond to most subjects. He
uses tubes and other colors
when he is working in a studio.

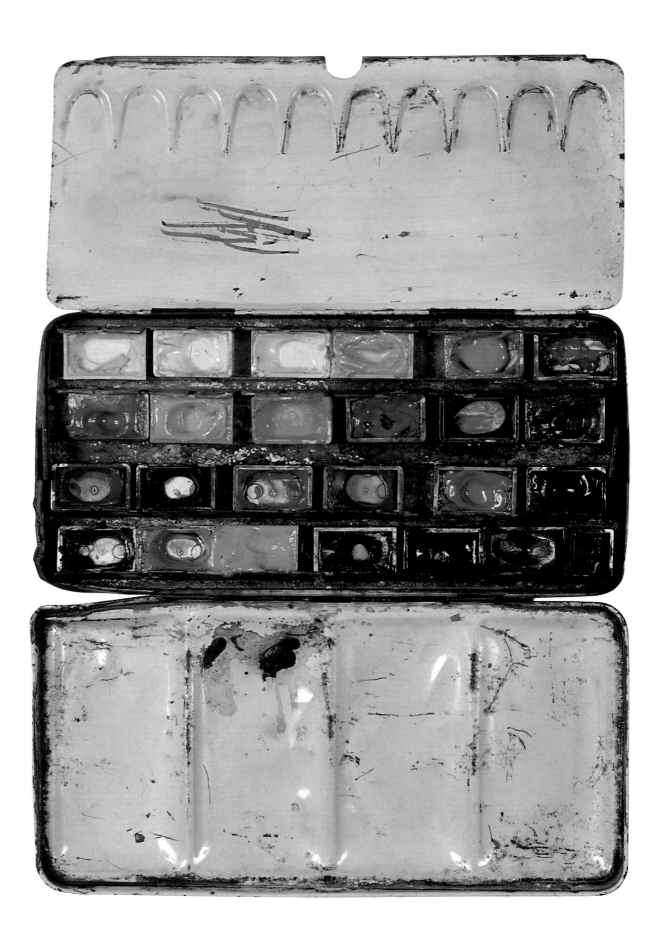

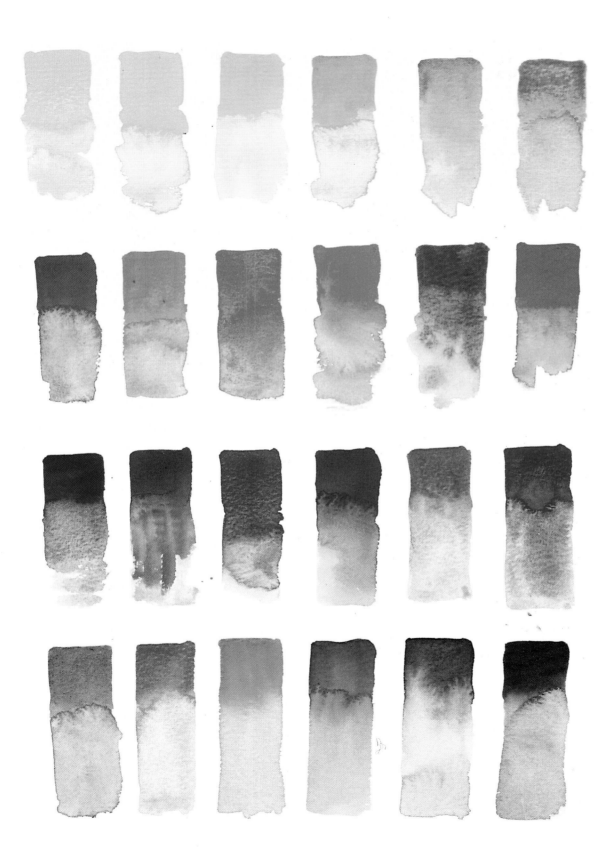

The colors in Gregory's travelling palette are arranged from warms to cools and are: Lemon yellow; permanent yellow; cadmium yellow; Indian yellow; yellow ochre; raw sienna; burnt sienna; cadmium orange; cadmium red; permanent rose; magenta; alizarin crimson; Indian red; glowing violet; cobalt blue; Winsor blue; cerulean blue; French ultramarine blue; turquoise; cobalt green; emerald green; permanent green; Winsor green; black.

MORE COMPLEX COMPOSITION

The still-life on the previous page is basically an arrangement of almost two-dimensional shapes within the picture frame. The landscape of *Scotney Castle* (below), one of the projects in this book, required the same considerations in terms of shape and areas but in addition it was necessary to create the illusion of depth by making distant shapes lighter in tone, so that the contrast between them and the background space is less harsh than the tonal relationships of the foreground shapes. Diagonal lines lead from an unfocused foreground to the castle, and on to the spaces in the distance.

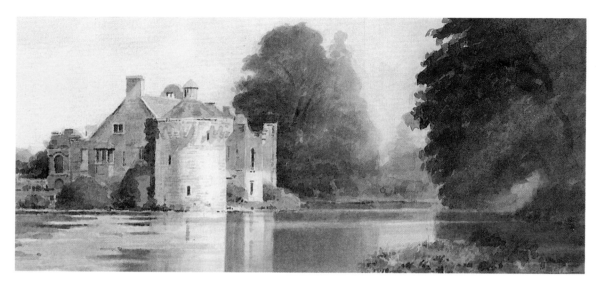

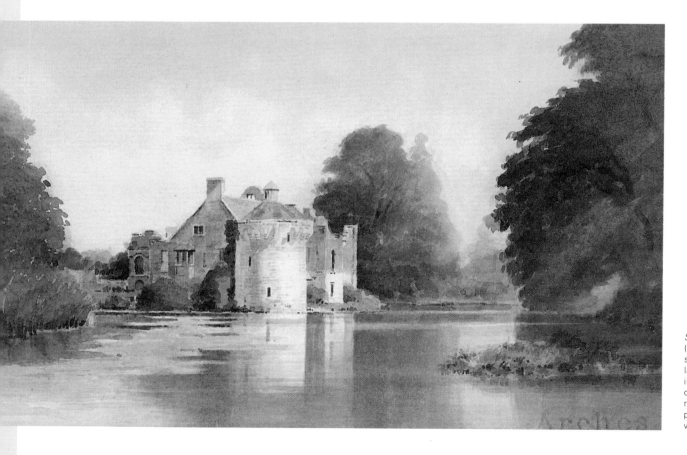

Dynamic compositions can be achieved by the more unusual placing of the main elements. Although the castle is the main focus the diagonals force the eye towards the right. There is a sense of wishing to see behind the tree.

Scotney Castle (page 130): The shapes in this landscape are seen in relation to each other and also in relation to their position in space within the picture.

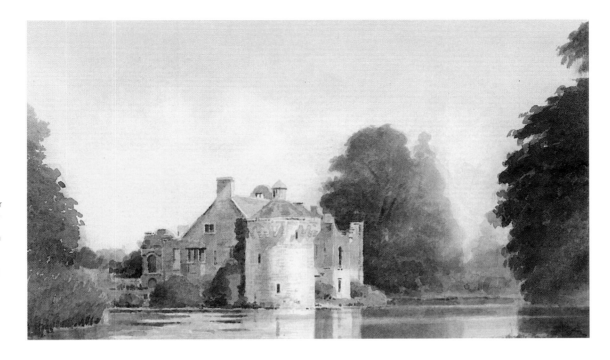

The prime motive for the painting was the way the castle's image is reflected in the surrounding water. Here the viewpoint is too low and there is not enough space to fully indulge this most important aspect of the composition.

The compositional arrangement is rather too central and creates a rather static quality. Although this is not unduly worrying in itself, there is not enough variety to excite and stimulate the eye.

This composition fails because it is close to the main subject instead of showing its relationship to its surroundings in space. The castle takes up too much of the painting and there is a sense of claustrophobia.

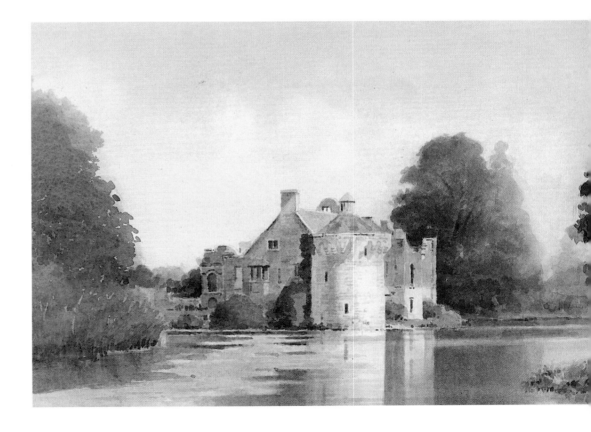

STARTING TO PAINT

Before you start to paint make sure that you are comfortable and that all the materials you are likely to need are within easy reach. There is nothing more frustrating than picking up a brush that has not been cleaned or having to stop in mid-flow to retrieve a watercolor that has been left in the car.

If you are working indoors, have a large mixing plate and plenty of clean water in a large pot — or even two pots — close by. If you don't possess an easel use a table and rest your drawing-board on a couple of thick books to achieve the angle you want. Daylight is best to paint by, but it is perfectly possible to use an artificial light. Arrange it so that it doesn't cast a shadow over your work.

If you are painting outdoors, try to take as little equipment as possible. Remember, you will have to carry it to your painting site and back again. If you want to take something to sit on, make sure it is comfortable. Perching on a fisherman's stool is not fun ! You can use your lap as an easel; hold the board up with your hand when you need to tilt it and prop the painting against your watercolor box to dry. If you are shy about painting in front of other people find subjects and places where you can work undisturbed.

Finally, whether you are painting indoors or out — don't be niggardly with your colors. You have to decide whether you want your paint in tubes or watercolor boxes or on the painting. You can't have it both ways.

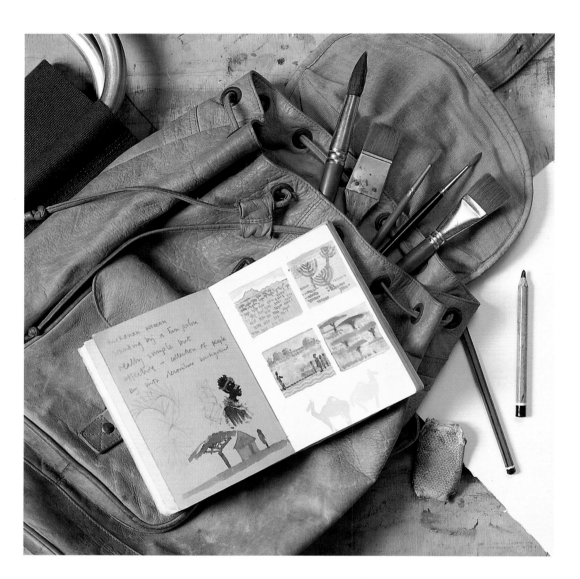

Be selective about your equipment when you're painting outdoors. Gregory is content with a rucksack for his materials, which include a small notebook for drawings and color notes. A portable (and comfortable) stool is useful — and don't forget to take plenty of water along.

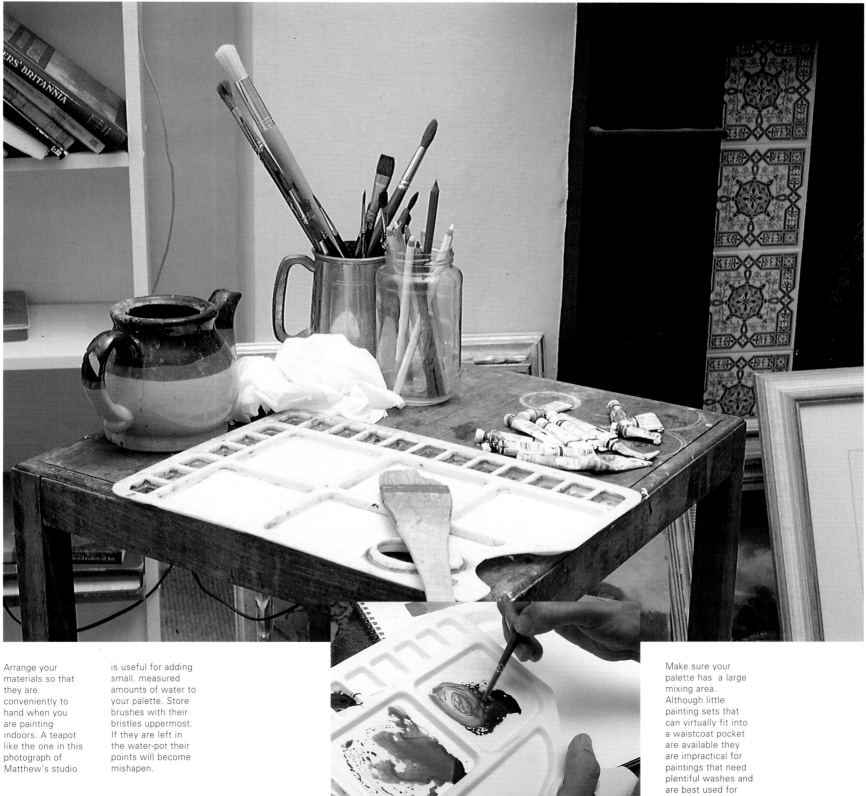

Arrange your materials so that they are conveniently to hand when you are painting indoors. A teapot like the one in this photograph of Matthew's studio is useful for adding small, measured amounts of water to your palette. Store brushes with their bristles uppermost. If they are left in the water-pot their points will become mishapen.

Make sure your palette has a large mixing area. Although little painting sets that can virtually fit into a waistcoat pocket are available they are impractical for paintings that need plentiful washes and are best used for color-note sketches.

In the fourteen projects that follow we take you through the development of our paintings from initial inspiration to the finished picture.

■ The text in the tinted columns summarizes the steps in the stage that has been reached in the main illustration which is surrounded by a colored border, and gives the sequence of the steps involved.

■ The captioned illustrations focus on particular steps.

■ Materials are listed at the start of each project.

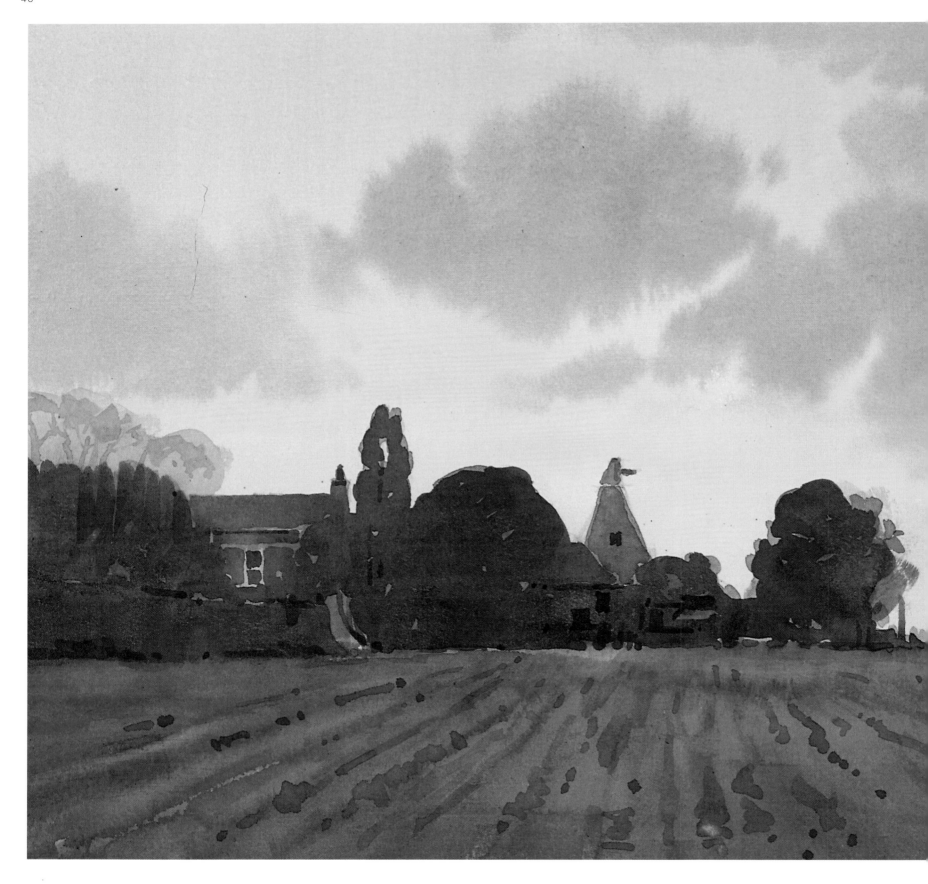

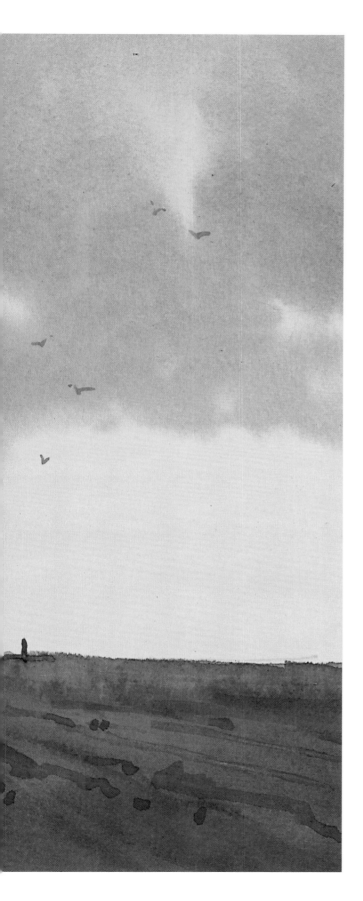

Sunset Scene
(34.5 cm x 22 cm /
13½ in x 8½ in);
Matthew Alexander.

SUNSET SCENE: SILHOUETTES FOR A STARTER PROJECT

This is the first project in the book and I therefore wanted to create a simple image that would nevertheless make use of most of the concepts that are involved in painting with watercolors: warm colors contrasted with cool ones, large shapes shown against small ones, dark against light, hard and soft edges.

I decided to create a simple landscape using five or six colors, showing shapes silhouetted against a sunset sky. I selected this subject because of its relatively simple sky: the evening glow can be realized quite simply by using yellow and orange pigments in a gradated wash. The cloud shapes are in silhouette because this allows you to deal with flat shapes rather than three-dimensional forms.

To a certain extent, too, the colors have been selected with simplicity in mind: they are closely linked and generally warm with some darkish tones. It is important to remember that silhouettes in painting are never black. Although the subject is lit strongly from behind there is always plenty of reflected light — in this case from other parts of the sky — which illuminates and informs the linked pattern of dark shapes, revealing subtle variations of color, tone and temperature.

The sky is the predominant element in the composition and for this reason I have made the line of the horizon relatively low down in the painting. The perspective of the ploughed furrows in the field leads the eye from the foreground to the buildings and trees silhouetted against the sunset sky. The clouds are mainly in the righthand side of the painting and the central formation, just above the silhouettes, works with the furrows to make the trees and buildings the focal point of the composition.

The birds on the right were a final touch, added to give atmosphere and a sense of freedom.

Materials
◆ 3B pencil
◆ Paper: 190 lb Rough; stretched
◆ Brushes: ¾ inch flat; 2 ½ inch; No. 4; No. 6; No. 8
◆ Colors: Indian yellow; alizarin crimson; burnt sienna; indigo blue; sepia.

1 Creating a sunset glow

I lay a strong background wash that will form a vivid contrast with the clouds and the silhouettes of the trees and buildings and the field. It gradates from light yellow to an orange glow that will form part of the sky. I add the red for the glow as I come towards the bottom; if I apply it at the top it will fall and blend with the yellow. (Illus. A, B, C.) When the painting is dry I turn it the right way up (see Stage 2, step A).

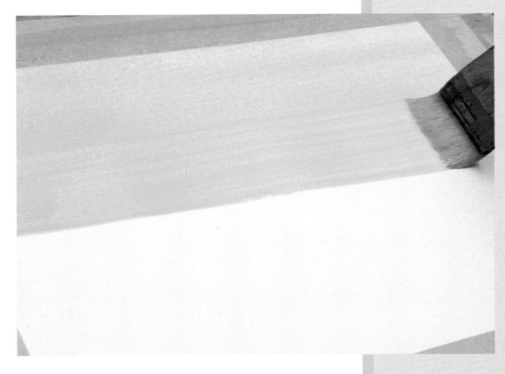

A Start by putting your board at an angle and then dampen the paper with clean water and a 2½ inch brush. Make up plenty of Indian yellow and apply the wash from the top down. Make sure your brush is fully loaded with paint and work from right to left, then from left to right, picking up the wet edge from the line above.

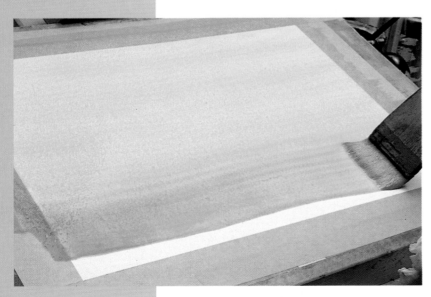

B Add a little alizarin crimson to the yellow as you come towards the bottom of the paper and continue laying the wash, from right to left then left to right as before, until you have filled in the entire background.

C When you have finished laying the wash, tilt the top of the board upwards so that the dark pigment falls towards the bottom edge of the painting — what will be the top of the sky. This illustration shows the wash blending and gradating.

Pick up any excess moisture at the base of the painting with a dry brush, and leave the painting to dry.

2 Establishing cloud formations

The cloud formations in the sunset sky provide a nice contrast of cool colors against the warm background. Because the light in this painting always comes from behind, all the objects are seen just as simple shapes and all of them are in shadow. I use a cool color — purple — for the clouds in this project so that the shadows appear cooler than the background against which they are seen (illus. **A, B**).

I am careful to mix different shades of purple as it is important to have variations in the colors that are applied; and I encourage them to bleed and fuse in order to create a feeling of movement.

A Once the painting has dried turn it so that the orange glow is at the top. Dampen it again with clean water. Use your large brush and work with quick, broad strokes, going from right to left and left to right as when you applied the wash. Then pinch the brush out and go back lightly over the painting to take off any excess water — the paper must not be saturated.

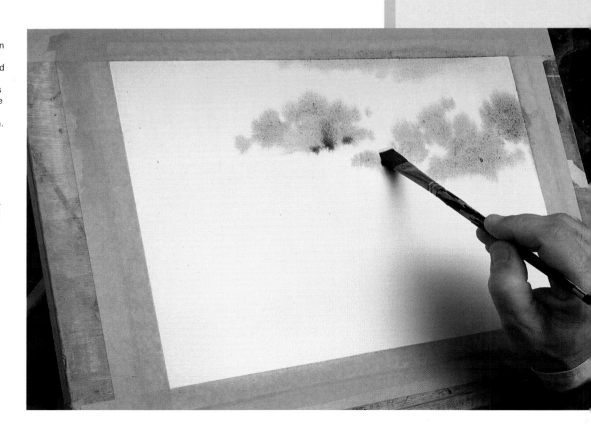

B Mix indigo blue with alizarin crimson to make a range of purples for the cloud shapes. Keep the board tilted towards you at a slight angle and use a ¾ inch brush to apply them. Because the paper is damp, the paint will tend to bleed and form its own shapes. Encourage these to be as random as possible. Leave the painting until the cloud shapes are dry.

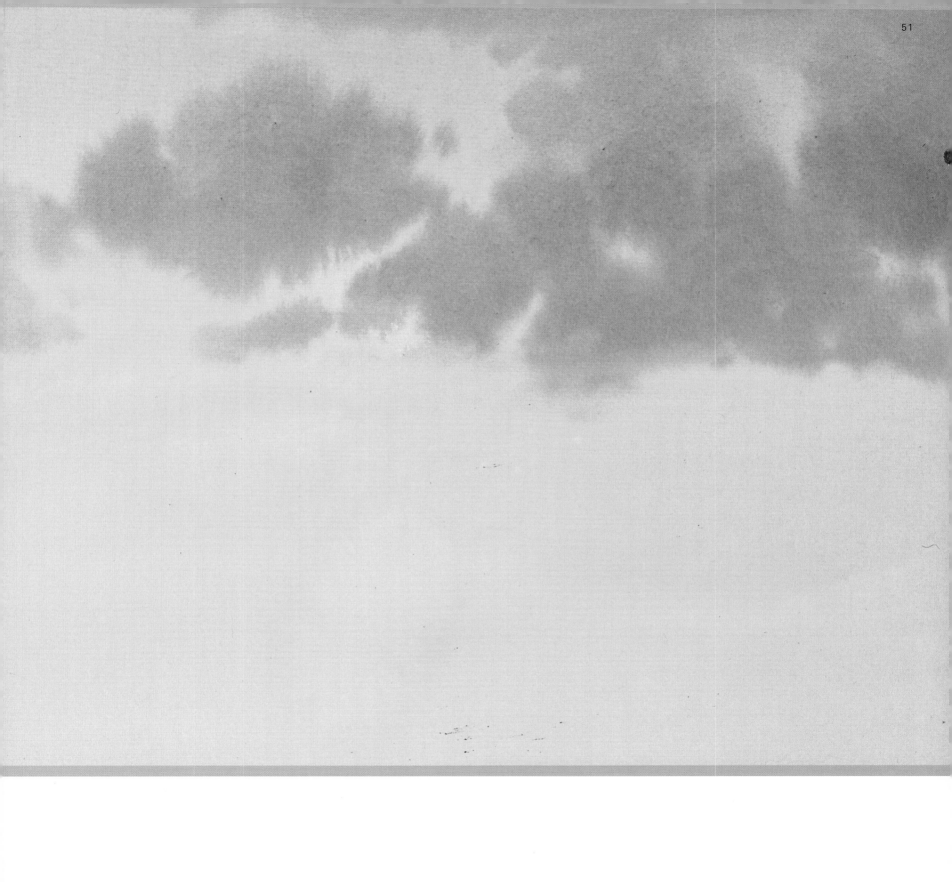

3 Filling in silhouette shapes

I establish the silhouettes of the trees and buildings against the simple sky background. Like the clouds, these interesting and varied shapes are seen against the light as simple, dark masses, so I continue to use cool purples against the warm yellow of the sky and bring these colors into the foreground (illus. A, B, C, D).

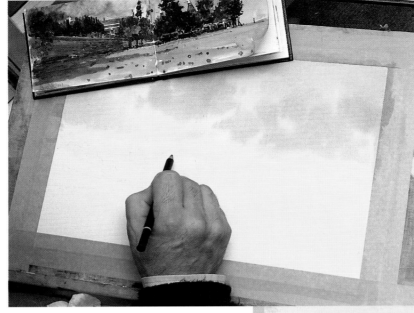

A When the sky and clouds are dry, draw in the shapes of the buildings and trees with a 3B pencil. The buildings in this project were taken from a sketch book — convincing shapes are difficult to invent, so always try to use some kind of reference — in this case the finished painting on page 46. Check the Stage 3 picture on the opposite page to see how the buildings and trees are positioned — below the centre of the painting and to the left.

B Use shades of purple — mixtures of indigo blue and alizarin crimson — to outline the silhouetted shapes of the buildings and trees. The sketchbook at the top of the photograph shows some of the buildings that were incorporated in this painting.

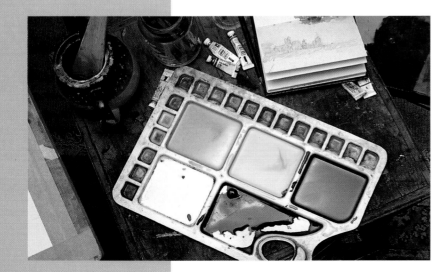

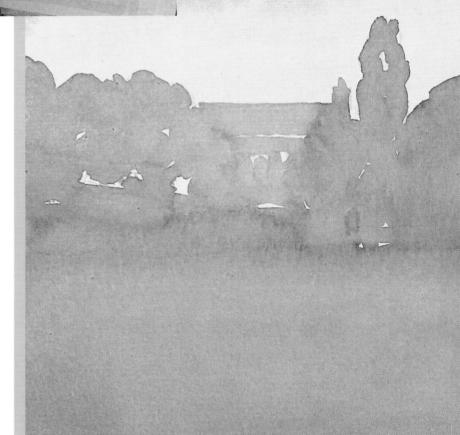

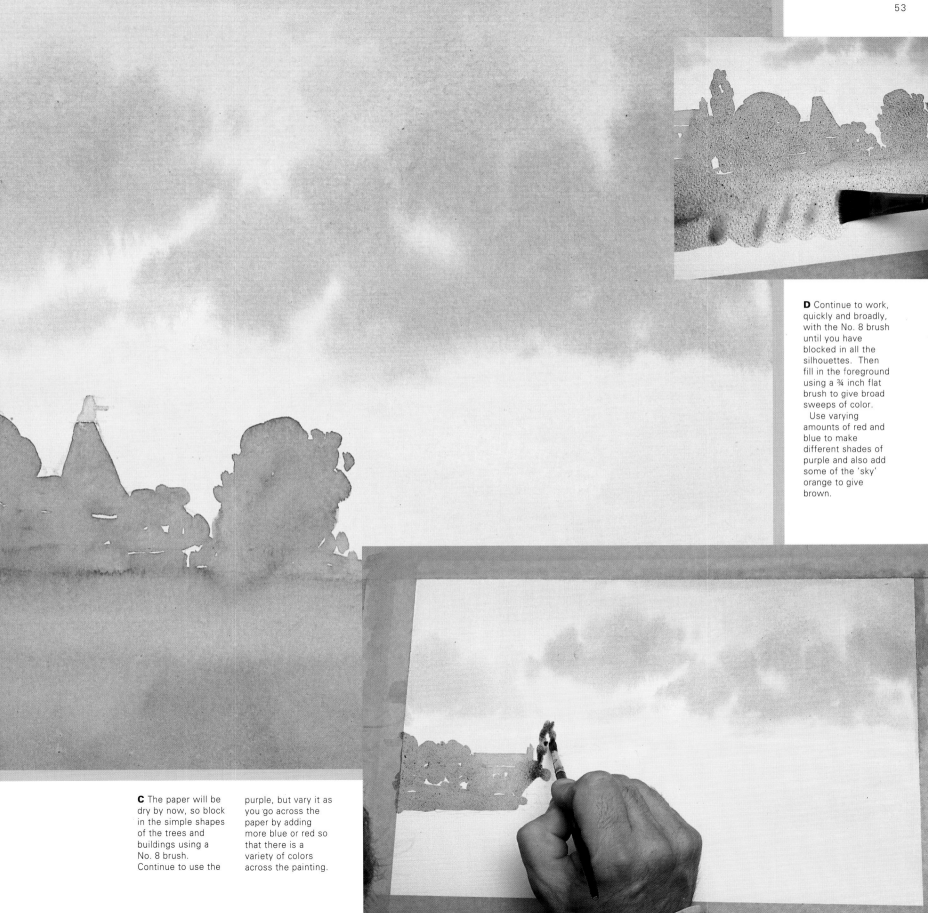

D Continue to work, quickly and broadly, with the No. 8 brush until you have blocked in all the silhouettes. Then fill in the foreground using a ¾ inch flat brush to give broad sweeps of color.
 Use varying amounts of red and blue to make different shades of purple and also add some of the 'sky' orange to give brown.

C The paper will be dry by now, so block in the simple shapes of the trees and buildings using a No. 8 brush. Continue to use the purple, but vary it as you go across the paper by adding more blue or red so that there is a variety of colors across the painting.

4 Realizing the tonal weights

I refine the shapes of the silhouettes and apply darker browns in order to establish the tonal weights of the buildings. I use the perspective of the furrows to lead the viewer's eye to the main, vertical focus of the painting. I introduce the birds in the sky on the right to add a sense of movement and atmosphere to what could otherwise be a static composition. (Illus. A, B, C, D)

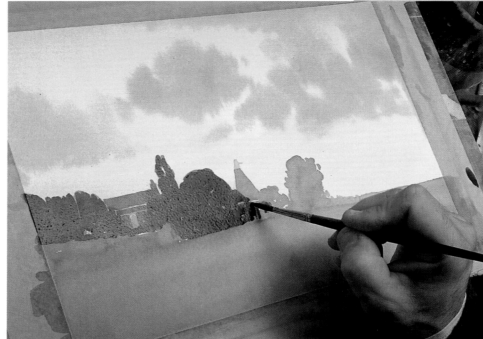

A Accentuate the silhouettes where necessary with a darker tone of purple. Then apply a mixture of burnt sienna and sepia over the purple shapes of the trees and buildings, varying the tones in order to create lighter and darker accents.

Paint around the windows and other shapes. The initial wash will show through and, in contrast to the surrounding dark colors, will give the effect of light objects in shadow.

B Almost the last touch is to add in the birds. Use watered-down sepia and a No. 4 brush with a nice point. Paint in the birds with the tip of the brush and try to spread them randomly.

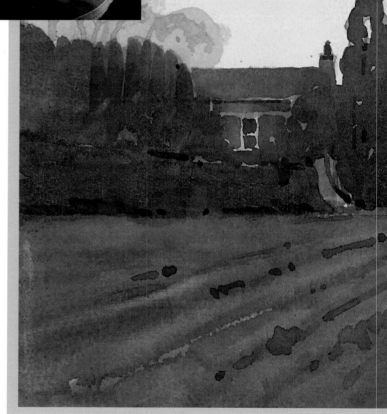

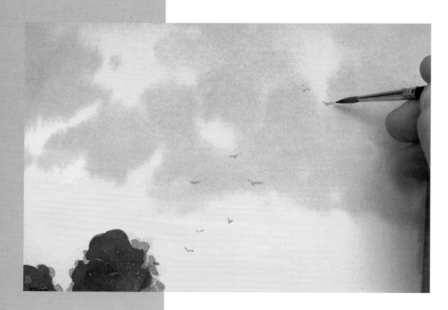

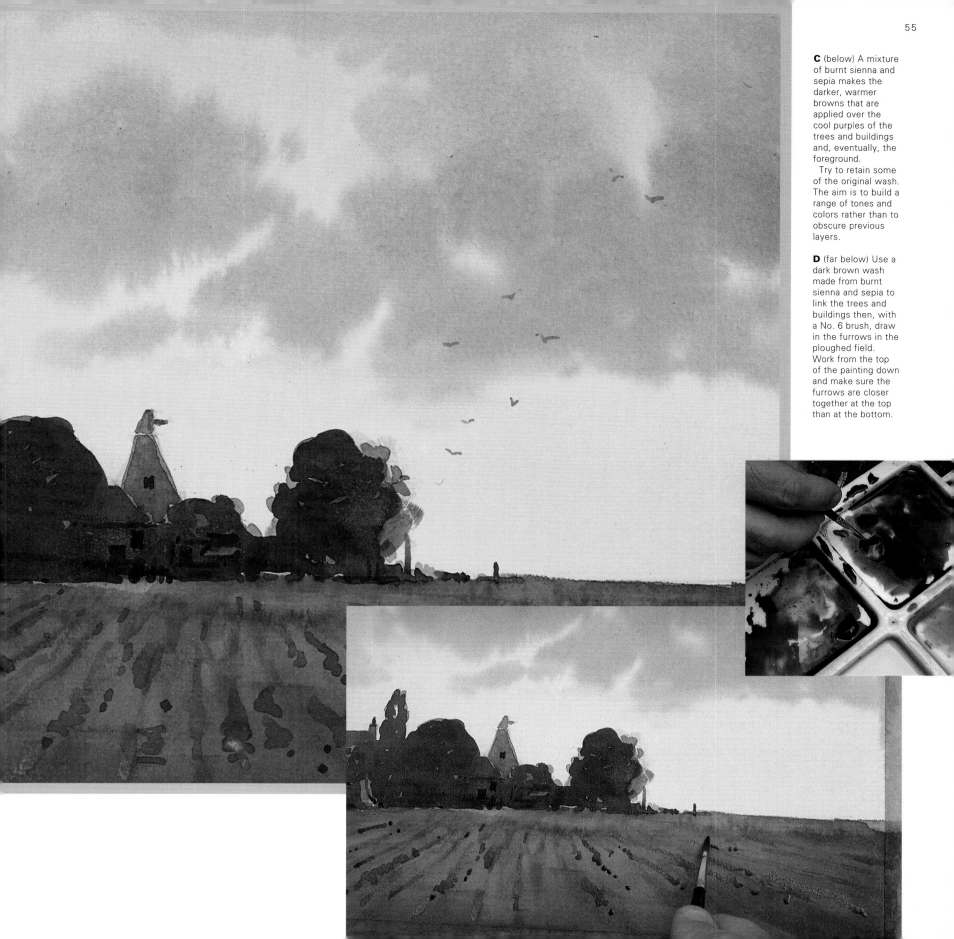

C (below) A mixture of burnt sienna and sepia makes the darker, warmer browns that are applied over the cool purples of the trees and buildings and, eventually, the foreground.

Try to retain some of the original wash. The aim is to build a range of tones and colors rather than to obscure previous layers.

D (far below) Use a dark brown wash made from burnt sienna and sepia to link the trees and buildings then, with a No. 6 brush, draw in the furrows in the ploughed field.

Work from the top of the painting down and make sure the furrows are closer together at the top than at the bottom.

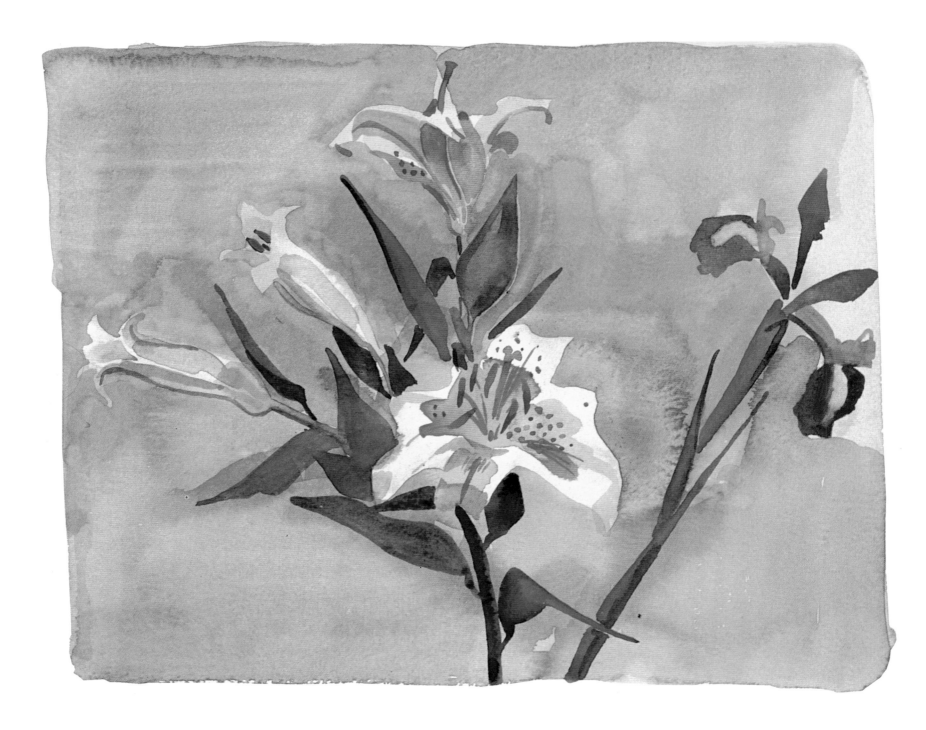

FLOWER STUDY: WET-INTO-WET AND LIFTING-OUT

Once again, in this project, I am in pursuit of my own personal definition of painting: the marriage of subject and medium. It interests me greatly to try to find a balance between the two so that they are both equally apparent. It often seems as though they are on a knife-edge. Attempting to do this is almost like waiting for a singer to reach a high C — you imagine that they may not quite reach it, but when they do the relief makes the listening almost sweeter.

This element of risk provides excitement for me, and, I hope, also for the onlooker.

Flowers are inherently transitory and delicate. They live and change almost as you look at them and in a day or two they may have withered away. In this study I was trying to capture something of their ephemeral nature.

I used a large sheet of paper because I was working directly from the subject — there was no preliminary drawing — and I wanted to have the freedom to move to the left or right as the painting developed so that it could grow and find its own boundaries. I laid a delicate gradated wash on the background and then lifted out the lilies to create soft-edged shapes. I concentrated on responding directly to the subject so that it almost found itself as the work progressed. The watercolor stains interlock and overlap in a way that is slightly ambiguous. The flowers are revealed but not overstated.

The composition was more or less intuitive but, in as much as I wanted to focus on one particular flower, I placed the main stargazer lily more or less in the centre. The iris pulls the eye from the centre to the right before turning it into the picture.

Materials
- Paper: 140 lb NOT
- Brushes: No. 6; No. 8; No. 10
- Colors: Cadmium yellow; Indian yellow; lemon yellow; permanent rose; magenta; alizarin crimson; emerald green; Winsor green; cobalt blue; ultramarine blue; burnt sienna.

I lay the initial gradated wash of cadmium yellow and emerald green on dry paper. I paint this rectangle in the centre of a large sheet of paper so that there is room to move up or down or from right to left.

Flower Study
(26 cm x 22 cm / 10 in x 8½ in);
Gregory Alexander.

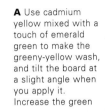

1 Creating a delicate ambience

Flowers are inherently delicate and transitory and I try to capture these characteristics right from the start of the project.
I allow the green of the leaves and stems to bleed and lift the lily out of the wet background to give a soft-edged shape that lends itself to flower studies. A hard edge would look artificial. (Illus. A, B, C, D)

A Use cadmium yellow mixed with a touch of emerald green to make the greeny-yellow wash, and tilt the board at a slight angle when you apply it. Increase the green pigment slightly as you get towards the bottom. Use a No. 10 brush.
 Put the board flat and while the wash is wet lift out the lily shape from the background. Dry the brush first on kitchen paper. Make sure the edges of the shape are soft. Keep on drying your brush so that you get a flowerlike effect. Lift out all the other lilies.

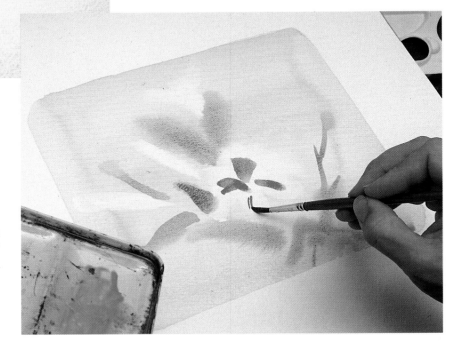

B To indicate the shapes of the leaves and stems, add some Winsor green to your base wash and paint them in while the initial wash is still damp. Use the same brush. The shapes will bleed to give a nice, soft effect.
 Prepare some permanent rose and, still using the No. 10 brush, paint the star-gazer centre of the lily into the shape you lifted out from the background.

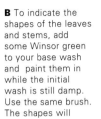

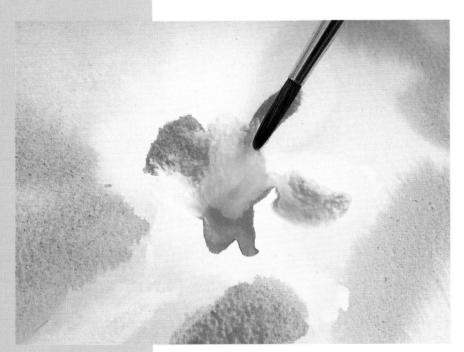

C Use Indian yellow for the stamen of the lily in the foreground of the painting and apply it to the flower's rosy pink centre with a No. 6 brush. Allow the yellow to bleed into the surrounding pink.
 Throughout this project it is important to work with as light a touch as possible.

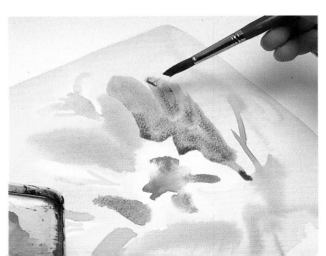

D When the previous washes are dry, mix magenta and ultramarine blue with lots of water to give a delicate red-purple and, with a No. 8 brush, define the edge of the lily shape. Define the other lily shapes and continue to apply the wash around the lily and over the background wash.

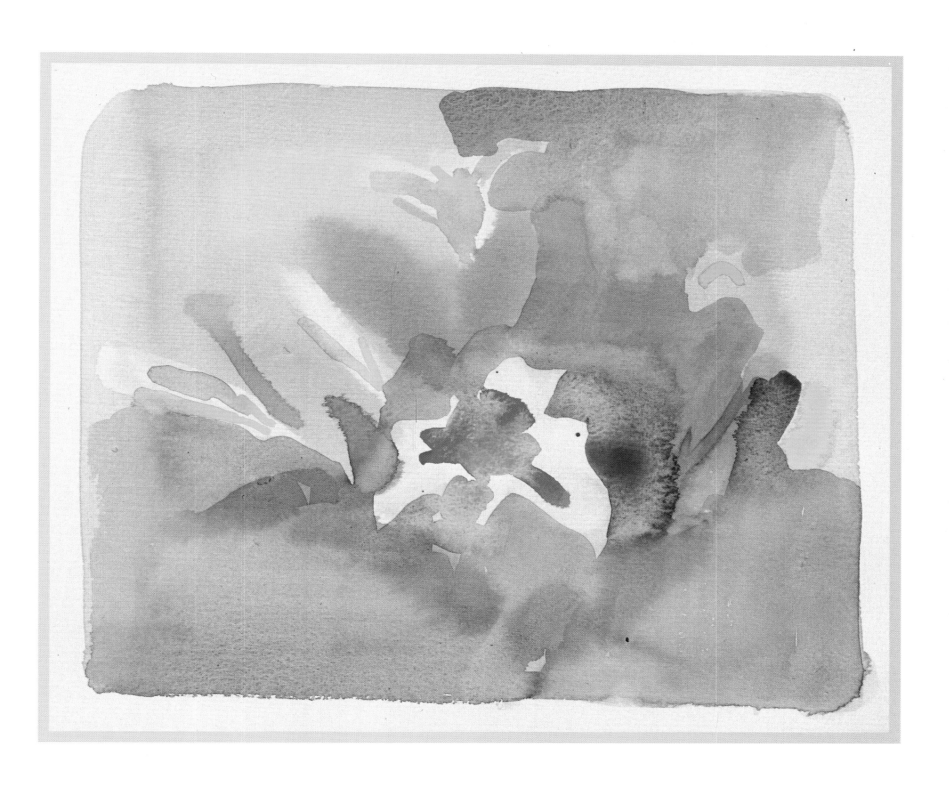

2 Painting abstract shapes

At this stage I am concentrating on filling in the abstract shape of the background to reveal the lilies themselves (illus. A). The first time you do this it may feel awkward and it can help if you squint and shift your focus from the flowers to the background itself. I add the iris and reinforce the background and paint the stamens (illus. B, C).

There is just one final step in this stage:

D Indicate the leaves and stems. Allow the wash to get drier before doing so to bring them into focus. Use varying greens — dark and rich for the leaves and stems of the lily and a lighter green for those of the other flowers — and pay particular attention to capturing their individual characteristics.

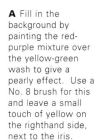

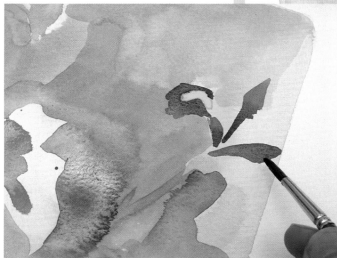

A Fill in the background by painting the red-purple mixture over the yellow-green wash to give a pearly effect. Use a No. 8 brush for this and leave a small touch of yellow on the righthand side, next to the iris.

Concentrate on painting the negative shapes between the lilies and iris. In other words, paint the spaces between them rather than the flowers themselves.

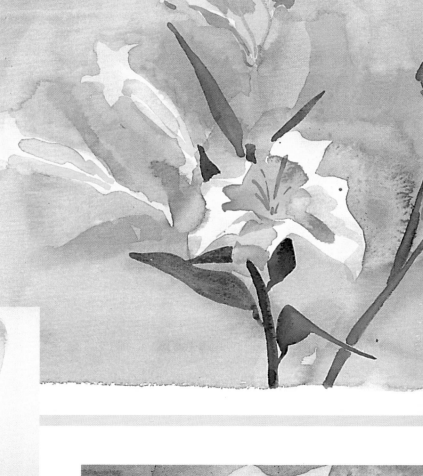

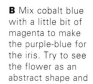

B Mix cobalt blue with a little bit of magenta to make the purple-blue for the iris. Try to see the flower as an abstract shape and paint what you see. Apply the color only to the petals and leave the initial wash untouched for the stamens. Use a No. 8 brush.

3 Filling in the final details

I add a few final touches to complete the painting, filling in details like the seed-pods and bringing the half-open lilies more into focus (illus. **A**, **B**). The leaves of the flowers now look nice and sharp. This is because the background wash was dry when they were painted.

The success of this project depends on a very light touch when applying the pigments and the ability to see the flowers and their leaves as abstract shapes. The temptation is always to paint what you think you know is there. Painting only what you see sounds easy, and basically it is, but you will need to look at everyday objects with fresh eyes.

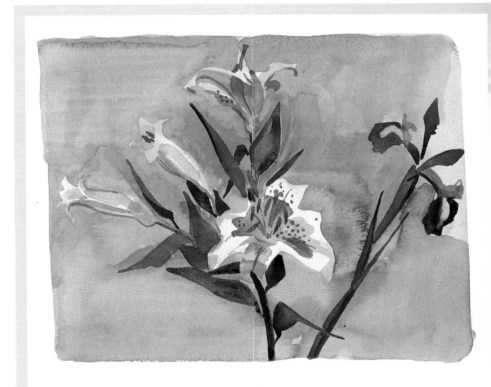

A Mix burnt sienna with a little alizarin crimson and use the tip of a No. 6 brush to paint in the seed-pods on the star-gazer lily's stamens. Use the same color and the same brush for the spots on its petals.

Focus on this one lily and add just a few seed-pods to the one on the left (see main illustration).

To define the leaves and stems, use the same green washes as before. The painting is now dry so they will be crisp and in focus.

B The final touch is to define the heads of the half-open lilies on the furthest left of the painting. Apply some more of the pearly color around their shapes with a No. 8 brush.Then blend the edges into the background with water and a clean brush.

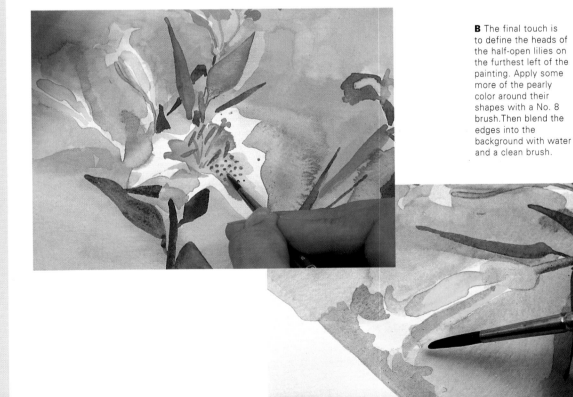

C When you have painted the iris, add a little more magenta to the background wash, then add a little water to this and paint the shadow side of the main lily.

Paint its stamens with the No. 8 brush and a mixture of emerald green and lemon yellow. Load your brush with the paint which will dribble down when it is applied.

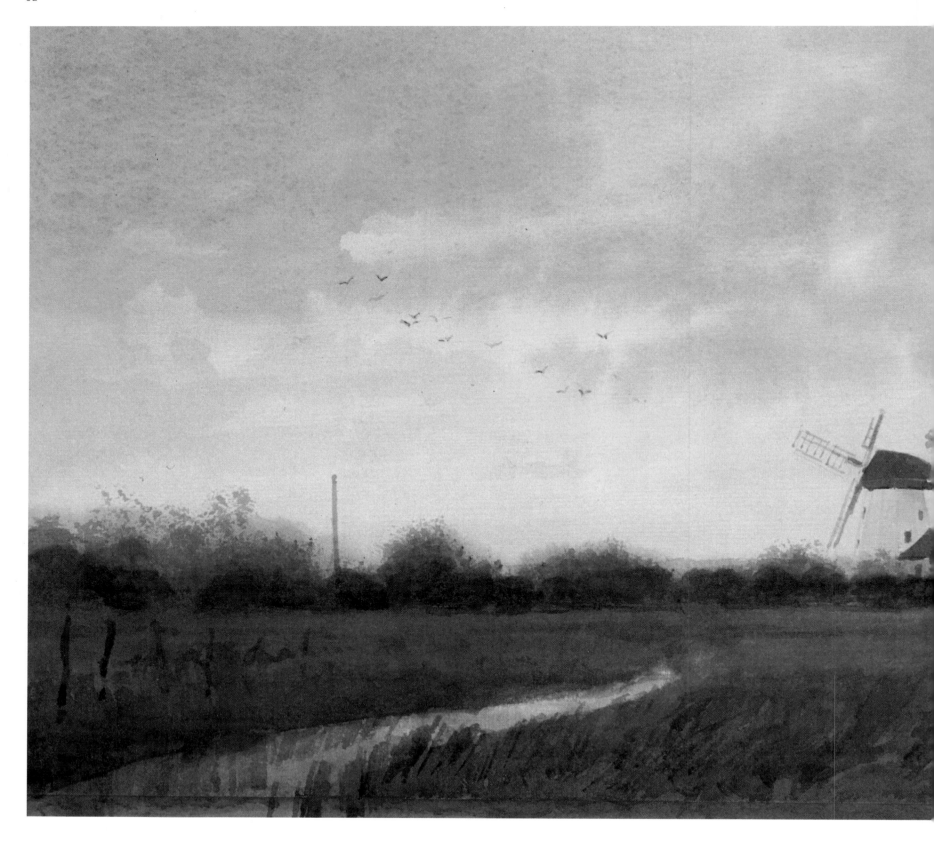

Clouds at Sunset
(34.5 cm x 22 cm /
13½ in x 8½ in);
Matthew Alexander.

CLOUDS AT SUNSET: BLOTTING-OUT AND GRANULATION

I first saw the windmill that is the focus of this painting late one afternoon when it was bathed in a golden, evening light. I was intrigued by the mill itself, with its broken sail, and by the fact that it stood alone, uncluttered, on high ground — and that it commanded that high ground. I also liked the sense of desolation that seemed to infuse the scene.

I was reminded of seventeenth-century Dutch paintings of windmills just like this one, standing in open landscapes and usually silhouetted against a late afternoon sky.

It is important to try to see any subject in as many varying conditions as possible and I recommend returning to the same subject at different times of the day and in different seasons. All too often people paint only on a nice sunny day and miss the excitement of stormy weather or the beauty of light at the beginning and end of the day.

I decided on a tracery of silhouettes against a background of warm, evening light in order to create a scene with the romantic overtones that particularly appeal to me. I invented the stream: the real foreground consisted purely of reeds and needed breaking up in some way. The water leads the eye towards the windmill which is the vertical focus of the painting, and is echoed by the flying birds which also focus attention on the mill.

The colors I used all reflect the overall warmth of a late afternoon scene: yellows, reds and warm green-browns and I added textural interest by using a sponge for foliage and encouraging granulation in the cloud formations.

The cloud shapes themselves are blotted out of the warm evening sky that I created by combining a flat raw sienna wash with a gradated wash of burnt sienna and raw sienna.

Materials
- 2B pencil; tissues; sponge
- Paper: 90 lb Hot-pressed; stretched
- Brushes: ¾ inch flat; 2½ inch flat; No. 2; No. 6; No. 8; No. 10
- Colors: Raw sienna; light red; magenta; burnt sienna; burnt umber; ultramarine blue; Prussian blue; sepia.

1 Creating the glow of sunset

The effect of the sky is all-important in this painting and I immediately establish its warm glow and blot out the shapes of the clouds (illus. **A, B, C**).

Blotting-out is an effective way of creating interesting and complex cloud formations. The shapes could be left as they are in the main illustration on the opposite page or, as in this project, they could be developed to give more varied effects.

Using a ball of tissue that was crumpled rather than rolled into strips would create totally different — but equally effective — shapes.

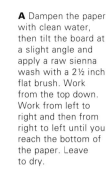

A Dampen the paper with clean water, then tilt the board at a slight angle and apply a raw sienna wash with a 2½ inch flat brush. Work from the top down. Work from left to right and then from right to left until you reach the bottom of the paper. Leave to dry.

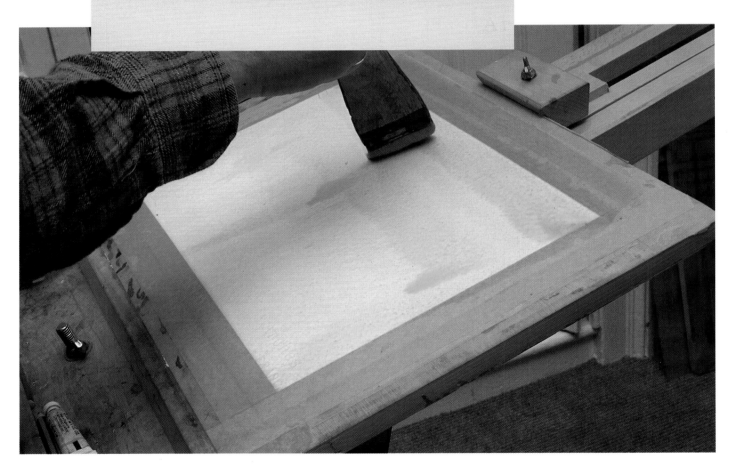

B Mix some burnt sienna with the raw sienna and, when the painting is dry, use the 2½ inch brush to apply the second wash. Add more raw sienna as you approach the bottom of the painting: the color should tend very slightly towards brown at the top and towards yellow at the bottom.
 Make sure the shades of color blend together and that there are no hard edges.

C To create the cloud formations, roll up strips of tissue and, while the gradated wash is still wet, use them to blot out long, striated shapes. The original warm wash will be revealed.

Use both hands to press the tissue firmly down on the painting, wherever you want a cloud effect — and remember to change tissues often or the pigment they absorb will be returned to the picture.

Leave to dry.

2 Introducing a sense of direction

I build on the cloud shapes I created in Stage 1 to introduce some direction and weight in the sky, and counterbalance the coolness of the blue-purples on their shaded sides with the light reds that give a sunset feel to the painting (illus. A).

Ultramarine blue and light red — the colors I mix to get this effect — are both granulating pigments and will add textural variety when they dry.

My aim at this stage is to establish the sense of a warm, late afternoon light. This is the background against which other shapes will be seen.

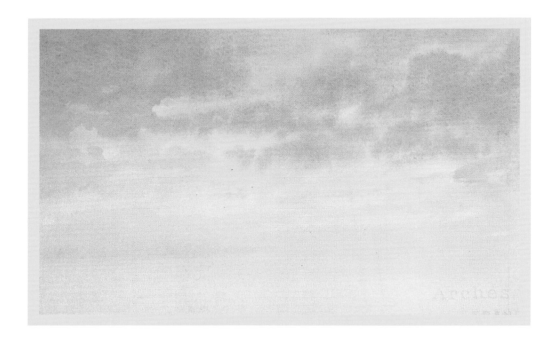

A Mix ultramarine blue with light red to make a range of strong colors from blue-purple to light red.

Now dampen the painting with a 2 ½ inch flat brush and clean water — work from left to right, then right to left from the top down — and then apply the dark cloud shapes. Use a No. 10 brush and try to follow the direction created in the earlier cloud formations.

Allow these washes to dry flat so that the pigments granulate.

3 Establishing the land mass

I want to retain the interest in the sky when I establish the land mass, so I keep the horizon relatively low down in the composition (illus. **A, B**).

There are a number of other steps:

C Fill in the foreground with a mixture of burnt umber and burnt sienna. Use a ¾ inch flat brush and leave the stream unpainted as a lead-in to the picture.

D Use a No. 6 brush and a mixture of magenta and Prussian blue to create a slightly purple glow on the shadow sides of the windmill buildings.

E Finally, use dilute sepia for the windmill's roof and windows and a mixture of sepia and burnt sienna for the roof of the buildings next to it. Use a No. 6 brush.

A Use a 2B pencil to draw the buildings in the middle ground of the picture. The windmill will provide a vertical accent against the horizontal sweep created by the clouds.

The line of trees and bushes (see main illustration) will complement the hard, structural buildings.

B Mix ultramarine blue with lots of water for the hills behind the vegetation and buildings. The color must be very dilute so that it suggests distance. Use a No. 8 brush.

Paint the bushes and trees in the middle ground with a mixture of Prussian blue and burnt sienna. Make a variety of greens with these two pigments and use them to establish different shapes and forms.

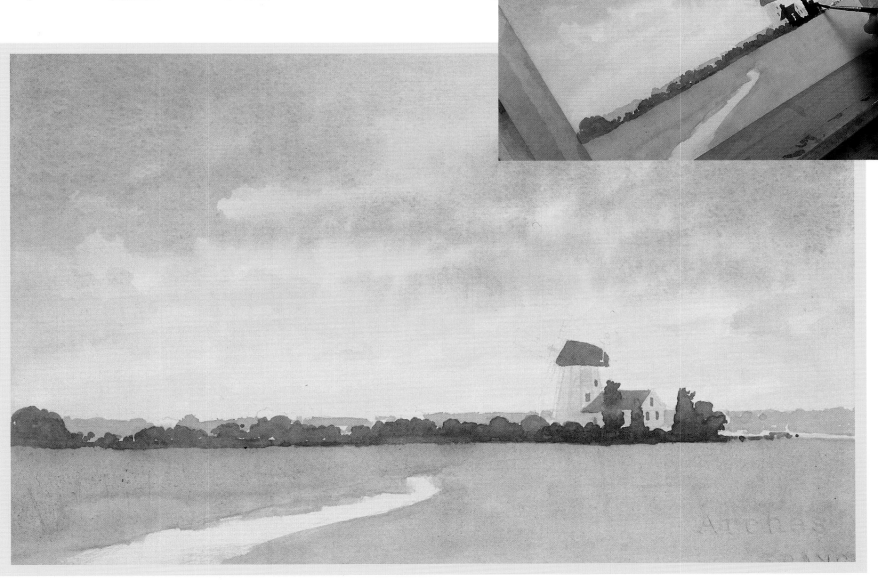

4 Adding the final touches

I use dark colors for the foreground of the painting to add weight at the base of the composition. I sponge in the foliage and add the birds to enliven what would otherwise be a static image. (Illus. A, B, C, D)

There are number of details to be finalized:

E Strengthen the middle ground with washes of Prussian blue and then burnt sienna, using a ¾ inch brush.

F Mix Prussian blue and magenta to make a blue-purple wash for the windmill's sails and windvane. Use a No. 2 brush and add the cool blue-purple shadow under its roof.

G Finally, use sepia and the No. 2 brush for the tracery of the fence alongside the stream, the posts next to the building and for the pole on the left.

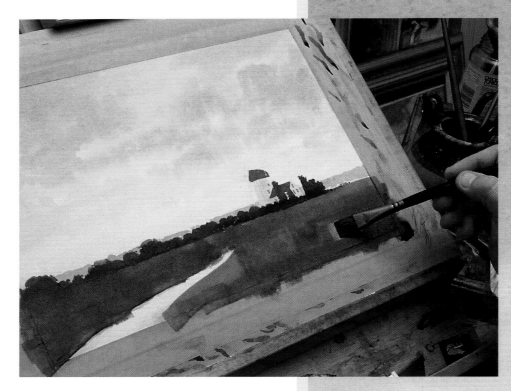

A Mix burnt umber and Prussian blue to make a rich, dark green wash for the foreground and apply it with a ¾ inch flat brush. This will establish the tonal strength of the color and will link the area to the middle ground.

Put the paint on with irregular strokes in order to add vitality to what could otherwise be bland areas. The flat brush will make it easier to do this.

B Use the same ¾ inch brush to apply a dark sepia wash to the area at the bottom of the painting. Put the color on with short, staccato dabs to give the impression of reeds in the foreground.

Using a large brush will help you to create the texture of the reeds without being too specific.

Finally, add more short brush strokes to the reed area (see main illustration). Use a very dark green made from Prussian blue and sepia.

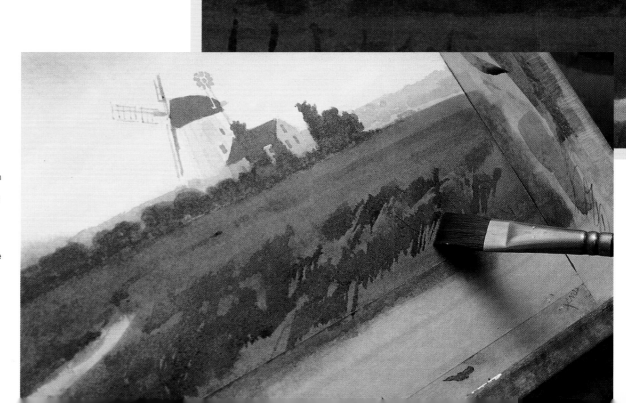

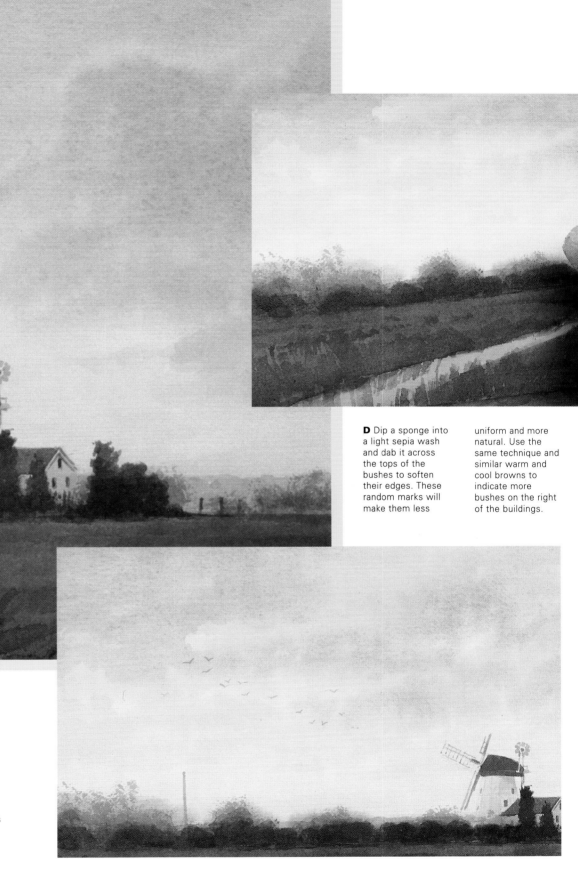

D Dip a sponge into a light sepia wash and dab it across the tops of the bushes to soften their edges. These random marks will make them less uniform and more natural. Use the same technique and similar warm and cool browns to indicate more bushes on the right of the buildings.

C Mix Prussian blue and magenta to make a very delicate blue-purple and use a No. 2 brush to indicate the birds in the lefthand part of the sky.

Work very lightly at first, using just the point of your brush. When the wash is dry, use dilute sepia to add darker accents to some of the birds (see main illustration).

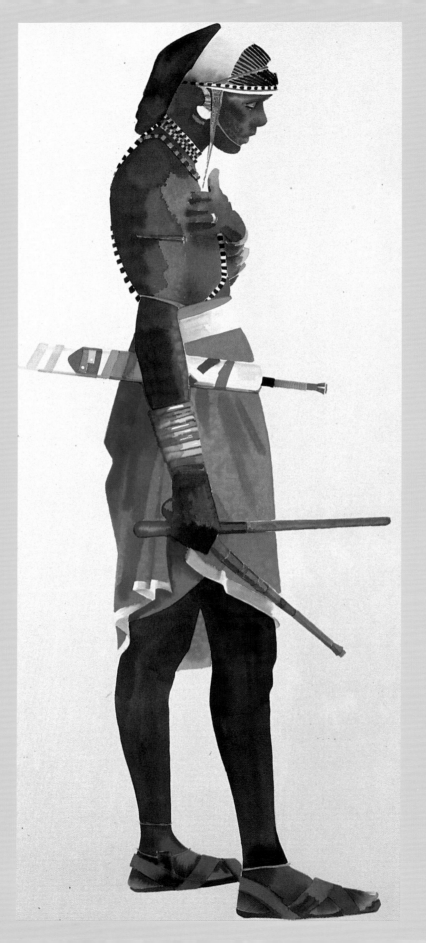

Samburu Warrior
(50 cm x 136 cm /
19½ in x 53½ in);
Gregory Alexander.

SAMBURU WARRIOR: TACKLING A LARGE WORK

I have been visiting Kenya for many years and am always impressed by the statuesque and impressive Masai and Samburu. I have made many studies and paintings of them but most have shown groups of figures, or figures against a backdrop of landscape or color, and have been of average size.

It occurred to me that if I were to concentrate on one figure, and enlarge that figure considerably, I might create a strong image that would convey something of the proud, handsome and sophisticated nature of these people.

My first concern was to enlarge the image and give myself a simple drawing on which to base my painting. I projected my reference on to a separate sheet of paper and then traced that drawing on to the stretched paper. I could also have squared it up by drawing a grid of squares over the reference drawing and then copying the outlines in each square into the squares of a larger grid.

If the work had been an oil painting I would have been able to stand it on an easel and paint it at arm's length, constantly stepping back to view it from a distance. However, because it was a watercolor I had to work flat to prevent the colors merging. I therefore had to hold the image in my mind's eye and frequently stand the painting up — when it was dry — to look at it. I also stood on a chair to see it from above, or viewed it in a mirror.

I had to zone in on a particular area and finish painting it before moving on to another. An advantage of this method of working was that I saw each part as a completely abstract shape, isolated from the rest of the figure, and was able to paint it without preconceptions.

Materials
◆ 1B pencil; putty rubber
◆ Paper: 140 lb Rough; stretched
◆ Brushes: No. 2; No.6; No. 8; No. 10
◆ Colors: Cadmium yellow; cadmium orange; raw sienna; permanent rose; cadmium red; alizarin crimson; magenta; Winsor red; viridian green; turquoise; ultramarine blue; cobalt blue; cerulean blue; burnt sienna; sepia; ivory black

The size of the painting means that I must use a large — 60 cm x 150 cm (24 in x 60 in) — board which I lay flat throughout the painting process. The sheet of paper on the right protects the image from water and splashes of paint.

1 Filling in the torso area

I fill in the warrior's torso area with blues and browns to give the impression of glossy flesh (illus. A, B).

Before doing this I stood the board upright and drew the figure with a 1B pencil. I kept the lines simple: they indicate where the different washes will meet and identify separate areas in the painting.

I lay the board flat for the rest of the project to prevent the colors dripping and merging.

There are two final steps in this stage:

C Paint the very top of the garment area with cadmium red and a No. 10 brush and the bangles in a variety of colors.

D Start to indicate the warrior's bead ornaments with black and cadmium red using a No. 6 brush.

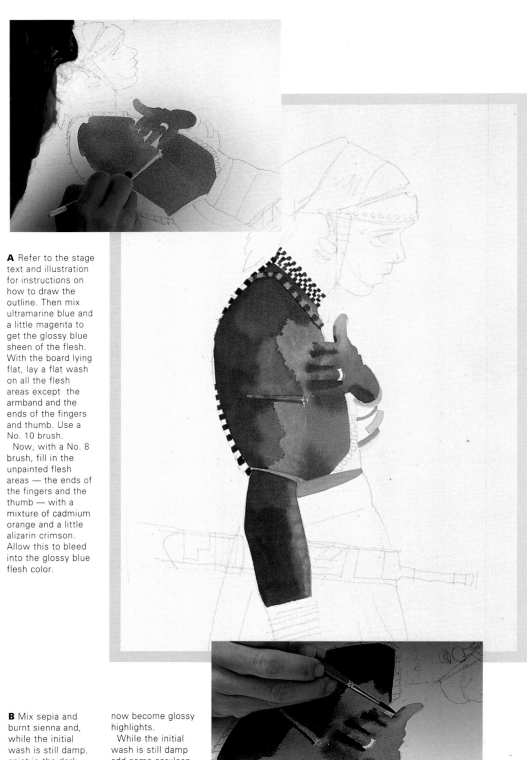

A Refer to the stage text and illustration for instructions on how to draw the outline. Then mix ultramarine blue and a little magenta to get the glossy blue sheen of the flesh. With the board lying flat, lay a flat wash on all the flesh areas except the armband and the ends of the fingers and thumb. Use a No. 10 brush.
Now, with a No. 8 brush, fill in the unpainted flesh areas — the ends of the fingers and the thumb — with a mixture of cadmium orange and a little alizarin crimson. Allow this to bleed into the glossy blue flesh color.

B Mix sepia and burnt sienna and, while the initial wash is still damp, paint in the dark areas of the flesh over the blue using a No. 8 brush. Allow this new color to bleed. You will see that the blue areas that have not been painted over have now become glossy highlights.
While the initial wash is still damp add some cerulean blue to the upper arm and allow it to bleed giving a greenish tinge. Once this area is dry, use cadmium red and a small No. 6 brush for the armband.

2 Filling in the garment

I complete the torso and fill in the garment area and the handles of the batons in the warrior's right hand. The warm colors of the bangles and cloth contrast nicely with the blue sheen of his flesh. (Illus. A, B, C, D)

There are two final steps in this stage:

E Paint the right hand in the same way as the torso in Stage 1.

F The final step is to paint the beadwork on the front of the warrior's torso with black and cadmium red. Use a No. 6 brush.

This is a good time to take a long, hard look at the composition, either by standing on a chair and looking down at it or by viewing it in a mirror.

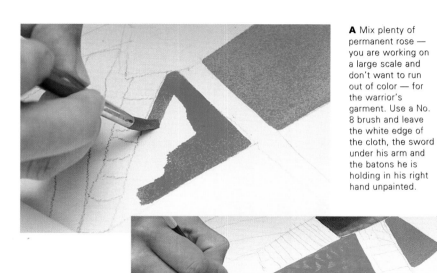

A Mix plenty of permanent rose — you are working on a large scale and don't want to run out of color — for the warrior's garment. Use a No. 8 brush and leave the white edge of the cloth, the sword under his arm and the batons he is holding in his right hand unpainted.

B While the permanent rose is still wet, squiggle cadmium red into it with a No. 10 brush. Allow the red to bleed giving the impression of fabric.
 Use purple made from ultramarine blue and alizarin crimson and a No. 2 brush to paint the handle of the baton.

C Mix a light wash of ultramarine blue and alizarin crimson and, with a No. 8 brush, paint the edge of the garment to create shadows and form.
 Use Winsor red for the cloth under the edge and, before it dries, mix Winsor red and sepia and add a dark shadow just under the hand.

D Paint the bangles in different colors, leaving the white of the paper to show through. Mix a light wash of ultramarine blue and alizarin crimson and, with a No. 8 brush, paint shadows over the colors (see main illustration).

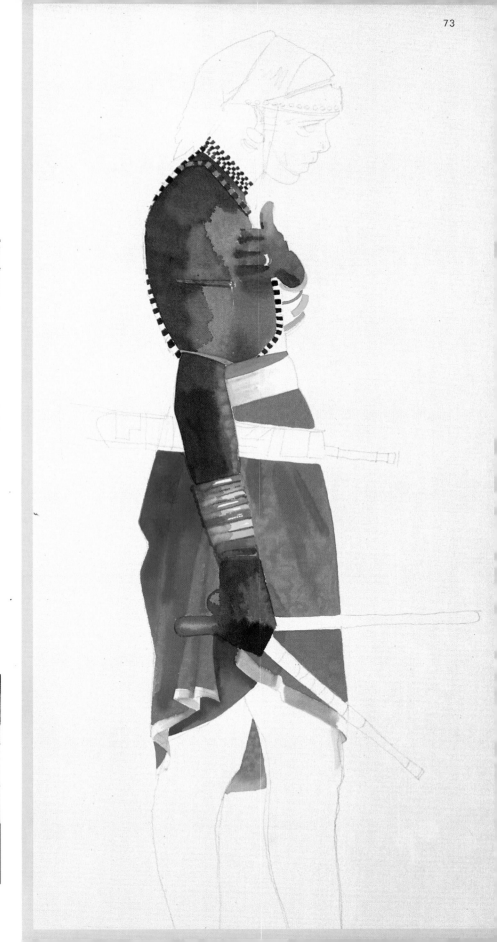

3 Filling in the legs and feet

The warrior's legs are in shade so I am careful to keep them simple, almost as silhouettes, as I fill them in. I paint his feet in the same way as his torso. (Illus. **A, B**)

There are two final steps in this stage:

C Use a variety of colors — cadmium red and yellow, turquoise, cobalt blue and raw sienna — and a No. 8 brush for the sword under his arm.

D Paint the sandals with a mixture of cobalt blue and ivory black using the same brush.

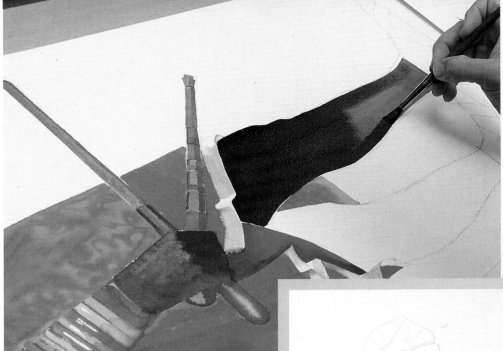

A Use raw sienna and a No. 8 brush for the wood in the batons in the warrior's hand and a mixture of cerulean blue with a touch of viridian green for the decorations. Then fill in the leg with the ultramarine blue and magenta wash, using a No. 10 brush. While this is still damp, paint on the sepia and burnt sienna mixture.

B This illustration shows the rough quality of the paper and the dampness of the wash, with the cadmium orange and alizarin crimson mixture on the side of the foot bleeding into the blue wash. It also demonstrates how important it is for the initial wash to be damp when the sepia and burnt sienna is applied to the darker areas.

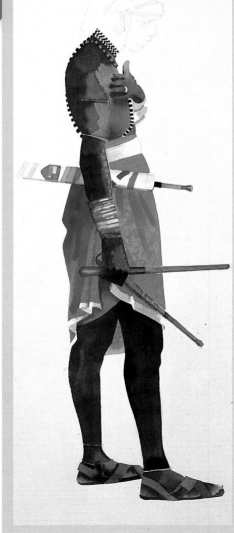

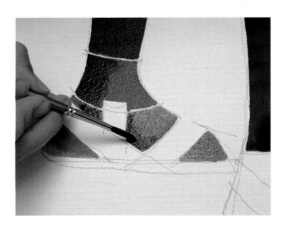

4 Completing the image

The warrior's head is the last part of the painting to be filled in. In contras to his legs, which are shaded and almost flat, his head, like his torso, is contoured and three-dimensional. In particular, the shadow on his headband immediately create a feeling of form. (Illus. **A, B, C**)

There are two more steps in this stage:

D Put a light wash of permanent rose over the warrior's eye to set it back in his head. Use a No. 6 brush.

E Finally, erase any pencil lines that are still visible in the painting with a putty rubber. Do this very carefully.

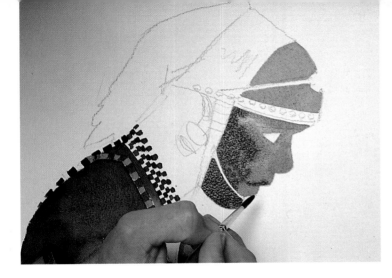

A Use a No. 8 brush and the ultramarine blue and magenta wash to paint all the face except the warrior's nose, lips and cheekbone. Fill in these unpainted areas with the cadmium orange and alizarin crimson mixture, allowing it to bleed into the surrounding blue.

Overpaint the darker areas of the face with the sepia and raw sienna mixture.

B Fill in the shadow on the headband with a No. 8 brush and the blue 'flesh' wash. Add a little water to this to make it thinner and lighter and use water to soften the edge of the wash where the shadow becomes lighter towards the top of the scarf, and blend the shadow to give a feeling of shape.

Use ivory black for the decorations on his head.

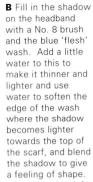

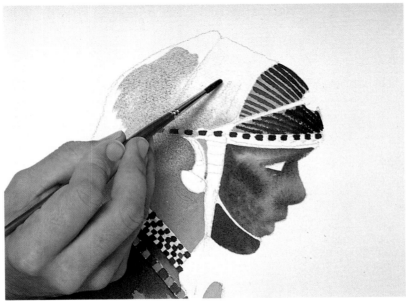

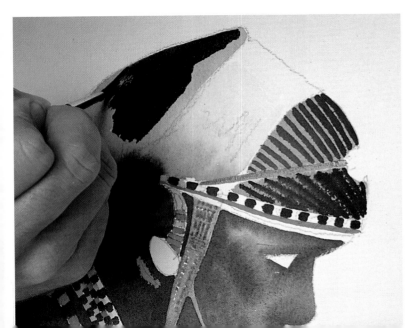

C To fill in the warrior's hair, first lay the original blue wash using a No. 8 brush. Then, with the same brush and black pigment, paint stripes into this initial wash while it is still just wet. The black will bleed to give the impression of braids.

Paint the neck, ear and face ornaments in yellows, reds and blues using a No. 8 brush. Leave the paper to show through where the beads are white.

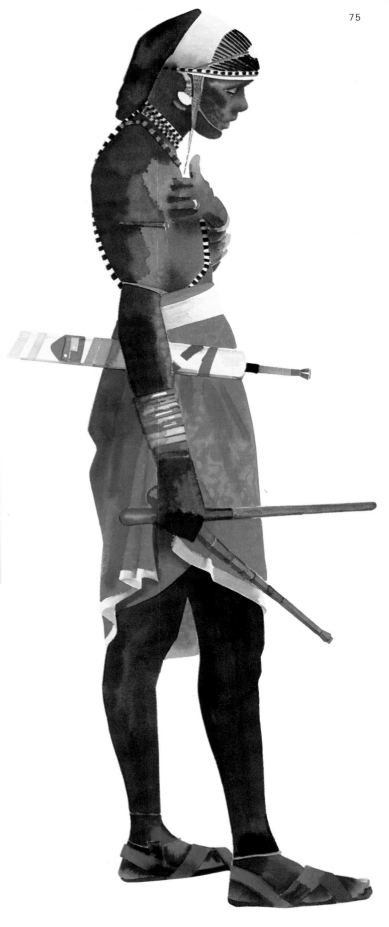

A SIMPLE PORTRAIT: SEPIA IN A VARIETY OF TONES

Use a pencil to check the proportions of a model's head. Hold it up to your subject and move your thumb along it to judge the ratio of height to width and width to height. This will also allow you to see how the image will fit the paper.

When you are painting a portrait from life it is always important to face the subject directly. In this project the model is posed against a window and his profile is seen almost as a silhouette.

A Simple Portrait
(28 cm x 32 cm /
11 in x 12½ in);
Gregory Alexander.

It is unnecessary to use all the colors you see in a subject in order to create a painting. Indeed, it is impossible — so diverse and subtle are colors and tones in reality. Painting is a process of selection: you take what you want or need to achieve your vision. And in this respect it is always an abstraction.

In this work I chose to represent the model's head in just one color and concentrated on the tones and their relationship to one another. In other words, I imagined that the person I was painting had been photographed in black-and-white.

I worked in sepia because it is a good dark brown and provided me with a wide range of tones from almost black through to the white of the paper. I prefer to use a brown when I am painting a model because of the inherent warmth of the pigment. If I had chosen to use black the result might have been too 'cold' and the finished study could well have resembled a plaster cast.

I placed the model against the light so that I could concentrate on the simple shape of his head and the characteristic angle at which he wore his hat. He became almost a silhouette and this helped me to see the most complex of subject matters — the human head — in simple terms.

Portraits can be complicated and it is always sensible to cut out as much detail as possible: the more you leave out, the stronger and more direct the image will be.

I half-closed my eyes so that I could see the model very simply and started by painting the shape of his silhouette. I then filled in the outline and added more detail, adjusting and re-stating as the painting progressed.

Materials
◆ Paper: 140 lb NOT
◆ Brushes: No. 6; No. 8; No. 10
◆ Color: Sepia
◆ Alternative colors: Burnt sienna, raw sienna, raw umber, burnt umber, black

1 Indicating the basic shape

The simplest way to establish the basic shape is to draw the outline (illus. **A**) and then fill it in. I use a sepia halfway in tone between white and black. It looks dark but if I use anything less than this mid-tone the wash will look too faint and have to be re-painted, losing freshness.

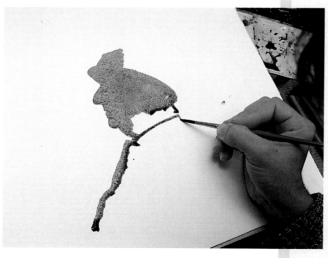

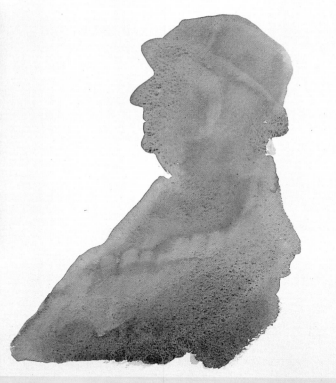

A Mix sepia with water to make a mid-tone then apply a little of the mixture to the edge of the paper and check that it will be dark enough when dry. Make lots of it. If you stop to mix more the initial wash will dry and you will lose spontaneity. Draw the outline of the model's head with a No. 8 brush. Follow the contours with great care and then fill in the head. Work slowly and specifically. Draw the line made by the collar and sweater.

2 Establishing the tonal elements

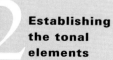

I start to establish the all-important tonal relationships in the painting by adding more sepia to the wash that has already been made up and then, when the initial wash is dry, applying this denser tone to areas of the model's head and shoulders that looked darker than the tone of his flesh (illus. **A**).

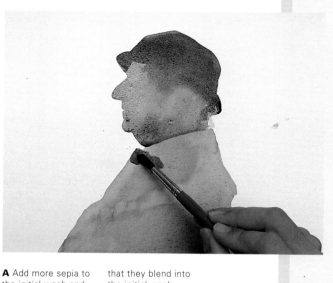

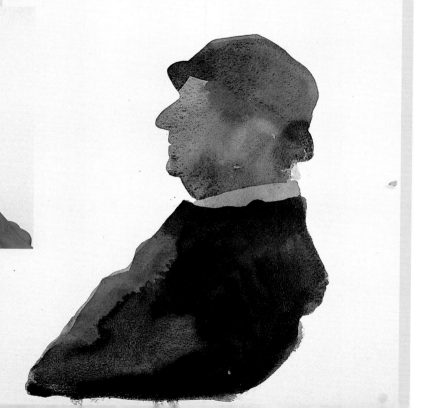

A Add more sepia to the initial wash and check the tone as before. Use the No. 8 brush to paint the darker areas on the head. Clean the brush and soften the edges of these areas with water so that they blend into the initial wash. Change to a No. 10 brush and paint the sweater. Add some water to the sepia so that the color bleeds at the base of the sweater to reinforce the form.

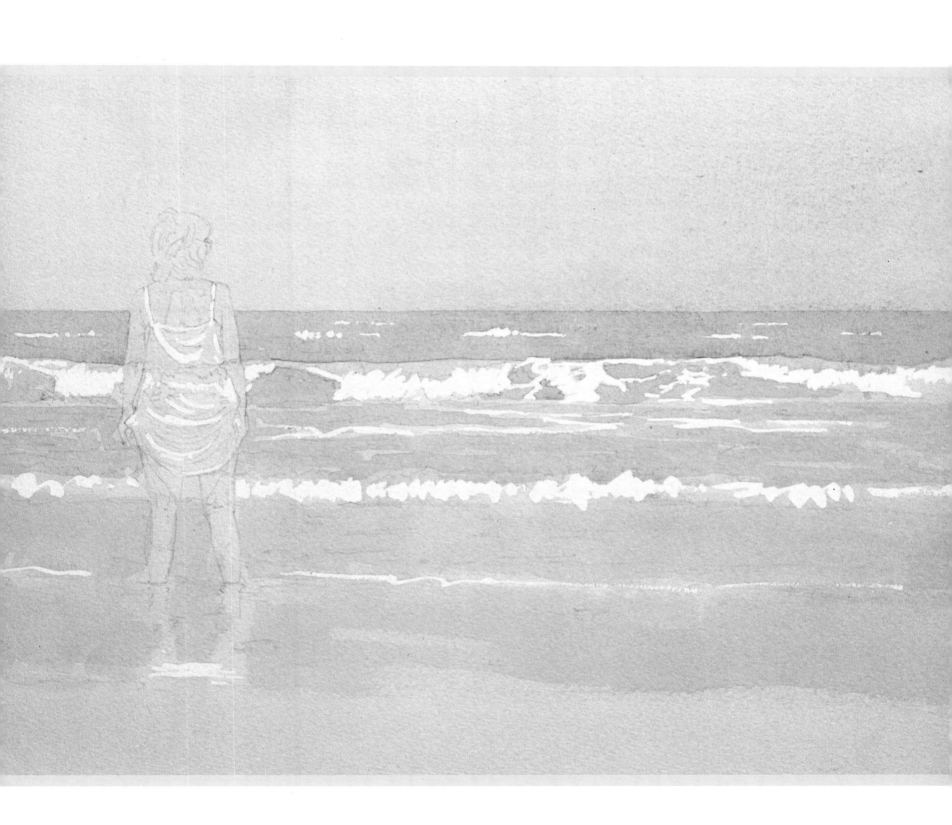

2 Contrasting warms and cools

The warm glow of the figure's flesh tones contrasts with the cool blues and purples of the surrounding sea and sky. My first step is to remove the masking fluid (illus. **A**).

There are two more steps in this stage:

B Use a No. 6 brush and a little burnt sienna to start to establish the woman's skin tone. Paint her hair with the same color.

C When a new color is introduced into a composition it must also come into other parts of the painting, so add a little bit of burnt sienna to the crests of the waves to separate them from the blues of the sea and, finally, to the undersides of the folds in the skirt to vary the purple of the dress.

A Allow the magenta wash to dry, then remove the dried masking fluid by rubbing it gently and carefully with another piece of dried fluid.

It is also possible to use your finger or an eraser, but there is always the risk of leaving dirty marks on the painting.

The main illustration shows how masking fluid allows you to create subtle and intricate shapes.

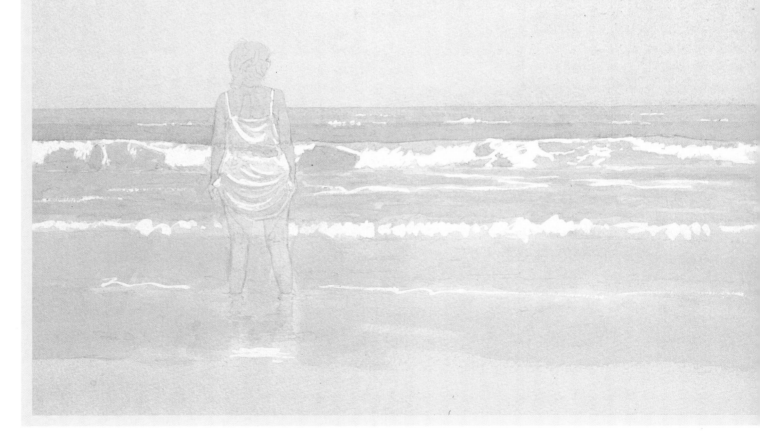

3 Creating shape and volume

I reinforce details of the figure to establish her form and pose (illus. **A**).

There are a number of other steps in this stage:

B Use a No. 6 brush and a range of dark greens made by mixing burnt sienna and Prussian blue for the dark tones on the crests of the waves and the shadows under the foam. Use the darkest green for the breaking waves on the left.

C Refine the figure further, using a No. 4 brush: mix burnt sienna and sepia and add the shadows under the skirt and around the arms. Paint this darker tone on the back of the woman's head to give a sense of shape and volume.

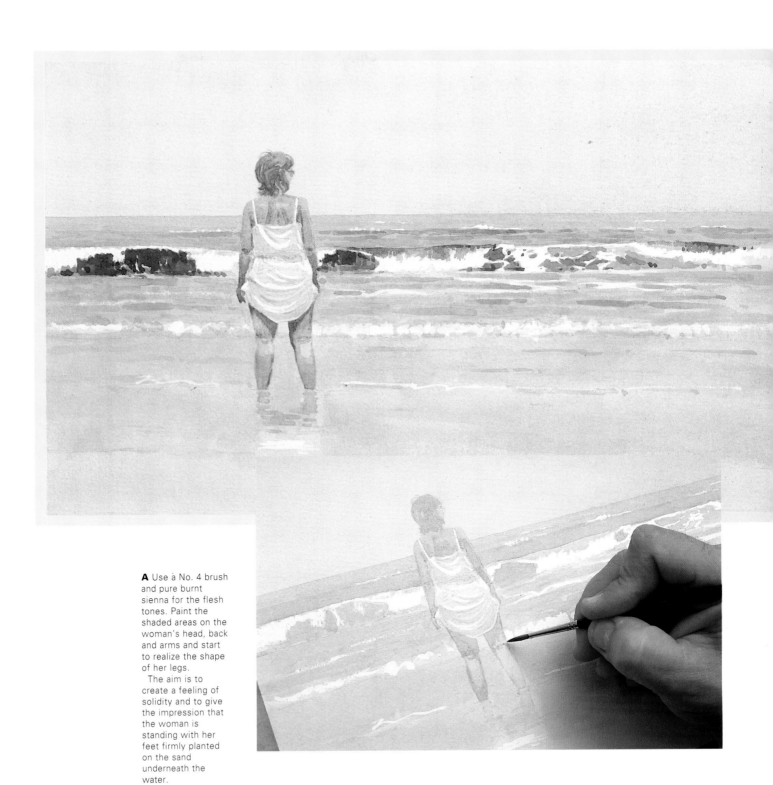

A Use a No. 4 brush and pure burnt sienna for the flesh tones. Paint the shaded areas on the woman's head, back and arms and start to realize the shape of her legs.

The aim is to create a feeling of solidity and to give the impression that the woman is standing with her feet firmly planted on the sand underneath the water.

4 Adding textural variety

I think that the composition needs textural variety so I scratch out areas of the painting with a Stanley blade and allow the dark foreground wash to granulate (illus. **A, B, C**).

There are several other steps to complete this stage:

D When the foreground wash has granulated, mix a darker tone of burnt umber and, using a No. 6 brush, paint the stones and seaweed in the foreground.

E Use sepia and a No. 6 brush to add a few more accents to the figure's arms, thighs and hair.

F Finally, indicate the white chalk stones on the beach by using the point of the Stanley blade to lift up the surface of the paper and reveal white accents.

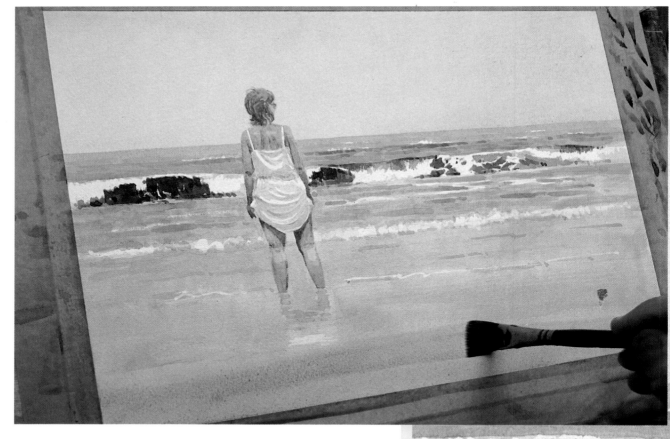

A Use a ¾ inch brush to apply a large wash of burnt sienna and burnt umber to the foreground of the painting, suggesting the color of the beach.

Blend this wash in with the blue-purple of the sea so that there is a gradation from the color of the water through to the warm brown of the sand. Leave the painting to dry

B When the painting is completely dry, hold the Stanley blade flat on the paper and scratch and scrape the white areas that were left when the masking fluid was removed. This will soften the edges and break them up slightly. Always keep the blade flat, and don't press too hard as this could damage the paper.

In the same way scratch across the broader areas of wash to create highlights, and movement in the water.

C Use a nice, wet burnt umber wash to strengthen the tone of the beach color. Apply it with a ¾ inch brush and then leave the wash to dry flat so that it granulates.

Granulation is a simple technique for creating a sense of texture in a painting. Here it adds textural variation by emphasizing the granular quality of the sand.

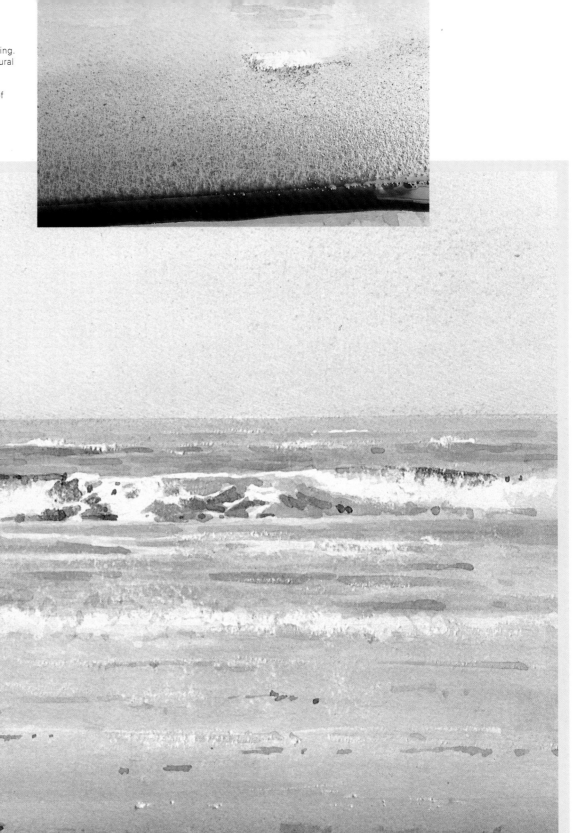

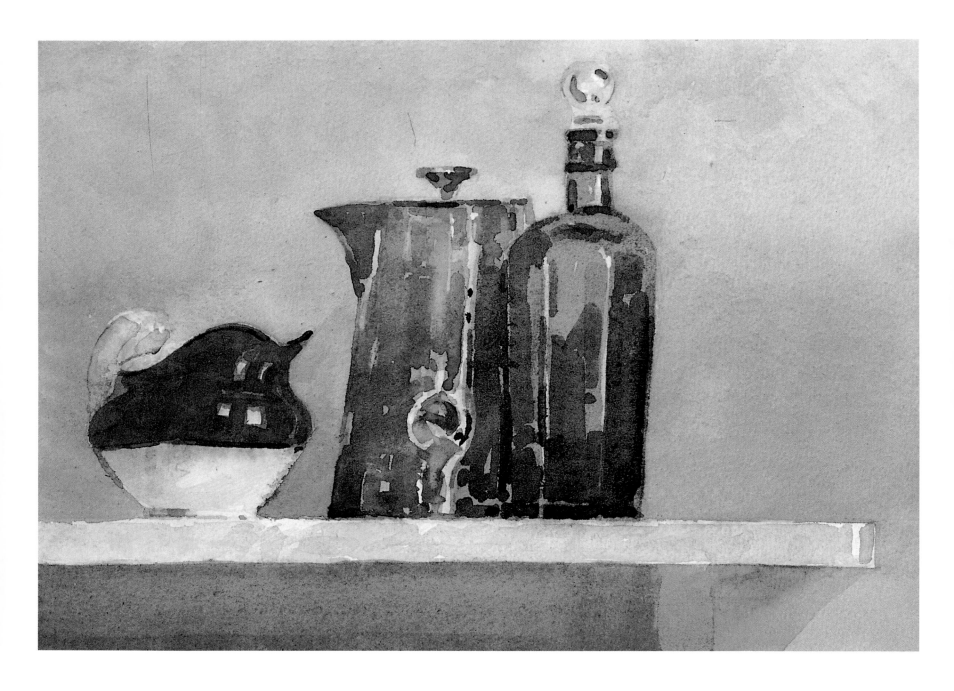

Still-life with Glass and Metal
(23 cm x 16 cm /
9 in x 6 in);
Matthew Alexander.

STILL-LIFE WITH GLASS AND METAL: PROGRESSIVE WASHES

In this project I combine ultramarine blue and sap green to give a range of colors from blue to green. These are used to paint the green bottle: colors are selected from either the 'blue' or 'green' side but they are all variations of the same mixture.

Painting a still-life is always a good exercise. Certain things can be guaranteed. You can arrange it to create the best possible composition and once you have done this it won't move; the light remains consistent; the objects themselves don't change; and it can be studied and worked on over a period of time.

Glass objects like the bottle in this painting are often thought to be difficult subjects but, as this project shows, the secret is to paint the effect of light shining through glass rather than the bottle itself. Similarly, shiny objects like the pewter pot can be resolved into simple divisions of color and tone.

A common mistake is to think that if something is shiny it must be light in tone. In reality, if you look at a glass tumbler or metal bowl in an averagely lit room through half-closed eyes it will appear to be surprisingly dark, with just a few highlights caused by light coming through a window or from lamps. It is therefore necessary to keep the tones of the objects darker rather than lighter for the highlight or reflection of the light source to be given its apparent sparkle.

The choice of colors in the cool spectrum — blues through purples to greens, applied over a flat yellow ochre wash — emphasizes the tactile coldness of pewter and glass. Even the blue background against which the objects are seen helps to lower the temperature. The only warmth to alleviate the generally cool arrangement is the ochre on the mantelpiece, and the highlights.

The jug, pot and bottle are all seen side-on so there is no need to worry about depicting ellipses. The main thrust of this painting is to concentrate on their shapes and the shapes between them and break them down into simple patterns.

Materials
- 2B pencil
- Paper: 190 lb Rough
- Brushes: ¾ inch flat; 2½ inch mop; No. 6; No. 8
- Colors: Yellow ochre; magenta; sap green; ultramarine blue; Prussian blue; indigo blue; burnt sienna.

1 Creating a cool ambience

I apply a general harmony of blues and purples to create the cool ambience of the painting (illus. D, E).

Before laying these colors do the following steps:

A Sketch the outlines of the ceramic jug, pewter coffee pot, glass bottle and the edge of the mantelpiece using a 2B pencil.

B Dampen the paper with clean water and a 2½ inch mop brush.

C With the board at a slight angle, lay a flat yellow ochre wash with a ¾ inch flat brush. Leave the areas that will be highlights unpainted so that the white paper shows through.

D Mix Prussian blue and magenta to give a range of colors varying from blue to purple. With a ¾ inch flat brush, apply these to the pewter pot and the glass bottle, and over the background area, painting around the ceramic jug. The initial wash will still be damp, so encourage the colors to bleed and wander over the edges of the objects. Follow the densities of blue and purple as they occur in the objects and leave white areas unpainted.

E Add some indigo blue to the magenta and Prussian blue wash to make a dark, blue-purple and apply it over the mantelpiece and to the background next to the jug using a ¾ inch brush. Then paint the same wash on the blue part of the jug. Leave the highlight areas unpainted.

Clean your brush, pinch off any excess water, and drag the brush across the mantelpiece to remove the blue pigment and re-establish the white of the marble. Leave the painting to dry.

2 Establishing the main groupings

I introduce green into the painting and also establish the main areas and the groupings of the objects by linking the pewter pot and the bottle with medium tones of color in contrast to the dark tone of the blue on the jug (illus. **A, B, C**). This emphasizes the tension that is inherent in the composition. The objects could have been all separate or all overlapping; putting a space between the jug and the pot and bottle created a more dynamic design.

There is one final step:

D Indicate the shapes within the objects, creating some hard edges and leaving others relatively soft.

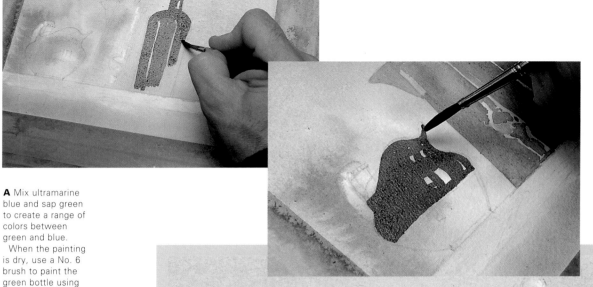

A Mix ultramarine blue and sap green to create a range of colors between green and blue.

When the painting is dry, use a No. 6 brush to paint the green bottle using blue-greens and green-blues taken from this composite mixture. Apply with plenty of water and be careful to paint around any highlights on the bottle.

B Mix indigo blue with a bit of magenta and use a No. 6 brush to paint the dark blue area of the jug. Make sure you retain the highlights by painting very carefully around them.

Indigo is a useful pigment because of its ability to create dark, neutral blues.

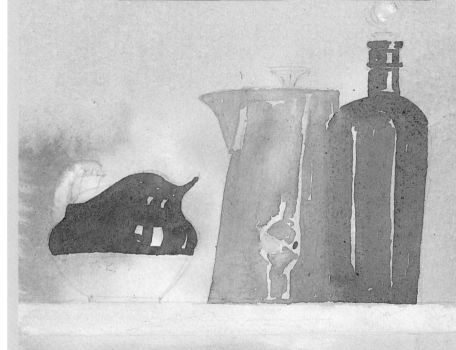

C Paint the pewter pot with the Prussian blue and magenta variations that you mixed in Stage 1. Use the No. 6 brush and paint downwards so that the colors are applied in large, vertical areas. Leave highlights unpainted as before and use the different shades of blue and purple to suggest the pot's shiny surface.

Encourage the green of the bottle and the pewter color of the coffee pot to merge into each other so that the green is reflected in the pot's shiny surface.

3 Bringing the image into focus

I am bringing the image into focus by establishing the darker areas of the painting to create greater contrasts and make the light areas sparkle. I add dark purples to the pewter pot, look within the blue glaze of the jug to find linked, darker shapes and accentuate the very dark greens of the bottle. I also add a few warm touches. I am careful to avoid any color on the highlights. (Illus. **A, B, C**)

D Finally, half-close your eyes to simplify masses and their links. Make the darks of the bottle generally slightly cooler, tending towards blue, and those of the coffee pot warmer — towards brown.

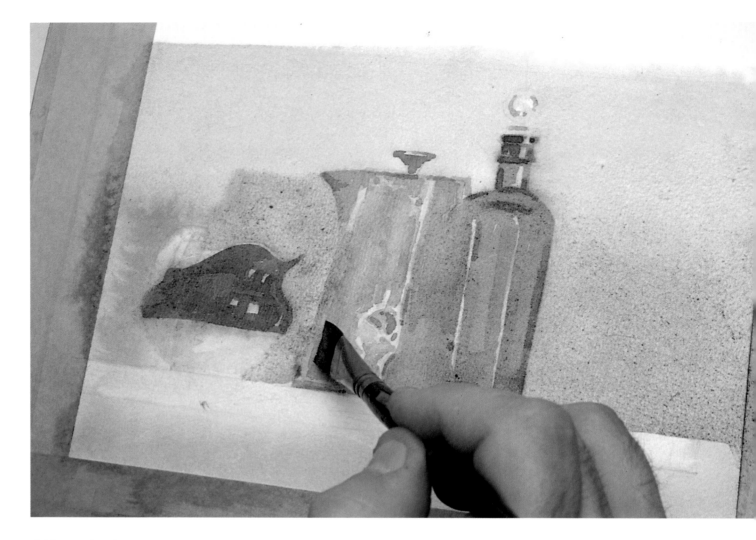

A Mix magenta and Prussian blue to make a blue-purple wash and dampen the paper with a ¾ inch brush and clean water. Use the same brush to darken the background to the objects and fill in the space between the jug and the pewter pot.

Add a touch of dilute burnt sienna to the underside of the white jug. Encourage the edges of the objects to melt into some of the blue-purple wash.

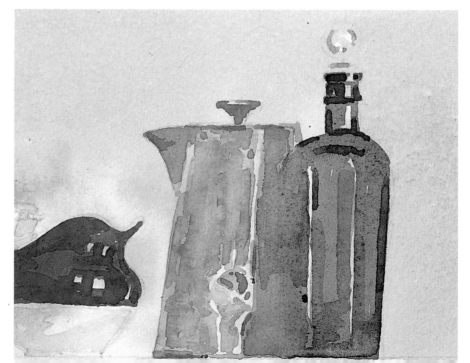

B Take some of the purple mid-tone that was used for the pewter pot and, with the point of a No. 6 brush, add just a little to the stopper of the bottle.

This shows how what you don't paint is often as important as what you do paint. Only a few brush strokes are needed to create the sparkle and transparency of the glass stopper.

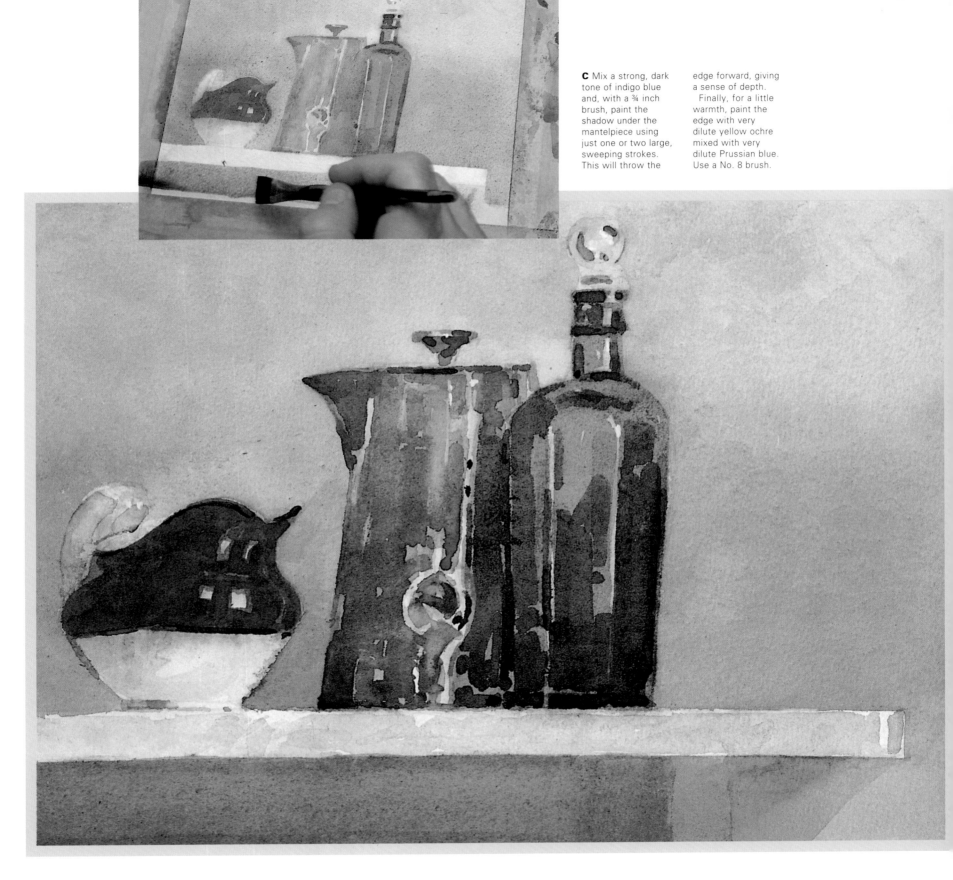

C Mix a strong, dark tone of indigo blue and, with a ¾ inch brush, paint the shadow under the mantelpiece using just one or two large, sweeping strokes. This will throw the edge forward, giving a sense of depth.

Finally, for a little warmth, paint the edge with very dilute yellow ochre mixed with very dilute Prussian blue. Use a No. 8 brush.

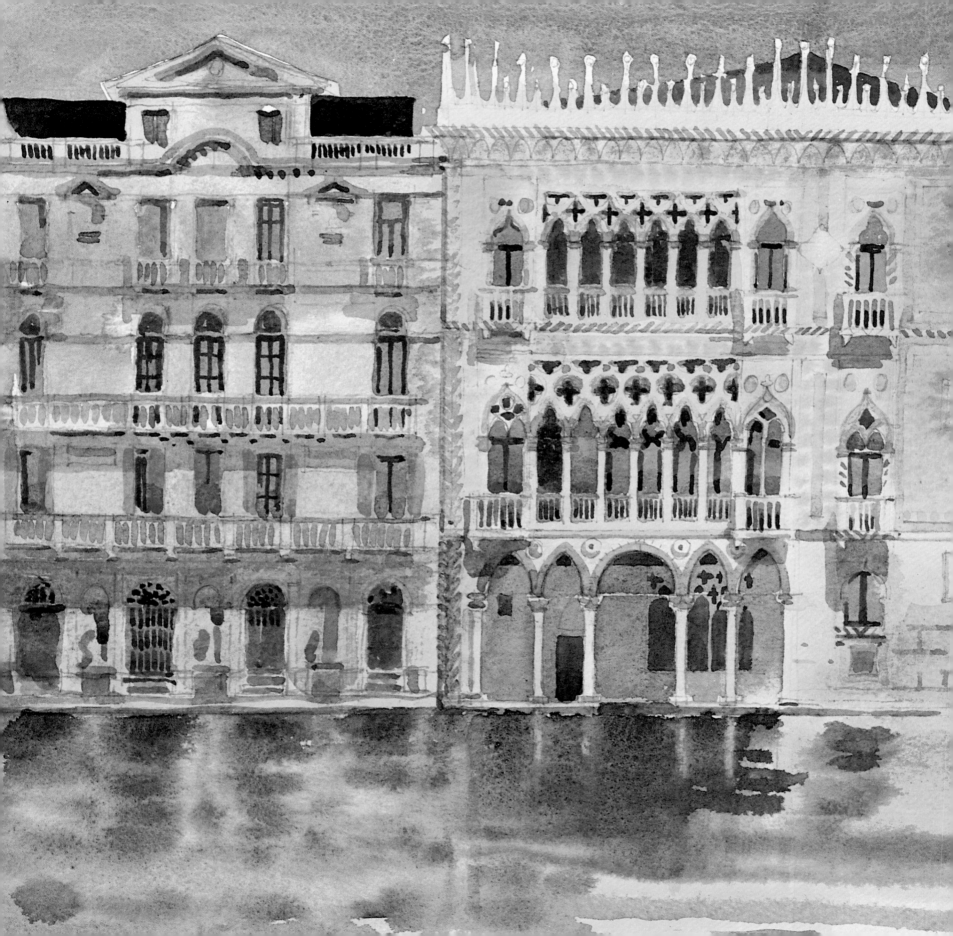

Venetian Façade
(35 cm x 29 cm /
13½ in x 11½ in);
Gregory Alexander.

VENETIAN FAÇADE: LIGHT TO DARK AND WET-INTO-WET

The building that is the subject of this picture is called the Ca' d'Oro or 'house of gold' and its very name conjures up the painting I was inspired to make: a shimmering image of golden yellows reflected in the waters of the Grand Canal. Venice is itself a decoratively golden city and I tried to capture this quality in my painting.

I chose to view the subject flat on so that I could concentrate on the patterns the windows, arches and decorative details made on the flat façades that are so typical of Venice. And I included the building on the left of the Ca' d'Oro so that its cool greenness could form a contrast to the warm glow of the others.

To create the shimmering effect that I felt was so important in the painting I started by working wet-into-wet, adjusting the initial flat wash with different colored washes. I allowed — indeed positively encouraged — them to bleed and run and merge together.

Later, when the initial washes had dried, I introduced shadows and other details and finally lifted out some of the reflections in the canal. The painting therefore moved from the general to the specific, from light to dark, from wet to dry and as it progressed I was able to see the architecture really coming to life.

Because I was working on the spot, I used a travelling palette with pans instead of tubes of watercolor. Although the pans demanded more working with the brush when I mixed the pigments with water than tubes would have done, the palette was easily transportable and I was able to slot my colors neatly into it.

Materials
- 1B pencil
- Paper: 140 lb Rough
- Brushes: No. 6; No. 8; No. 10; No. 16
- Colors: Raw sienna; Indian yellow; yellow ochre; lemon yellow; cadmium orange; permanent rose; magenta; viridian green; Winsor green; emerald green; ultramarine blue; cobalt blue; burnt sienna; sepia.

1 Creating a Venetian ambience

I establish the atmosphere of Venice by filling the paper with yellows, pinks, orange, ochres and greens — the colors of the city. The initial wash was still wet when I applied them so they are soft and bleeding into each other, creating the basis for the luminous effect that I want to achieve in the painting. (Illus. **A, B, C**)

I am working with pure colors at this stage — mixtures will come later in the project.

I include the green building in the composition because it provides a cool contrast to the warm glow of the Ca' d'Oro and the reflections in the canal.

A Draw the outlines of the buildings with a 1B pencil then, using a No. 16 brush, lay a flat wash of Indian yellow with the board at a 30 degree angle. Lay the board almost flat and, while this initial wash is still wet, use a No. 8 brush to add more Indian yellow to the Ca' d'Oro. Use permanent rose around the windows and on the façade. Paint some yellow ochre at the base of the building.

B Mix Indian yellow with a little cadmium orange to get the glow of Venice and, with a No. 8 brush, indicate the reflections under the Ca' d'Oro.

Add emerald green over the green building and in the canal area under it. Allow the color to bleed and dribble.

The original yellow wash now looks very pale.

C Add the brickwork around the windows of the Ca' d'Oro and the decorative patterns on its façade with a No. 6 brush and cadmium orange. Apply the paint almost as blobs. There is no need to be too specific — the aim is simply to create the impression of a highly decorated building. Finally, use raw sienna and a No. 10 brush to indicate the building on the far right.

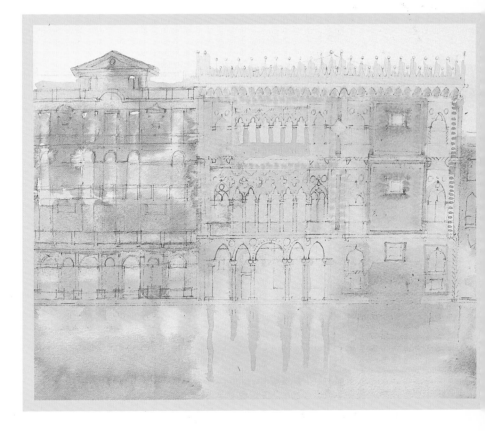

2 Refining some of the details

I add more color while the painting is still wet to refine details like the window areas of the green building, working very lightly (illus. **A**).

There are a number of other steps in this stage:

B Mix yellow ochre and raw sienna and, using a No. 8 brush, add some vertical lines to the canal area under the Ca' d'Oro to reflect the pillars of the arches in the water.

C Add more yellow ochre where the buildings meet the water to indicate decay, and lay an Indian yellow wash over the pediment of the Ca' d'Oro. Use a No. 8 brush.

A Use a No. 8 brush to add some lemon yellow to the carved details above the arches on the Ca d'Oro. The painting is still quite damp so the color will fuse with the initial washes.

Try to hold your brush high on its shank, as in this illustration. This will prevent you accidentally resting your hand on the painting while it is wet and spoiling the washes.

3 Drawing with a brush

I have applied the basic undercolors of the painting — the yellows, pinks, oranges and greens. The painting is now dry and I am adding cool purple-blues to introduce depth and create a three-dimensional form (A, B, C).

I pay great attention to the underlying drawing during this stage. I have been applying colors in a general way but for the rest of the project I will be drawing with my brush.

A This illustration shows ultramarine blue and magenta being mixed to create purple-blue. Make plenty of this color. It will be used for the windows and shadows, but will also form a basic mixture in which the proportions of blue to magenta will be varied and to which other colors will be added.

B Use the purple-blue mixture to indicate the arches and other architectural details on the façade of the Ca' d'Oro and other buildings. Use a No. 6 brush and check the density of the paint — it should be dark enough to create the impression of shade, but not too dark.

Work with care and control and be sure to follow the lines of the drawing.

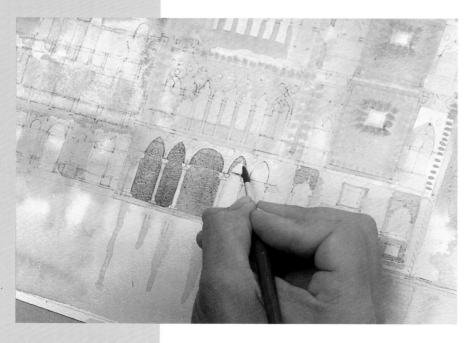

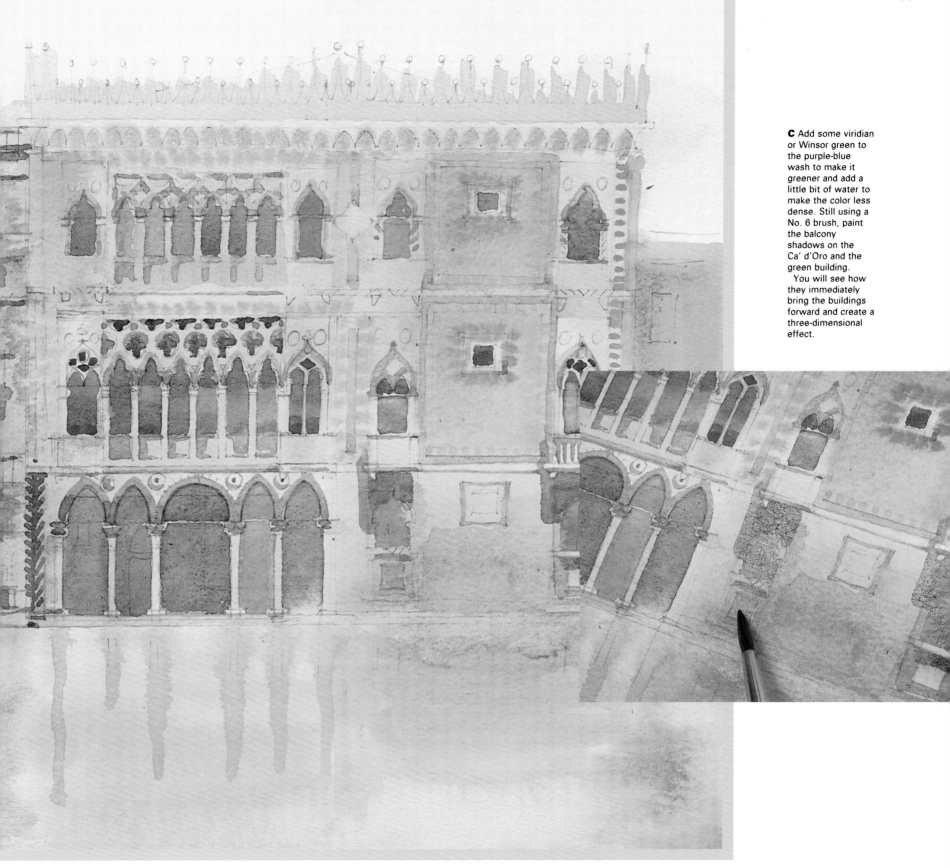

C Add some viridian or Winsor green to the purple-blue wash to make it greener and add a little bit of water to make the color less dense. Still using a No. 6 brush, paint the balcony shadows on the Ca' d'Oro and the green building.

You will see how they immediately bring the buildings forward and create a three-dimensional effect.

4 Realizing the final image

The painting is completely focused: almost the last touch — adding the shadows — gives value to the surrounding painting. Colors are more vivid and the architectural features of the buildings are emphasized. I keep the sky very simple — the rest of the painting is complicated and therefore demands a simple sky. (Illus. A, B, C, D)

There are two final steps:

E Use a mixture of sepia and burnt sienna and a No. 8 brush for the windows and roof of the building on the far right.

F Paint the greenery at its base in Winsor green mixed with a little Indian yellow. Use a No. 8 brush.

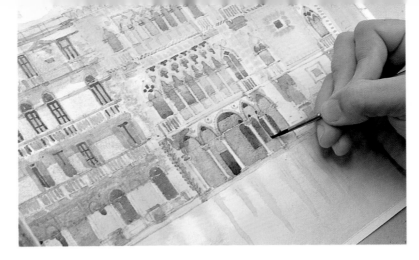

A Add more ultramarine blue and a little bit of sepia to the blue and magenta mixture to get dark purple. With a No. 6 brush, paint the shadows in the windows and between the balustrades. Paint the outlines of the window panes in the green building to reveal the pale purple.

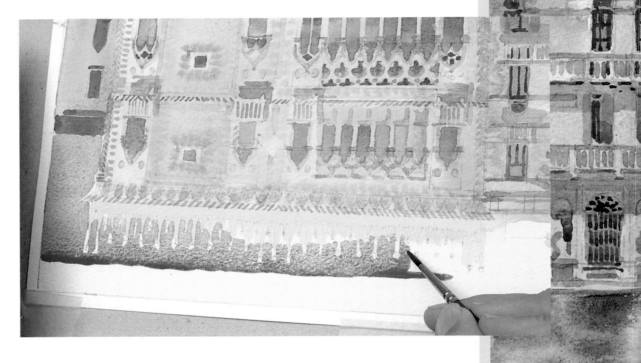

B Mix a tiny bit of permanent rose with cobalt blue for the sky and apply the color with a No. 6 brush. The details on top of the Ca' d'Oro are very intricate, so turn the painting upside down and tilt it at a slight angle. The watercolor will run down from the details, making it easier to apply the color. Work from the top lefthand corner of the sky.

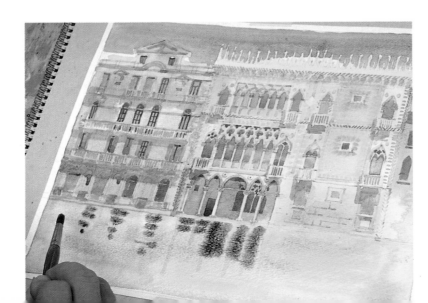

C Dampen the paper from the base of the buildings to the bottom of the painting. Use a No. l6 brush. Mix a dark wash of Winsor green, ultramarine blue and varying quantities of burnt sienna and apply it to the dampened area with a No. 6 brush. Add touches of cobalt blue under the green building. Allow the colors to bleed. Add more water as you come lower down.

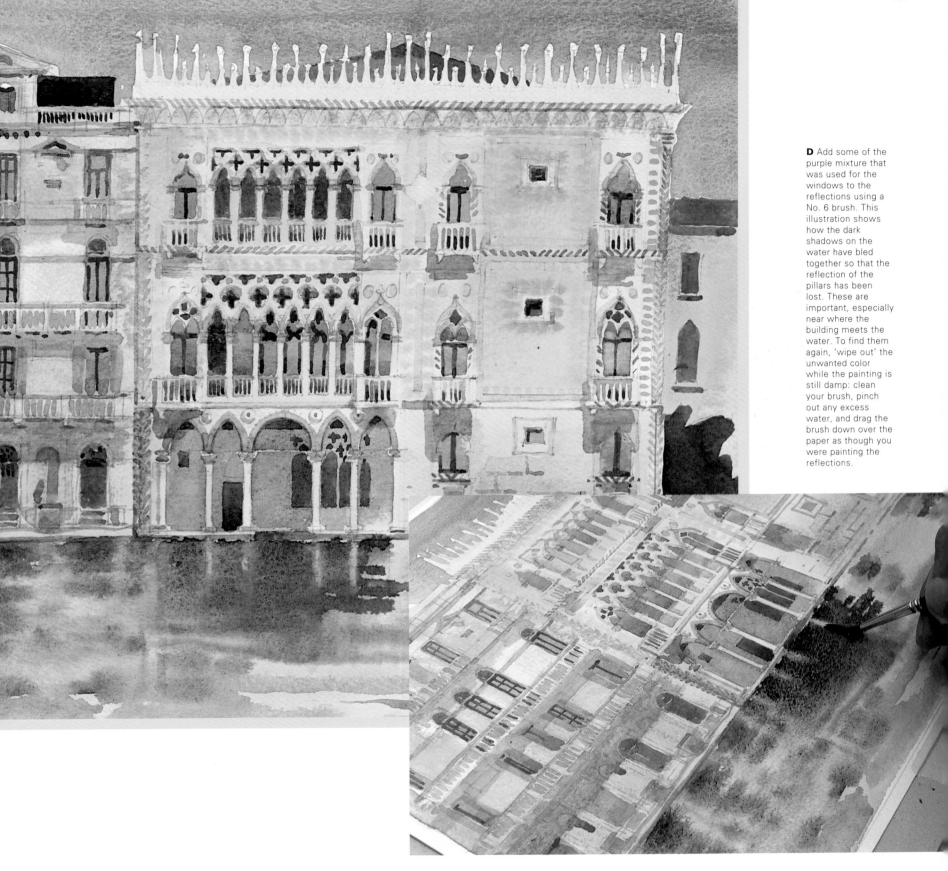

D Add some of the purple mixture that was used for the windows to the reflections using a No. 6 brush. This illustration shows how the dark shadows on the water have bled together so that the reflection of the pillars has been lost. These are important, especially near where the building meets the water. To find them again, 'wipe out' the unwanted color while the painting is still damp: clean your brush, pinch out any excess water, and drag the brush down over the paper as though you were painting the reflections.

OUTDOOR MARKET: MONOCHROME STUDY ON CREAM PAPER

This painting was done at home in my studio rather than on the spot. On a visit to Portugal I took many photographs of a lively and bustling market and on my return I decided to transform one of them into this study in sienna. A camera is a particularly useful tool for candid shots like this. In this case a powerful zoom lens allowed me to capture the characteristics of the traders without their noticing and becoming self-conscious.

The composition had already been worked out through the lens of my camera and is fairly detailed. There is a nice lead-in from the scales through the three seated figures on the lefthand side of the painting. These are balanced by verticals on the right and some small figures give a sense of distance and space.

I decided to paint this study on a warm, honey-colored paper and used burnt sienna to ensure that the painting would exude the warmth necessary to convey something of the heat associated with Portugal. Don't forget that a monochrome can be painted in tonal ranges of any one color so it is worth experimenting with blue, green or red.

I enjoy working in monochrome. The beauty of using this method is that I can deal with tonal relationships without having to worry about the complexities of color. I also enjoy meeting one of the challenges of this kind of study: maintaining the balance of tones with dark linked to dark and light to light. This kind of painting also involves virtually all the techniques that can be used in a more full-blown, color study.

For a beginner, the advantages of working in monochrome are obvious: you get accustomed to the way your brush works and learn to understand the concept of using contrasting tones. And you are also creating what can be a very satisfying painting.

Materials
- ◆ Burnt sienna watercolor pencil
- ◆ Paper: 90 lb Hot-pressed; cream; stretched
- ◆ Brushes: 2½ inch flat; ¾ inch flat; ½ inch flat; No. 2
- ◆ Color: Burnt sienna.

I use a cream paper for this project. The color tones in nicely with the burnt sienna washes — which themselves merge with the watercolor pencil I use for the drawing.

Outdoor Market
(14.5 cm x 22 cm /
5½ in x 8½ in);
Matthew Alexander.

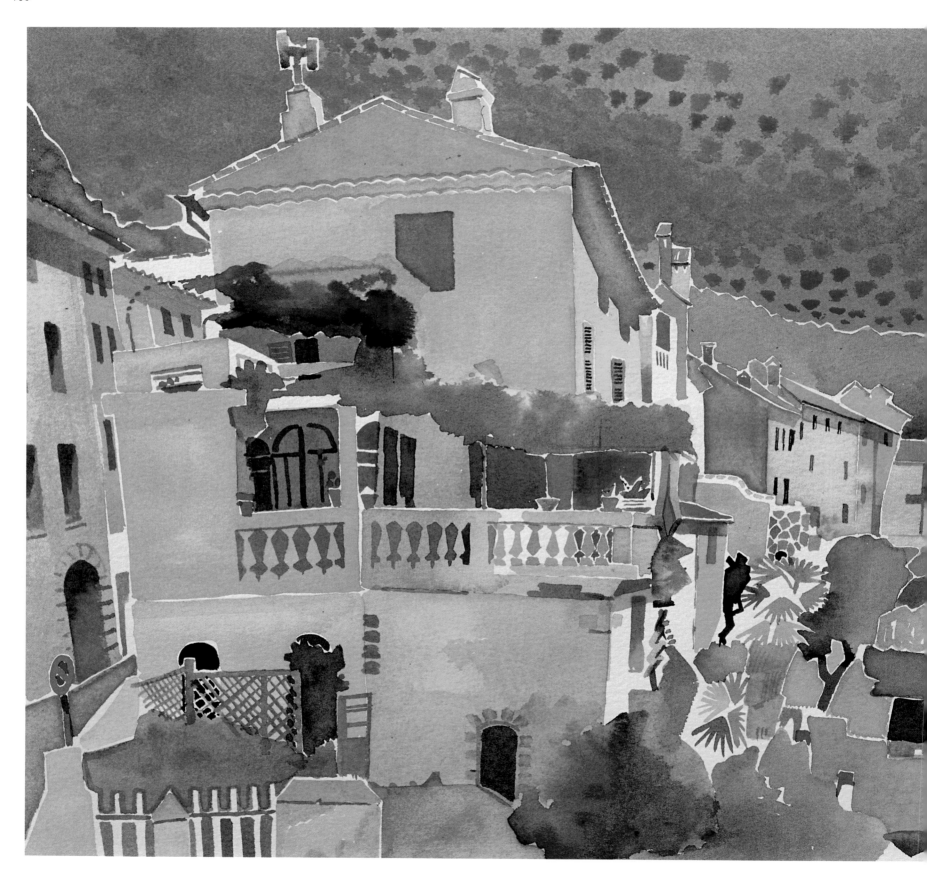

2 Creating a glow of heat and color

Throughout this project I am responding to the colors in a particular area and completing that part of the painting before moving to another. I paint most of the buildings on the left with variations of pinks and oranges to indicate warmth and greens and purples for cool areas. The vine over the balcony, like the vegetation in the foreground, provides a nice contrast to the very geometric forms of the architecture. (Illus. A, B)

I vary the quality of the washes as I lay them, sometimes keeping them simple, clean and clear and on other occasions adding variations of color while the initial wash is still wet. This variation helps to create a contrast and prevents the washes becoming too 'flat' and repetitive.

A Clean your palette regularly with a tissue. Mixtures must be kept pure when you are working piece-to-piece or the finished painting will look dirty and muddy and not have the heat and color associated with the south of France.

This is because you will often change from a dark pigment to a light one, rather than viewing the image as a whole and progressing from light to dark.

B Use cadmium yellow and then Winsor green with some blue and a No. 8 brush for the vine.

Use turquoise with yellow for the balcony area, and ultramarine blue mixed with a little alizarin crimson for the shadow on the yellow house. Add cadmium red to the house on the right in the background. Use alizarin crimson and ultramarine blue for the gate and entrance to the foreground building. Drop a little yellow ochre into this while it is still wet.

3 Adding details and accents

I fill in most of the lefthand side of the painting and refine and reinforce details (illus. A).

There are a number of other steps in this stage:

B Use a No. 6 brush and burnt sienna and sepia for the windows in the balcony area and paint the shadows here and under the roof with purple made from alizarin crimson and ultramarine blue.

C Use a light wash of alizarin crimson and a No. 6 brush for the façade to the left of the balcony and yellow ochre for the house on the far left.

D Add the dark accents to the windows on the yellow ochre house on the right with cobalt blue, burnt sienna and purples. Use a No. 6 brush.

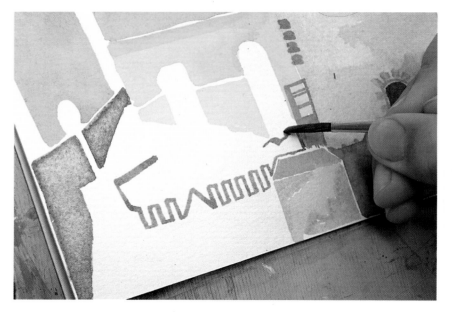

A Use a No. 6 brush and a green made with yellow ochre and Winsor green for the vegetation between and above the fence in the bottom lefthand corner of the picture. Try to see the greenery as a series of abstract shapes, and fill in the spaces between the posts, then the mass of vegetation above them. Follow the outlines of the fence very carefully, leaving the white paper to show through. As you do so, the fence itself will be revealed.

Painting the areas between objects — the negative shapes — is often more accurate than painting the objects.

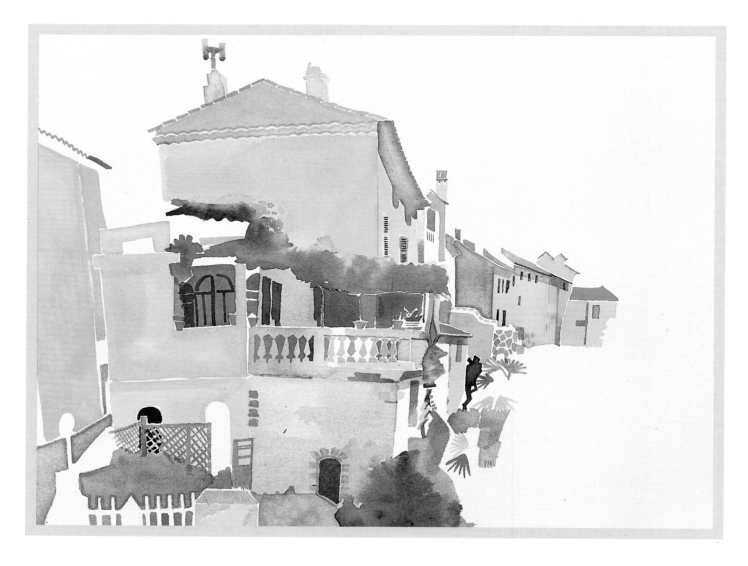

4 Abstracting complex shapes

In a project like this it is vital to look hard and find specific shapes that are interesting and diverse or the painting could become purely decorative like a jigsaw puzzle.

I continue to reinforce details on the lefthand side of the painting and fill in the lower righthand side (illus. **A, B, C**).

The shapes here are abstracted from the complex mass of vegetation and simplified into irregular shapes.

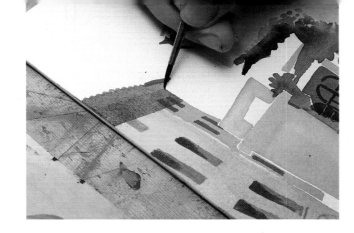

A Use a No. 6 brush and burnt sienna for the windows on the yellow house on the left, and the same brush and cobalt blue for those on the building next to it.

While the wash is still wet, add sepia for the shadows in the burnt sienna windows. Leave the painting to dry.

Mix alizarin crimson and ultramarine blue with some water to make light purple and, when the painting is dry, apply this to the underside of the roof and over the wall underneath.

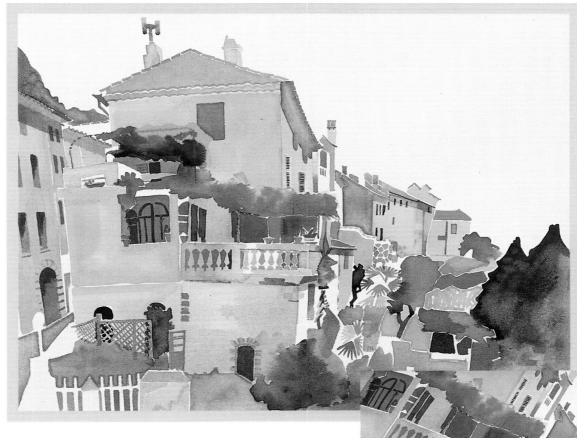

C Make a dense green for the pine trees by mixing Winsor green with raw sienna and Winsor blue. Define the outside shape of the trees with a No. 8 brush and allow the color to bleed down. Add more raw sienna as you come lower down towards their trunks and the dry earth of the field in which they are growing.

B Use Winsor green and a little ultramarine blue to make a blue-green for the hills in the top lefthand corner and yellow ochre with a little Winsor green for the yellow-green vegetation. Lay both washes with a No. 6 brush. Then clean your brush, dampen it with just a little water and rub it over the washes to blend them together.

5 Filling in the sky area

The sky is the last part to be painted. I use a vivid blue in order to give the sense of the hot sun beating down on the landscape. The color also brings the main building forward and makes it look less pink and more like a house in strong sunlight. (Illus. A, B)

A Before painting the sky, fill in the hills and trees in the background on the right with a mixture of cobalt blue and Indian yellow. Use a No. 8 brush. Mix ultramarine blue and magenta to make violet-purple for the sky: there should be more magenta than blue in the mixture. Make a generous amount — there is quite a large area to fill in.

Turn the painting upside down, tilt the board at a slight angle with the top higher than the bottom and lay a flat wash over the sky area with a No. 8 brush. Be careful to paint around roofs and chimney-pots. The color will run down from these details making it easier to apply the paints.

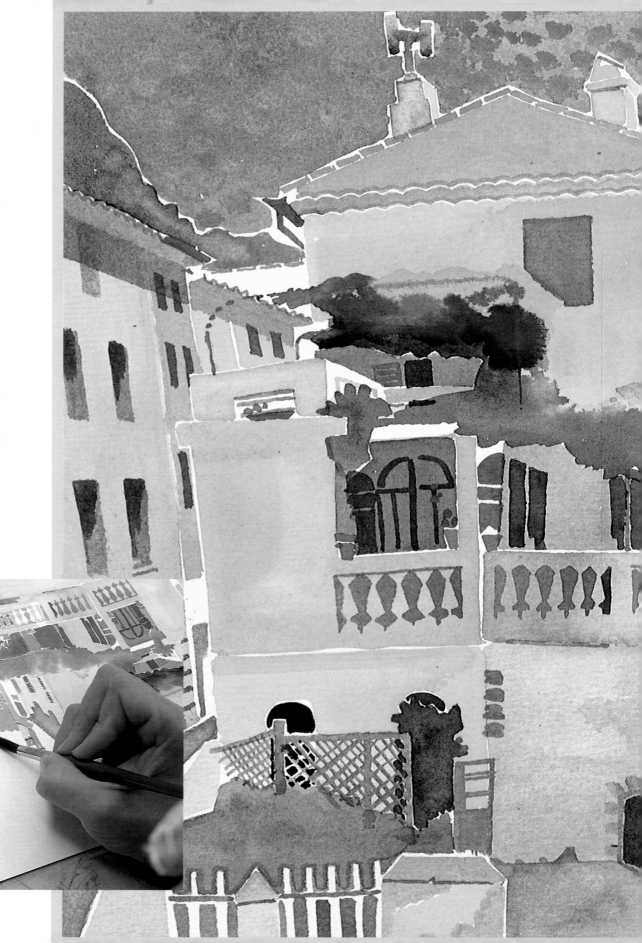

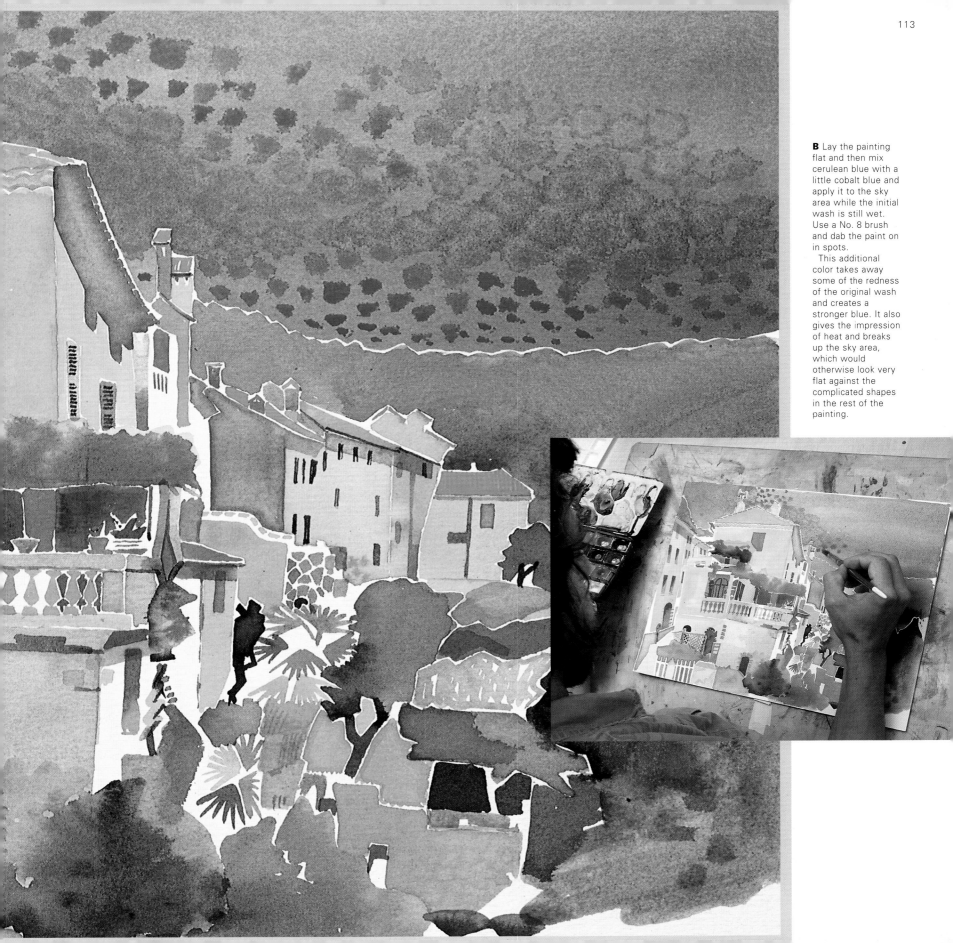

B Lay the painting flat and then mix cerulean blue with a little cobalt blue and apply it to the sky area while the initial wash is still wet. Use a No. 8 brush and dab the paint on in spots.

 This additional color takes away some of the redness of the original wash and creates a stronger blue. It also gives the impression of heat and breaks up the sky area, which would otherwise look very flat against the complicated shapes in the rest of the painting.

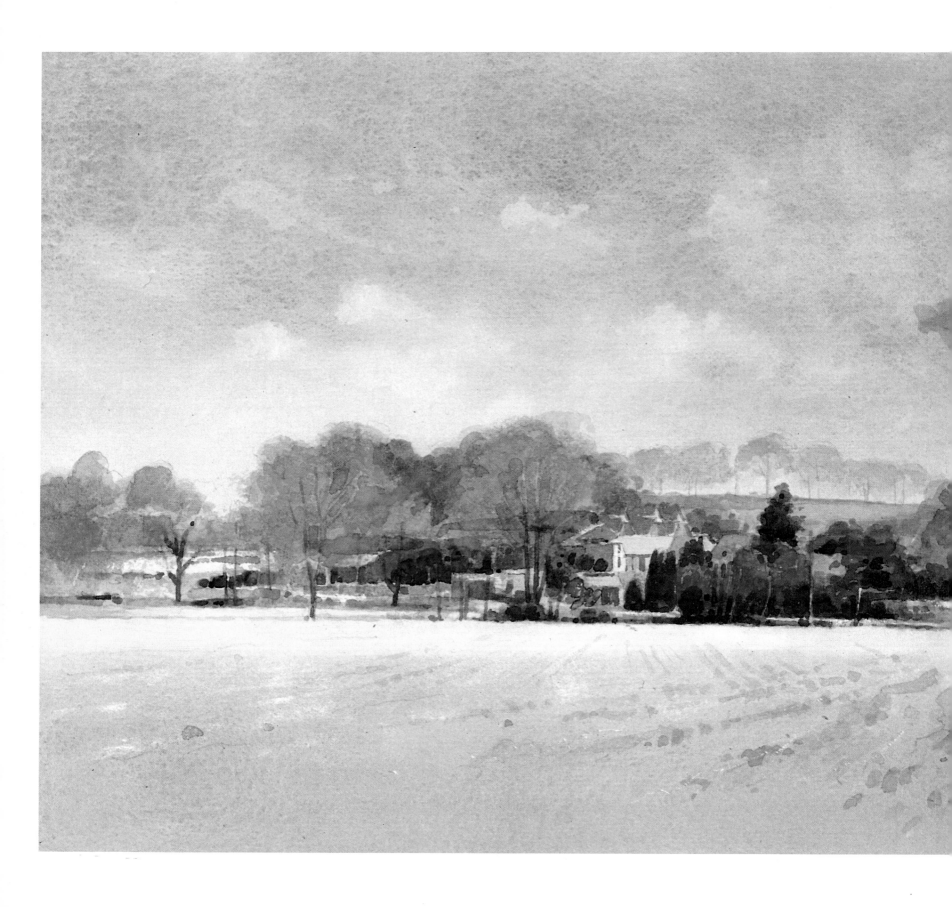

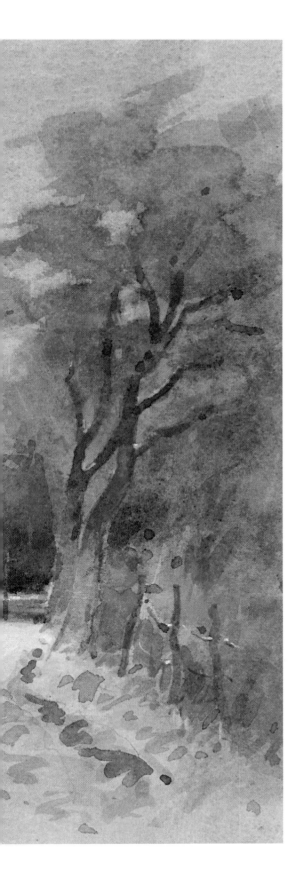

Landscape in Snow
(13 ½ in x 8½ in /
34.5 cm x 22 cm);
Matthew Alexander.

LANDSCAPE IN SNOW: PROGRESSIVE WASHES AND BLOTTING-OUT

I love the balance between an untouched landscape and the incursions man has made into it. At its best the combination can create an almost perfect harmony — one that intrigued the English watercolorists of the nineteenth century as much as it intrigues me. This particular scene needed hardly any changes. The composition, developed over the years, was just right and the buildings, securely nestled in a natural fold, gave me a cosy feeling. My main addition was the foreground shadow which leads the viewer into the picture. Constable used this device — and what was good enough for Constable ...

Painting snow is always an interesting problem. The challenge is to try to vary the apparently bland whiteness and meeting it is not as difficult as it may seem. Shaded areas tend to reveal cool purple-blues. Warmer, contrasting colors are inherent in snow touched by sunlight. Trees in winter vary enormously in color, from cool purples and browns to warm yellow russets.

In this landscape I used cool blues and purples for the sky and foreground and — to avoid an oppressive sense of cold and provide the maximum contrast — warm russets for the trees. I reduced the tone of the painting so that I could get plenty of color into the light areas and also added textural variety by scratching-out, using a sponge and encouraging granulation. The winter sky is achieved by blotting cloud shapes out from a Prussian blue gradated wash.

The composition is L-shaped with tensions leading off to the right: the furrows point in that direction and the clouds are descending to the right. This sweep is successfully stopped by the vertical trees on the right.

I used pastels as well as watercolors, to clarify parts of the painting.

Materials
◆ 2B pencil; tissues; watercolor sponge; pastels; Stanley blade
◆ Paper: 90 lb Hot-pressed; stretched
◆ Brushes: ¾ inch flat; 2 ½ inch flat; No. 3; No. 4; No. 5; No. 6; No. 8
◆ Colors: Raw sienna; light red; magenta; ultramarine blue; Prussian blue; burnt sienna; sepia

1 Establishing the base colors

My first step after drawing the trees and buildings with a 2B pencil is to establish the warm base colors. I lay a wash that gradates from magenta to raw sienna and back to magenta, using a 2½ inch flat brush to dampen the paper and apply the colors. I leave the painting to dry at an angle.

2 Creating temperature contrasts

I introduce cool Prussian blues and add warm raw sienna accents (illus. A, B, C, D).

There are two final steps:

E Use magenta and a No. 4 brush for the distant trees, the shadow under the hedge, the furrows and to overpaint the tree shadows.

F Reinforce some of the trees with burnt sienna.

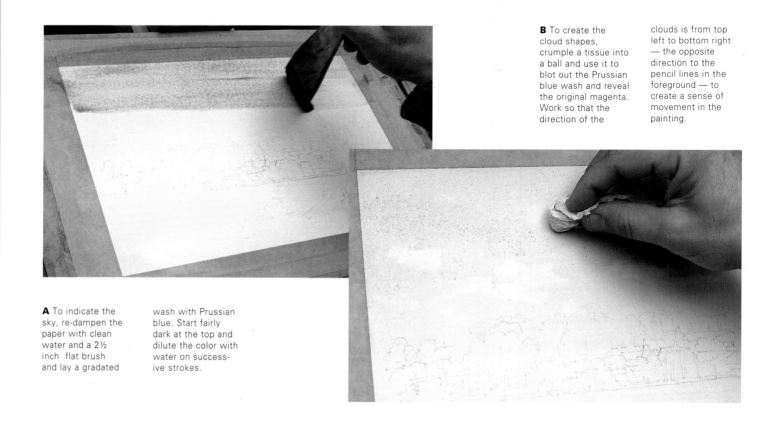

B To create the cloud shapes, crumple a tissue into a ball and use it to blot out the Prussian blue wash and reveal the original magenta. Work so that the direction of the clouds is from top left to bottom right — the opposite direction to the pencil lines in the foreground — to create a sense of movement in the painting.

A To indicate the sky, re-dampen the paper with clean water and a 2½ inch flat brush and lay a gradated wash with Prussian blue. Start fairly dark at the top and dilute the color with water on successive strokes.

D Use a ¾ inch flat brush and a little raw sienna to add warmth to the tone of the trees around the buildings. Apply the color with broad strokes.

As the main illustration shows, this raw sienna combined with an additional wash of burnt sienna gives a warmth that creates a difference in temperature between these middle-ground trees and the purple ones in the distance.

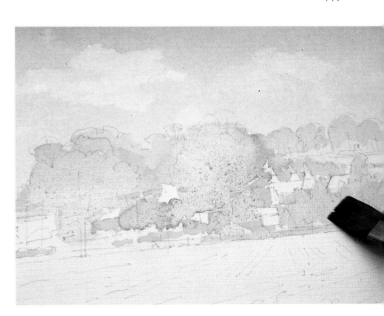

C Mix Prussian blue with water to make a very light wash for the buildings and trees in the middle ground of the picture. Use a No. 4 brush to establish their shapes and to indicate the shadows under the trees. Overpaint the shadows with magenta (see main illustration).

Apply the blue very lightly: any areas that are left untouched in the finished painting should give the impression of the transitory quality of light when it is reflected from snow.

3 Strengthening tones and colors

I decide that the tone of the sky in Stage 2 needs to be strengthened to give a more positive background to the rest of the painting. I also continue to extend the temperature range by adding warm accents to the distant view. (Illus. **A, B**)

There are two more steps in this stage:

C Tilt the board at an angle and, with a No. 5 brush, add more raw sienna to the middle ground.

D Finally, indicate the darker trees in the centre using a mixture of Prussian blue and burnt sienna and the same brush.

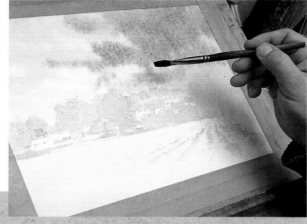

A Use a mixture of ultramarine blue and light red to strengthen the tone of the sky. You will need to mix a strong, dark wash with a range of colors varying between blue and red.

Dampen the paper and, with a ¾ inch flat brush, apply the wash between the clouds. The color will bleed and create soft-edged shapes. Use your brush to train these in the same direction as the cloud formations you blotted out in Stage I. Dry flat to encourage granulation.

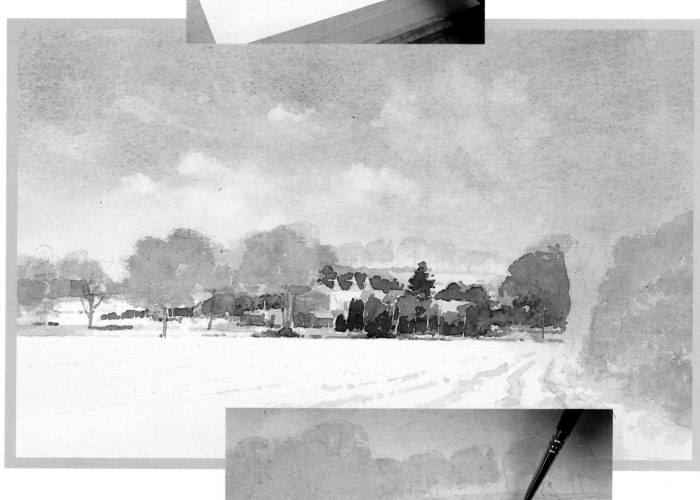

B Use the point of a No. 5 brush and burnt sienna to paint the tiled roofs of the distant houses.

These accents will help your eye to move across the painting, from the trees on the left of the buildings to the hedge on the right. The warmth of these colors also emphasizes the coldness of the surrounding snow-covered landscape.

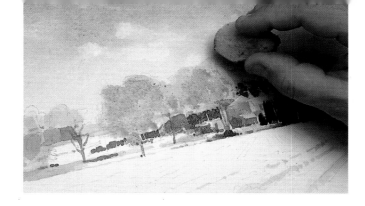

A Use a watercolor sponge and burnt sienna to add more tone to the russet trees in the middle ground and refine their shape. Just dip the sponge into fairly dense pigment and then dab it on to the trees.
 This technique is particularly useful for adding textural variation to a painting. Here it helps to give the impression of foliage.

4 Reinforcing and re-defining

There is now a range of tones in the middle ground and a variety of temperatures from warm to cool.
 I bring forward the trees on the left of the buildings by reinforcing their russet tone with burnt sienna and establish the trunks on the right (illus. A). I also decide to soften the dark green shapes of the middle-ground trees which became a little too heavy when the paint dried (illus. B, C).

B Lay a wash of clean water over the middle ground of the painting to soften the edges of the trees. It will also lighten the magenta wash over the trees in the distance so that they blend nicely into the sky.
 Mix burnt sienna and Prussian blue to get a range of greens from mid-tone to dark, and indicate the two trees on the right.

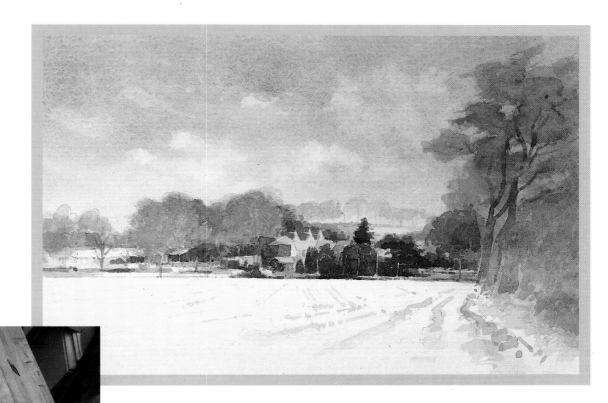

C When you have washed out the green areas, apply more dark greens to create a sense of form and volume. Use a No. 6 brush.
 Using the same brush and a darkish green wash, establish the direction and rhythm of the trunks of the trees on the right. Then apply a cool green to indicate their branches. Add magenta to indicate shadows.

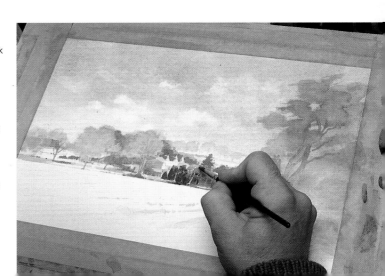

5 Providing a vertical block

I establish a good weight of tone on the righthand side of the painting to provide a vertical block to the movement of the trees and clouds. The shadow in the foreground leads the eye to the buildings — the central focus of the painting — and burnt sienna accents on the trees in the distance give the impression of winter sunlight catching their topmost boughs. I introduce more depth by adding a cool blue-purple to the painting. (Illus. A, B, C)

Establishing the tonal weight is one of the final steps in this stage:

D Use a No. 3 brush and sepia and burnt sienna, both separately and together, to begin to render the tree trunks. Add the edges of the buildings, the fence and other details.

A To define the distant trees more clearly, apply a very dilute wash of burnt sienna. Use a No. 6 brush to indicate their shapes. These accents will create a sense of form and volume. Keep the shapes of the trees as irregular as possible and don't allow your brush marks to become over-fussy; the shapes must be large and simple.

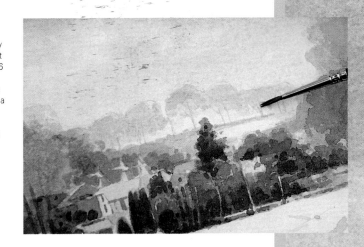

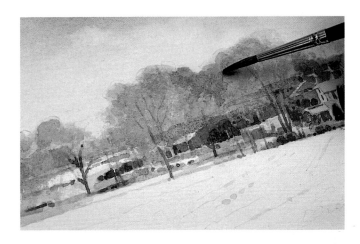

B Use a blue-purple from the ultramarine blue and magenta mixture to suggest a wooded valley in the area just beyond the middle-ground trees. Use a No. 6 brush to lay this wash.

This will give additional depth to the painting and add yet another contrast to the warmth of the red-roofed buildings and the russet trees in the middle ground and on the right.

C To darken the foreground and reinforce the coldness of the snow, use a dark purple from the ultramarine blue and magenta mixture. Use a ¾ inch flat brush to lay a broad wash. This creates a shadow and encourages the viewer to look into the picture.

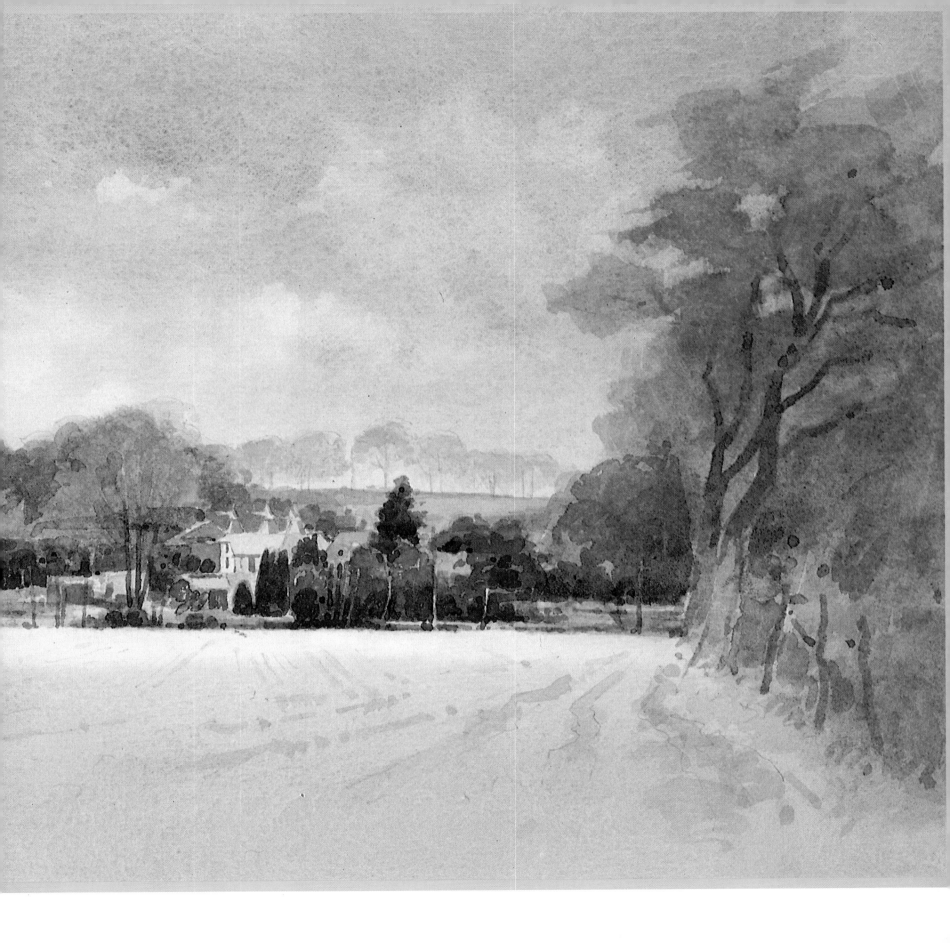

6 Adding some pastel touches

The composition is now realized with a good balance of warm and cool colors throughout the painting. I have added just a few selective touches in pastel to soften the edges of some of the washes (illus. A, B).

There are two final steps:

C Use magenta and a No. 8 brush to add a few furrows to the foreground of the picture.

D With the point of a Stanley blade, scrape a few extra furrows into the foreground to create snowy highlights. Make sure the furrows follow the general direction and rhythm of the composition.

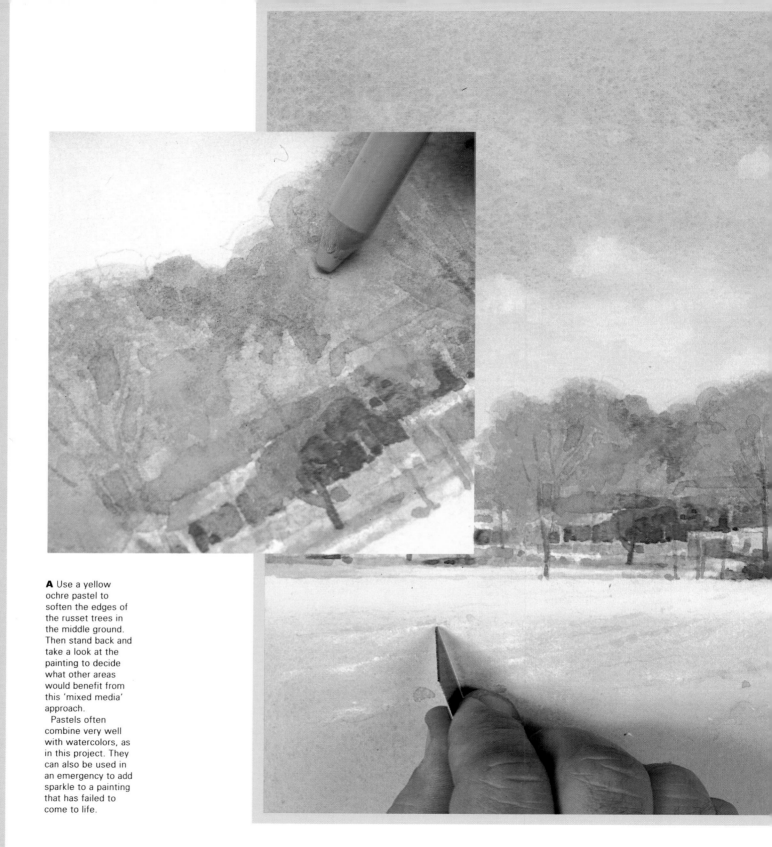

A Use a yellow ochre pastel to soften the edges of the russet trees in the middle ground. Then stand back and take a look at the painting to decide what other areas would benefit from this 'mixed media' approach.

Pastels often combine very well with watercolors, as in this project. They can also be used in an emergency to add sparkle to a painting that has failed to come to life.

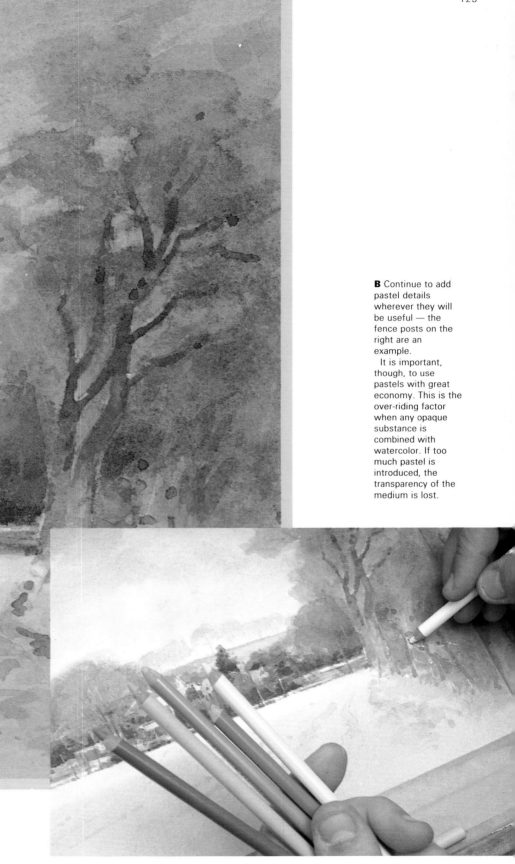

B Continue to add pastel details wherever they will be useful — the fence posts on the right are an example.

It is important, though, to use pastels with great economy. This is the over-riding factor when any opaque substance is combined with watercolor. If too much pastel is introduced, the transparency of the medium is lost.

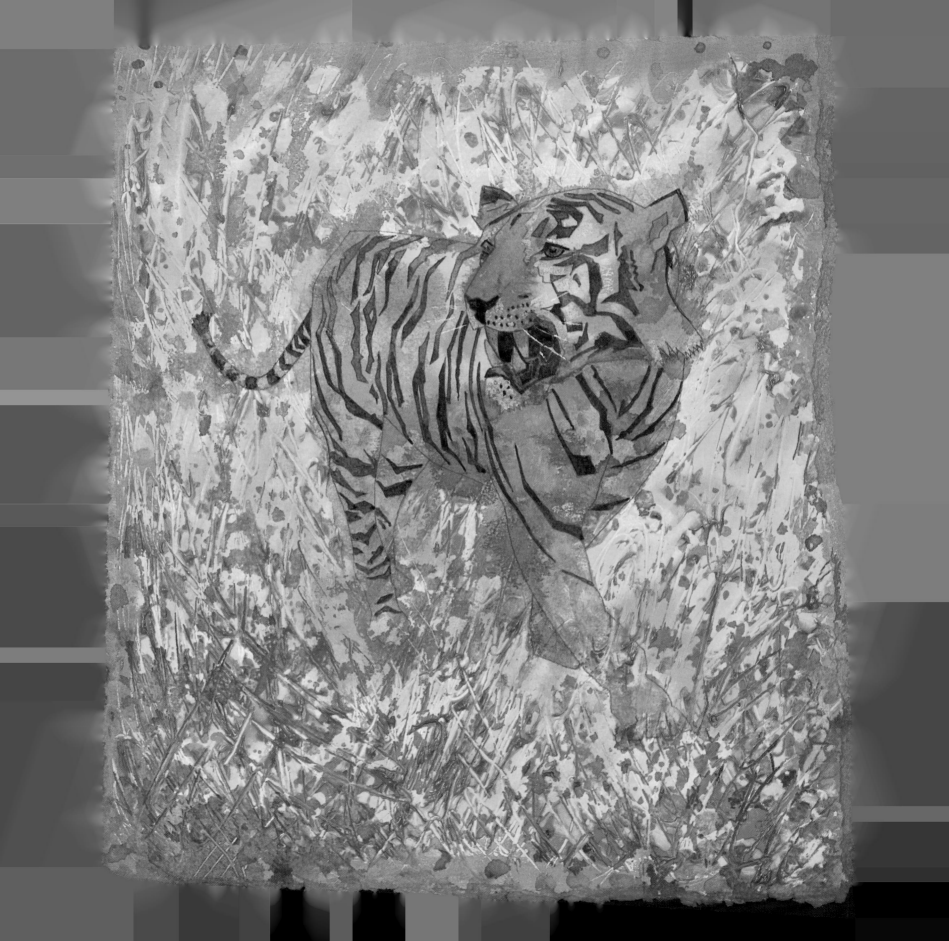

Tiger: Thick Paints and Aquapasto

For me, as for most people, the tiger has strong emotive connotations of power, exoticism and primitive strength. In this painting I was motivated by the desire to capture some of these qualities on paper.

I selected a heavy, handmade paper with a rough surface and tore it, rather than cutting it, to the appropriate size. I wanted to give the painting a primitive feel right from the word go; and also hoped that, when finished, it would be reminiscent of an old Indian manuscript partly destroyed by the ravages of time and climate (and possibly discovered by chance in an Indian bazaar).

The original drawing of the tiger was made in a museum on a separate sheet of paper. I wanted to refine the strong and confrontational pose at an earlier stage rather than draw directly on to the watercolor paper which could have been harmed by erasures and alterations. I then transferred the drawing to the watercolor paper using tracing paper and re-stated the tracing using a 1B pencil and by pressing hard. I needed strong outlines that could be referred to later, even after numerous colored washes had been applied. I worked wet-into-wet and filled the painting with thick, wet yellows, oranges and reds — fierce colors fiercely applied and spattered on to convey something of the animal itself. I used aquapasto for the background and scribbled into the creamy colors to create a sense of the tiger's habitat. I wanted to exploit the potentialities of the medium of watercolor to the full and give the impression of an animal emerging from its environment almost camouflaged and slightly ambiguous.

Materials
- ◆ 1B pencil; aquapasto; palette knife
- ◆ Paper: 300 lb Rough; handmade
- ◆ Brushes: No. 8; No. 10; No. 16; No. 24
- ◆ Colors: White gouache; Indian yellow; yellow ochre; cadmium orange; cadmium red; Winsor red; permanent rose; alizarin crimson; magenta; emerald green; ultramarine blue; burnt sienna; black.

The torn edges of the handmade paper are an important element in this project: they help to create an ambience that is in tune with the atmosphere of the painting.

Tiger
(34 cm x 41 cm /
13 in x 16 in);
Gregory Alexander.

1 Creating a foil for the image

To create a rich foil for the tiger I use warm reds, oranges and yellows to establish the background (illus. A, C, D, E).

After the initial washes are laid there is an intermediary step:

B Fill in the shape of the tiger with a mixture of Indian yellow and yellow ochre. Use a No. 10 brush and, while the initial washes are very wet, add a mixture of burnt sienna and cadmium red around the nose, ears, side and lower part of the legs and back.

A Draw or trace the outlines of the tiger on to the paper with a 1B pencil. Press hard so that they will show under the washes. Lay the board flat and dampen the paper liberally with water, then apply Indian yellow to the background with a No. 24 brush. Add cadmium orange while this wash is wet. Use the No. 24 brush to splash the paint on with short, haphazard strokes. Allow it to bleed.

Squeeze a liberal amount of aquapasto on to a palette (illus. **C,** below left) and use a small, trowel-like palette knife to apply it to all areas of the painting except the tiger (illus. **D,** below). Put the medium on with rapid, stroking motions. Work the aquapasto in with the palette knife to make a thick base for the paints that will be applied later. Try to create a thick, slightly rough surface rather like butter icing.

E Load a No. 16 brush with Winsor red and spatter and drop the color over the background. The painting is still wet so the red will bleed and run.

To get the larger drops of red, hold the brush over the painting and allow the color to drip off. To spatter the paint, tap the brush on your index finger so that it is flicked on to the surface.

Finally, paint the border with the Winsor red. Allow some of the red to drop on the tiger's nose and ear areas while they are still wet so that the red bleeds.

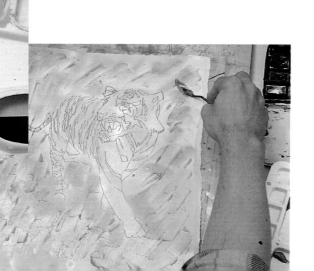

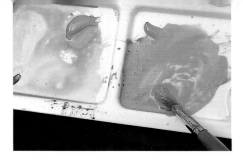

A Mix emerald green and yellow ochre to make the green for the tiger's chest and the lower part of the painting.
 This illustration shows the amount of color that should be prepared and the density that is needed: add just enough water to the pigment to give the mixture the consistency of milk.

2 Intensifying color values

To give an added intensity and value to the reds and oranges that predominate in the painting I decide to introduce green — the complementary color to red — at this stage (illus. **A, B, C**).

Throughout this project I am careful to work loosely and lightly in order to retain a sense of freshness and spontaneity. Any overworking would lose these qualities and, with them, the impression of primitive power that is inherent in the subject of the painting.

The picture now has an exciting, painterly quality that is reminiscent of the bushland that is the tiger's natural habitat.

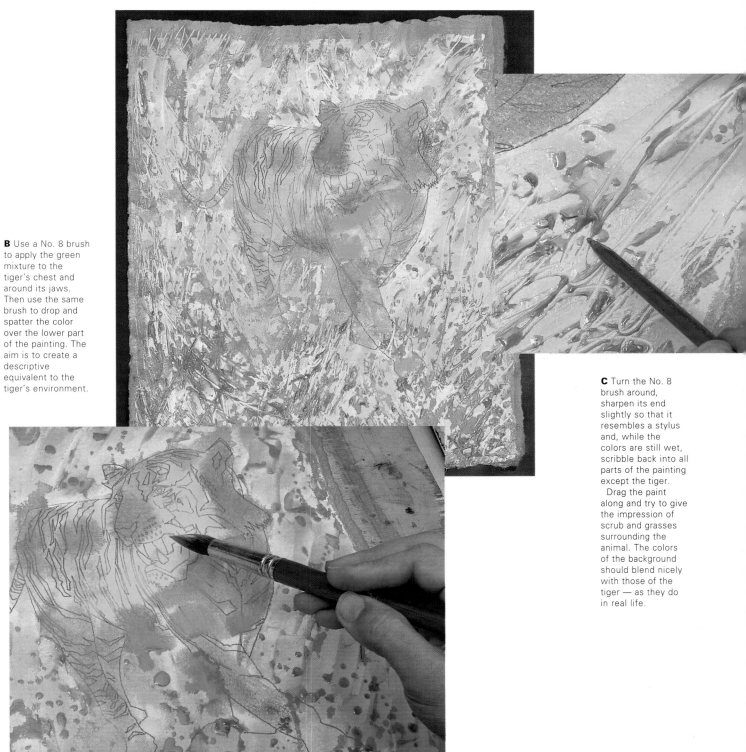

B Use a No. 8 brush to apply the green mixture to the tiger's chest and around its jaws. Then use the same brush to drop and spatter the color over the lower part of the painting. The aim is to create a descriptive equivalent to the tiger's environment.

C Turn the No. 8 brush around, sharpen its end slightly so that it resembles a stylus and, while the colors are still wet, scribble back into all parts of the painting except the tiger.
 Drag the paint along and try to give the impression of scrub and grasses surrounding the animal. The colors of the background should blend nicely with those of the tiger — as they do in real life.

3 Revealing the shape of the tiger

I introduce the purple — the complementary color to yellow — for the same reason that I added green in Stage 2: to give intensity and value to the surrounding colors. I am careful not to overwork the background as I want the painting as a whole to have an untamed feeling. I also add the stripes to the tiger to reveal its shape so that it seems to be caught in the act of emerging from its background. It is important to mix a black that is not too strong — the mixture should be mainly black but not too dense and dark. Finally, I add the finishing touches to the tiger's head. (Illus. A, B, C, D)

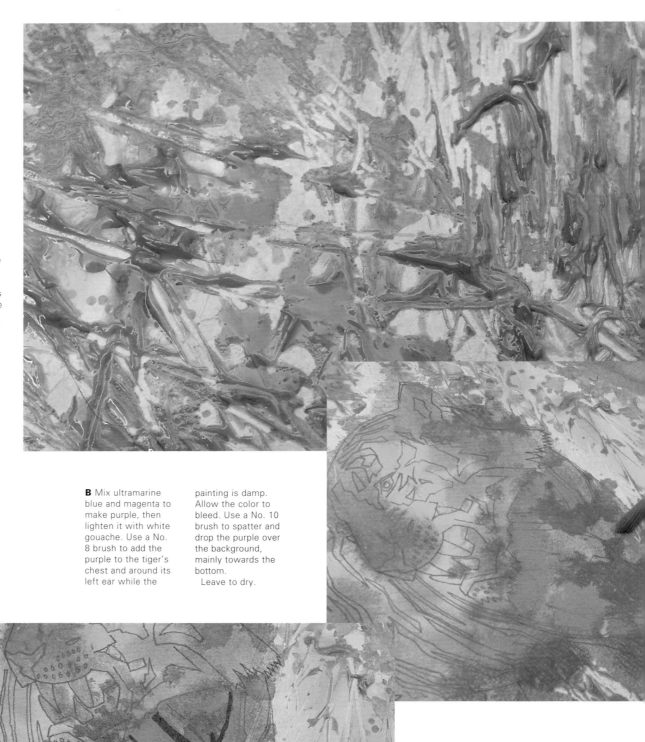

A This detail of the grasslands area of the painting shows the texture that has been created by the different colors in the painting and by the use of aquapasto and two of my favourite techniques: scribbling into the pigment and spattering. It also demonstrates the potential of watercolor as a textural medium.

B Mix ultramarine blue and magenta to make purple, then lighten it with white gouache. Use a No. 8 brush to add the purple to the tiger's chest and around its left ear while the painting is damp. Allow the color to bleed. Use a No. 10 brush to spatter and drop the purple over the background, mainly towards the bottom.
 Leave to dry.

C Mix ultramarine blue and alizarin crimson with black.
 When the painting is dry, use a No. 8 brush to apply the stripes on the tiger's body and head. Follow the lines of the underlying drawing and vary the density of the black depending on whether a particular part of the animal is in light or shade.
 Use the same black to fill in the dark areas on the tiger's head.

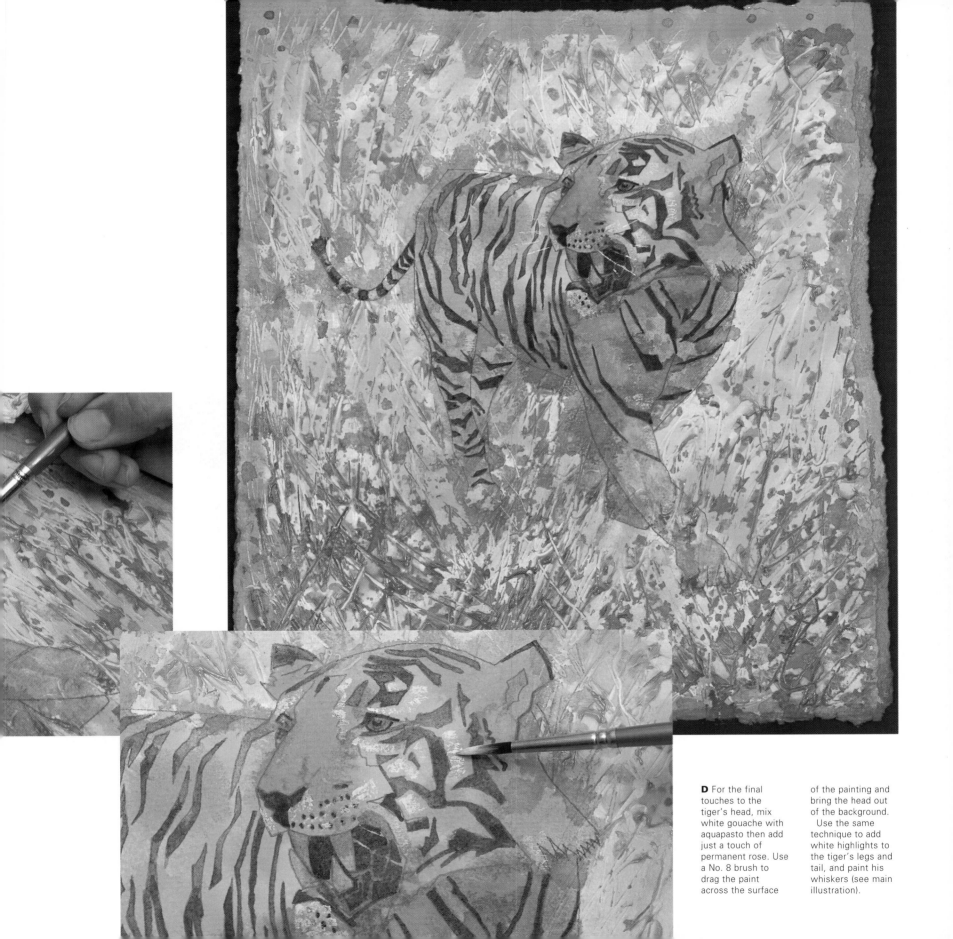

D For the final touches to the tiger's head, mix white gouache with aquapasto then add just a touch of permanent rose. Use a No. 8 brush to drag the paint across the surface of the painting and bring the head out of the background.

Use the same technique to add white highlights to the tiger's legs and tail, and paint his whiskers (see main illustration).

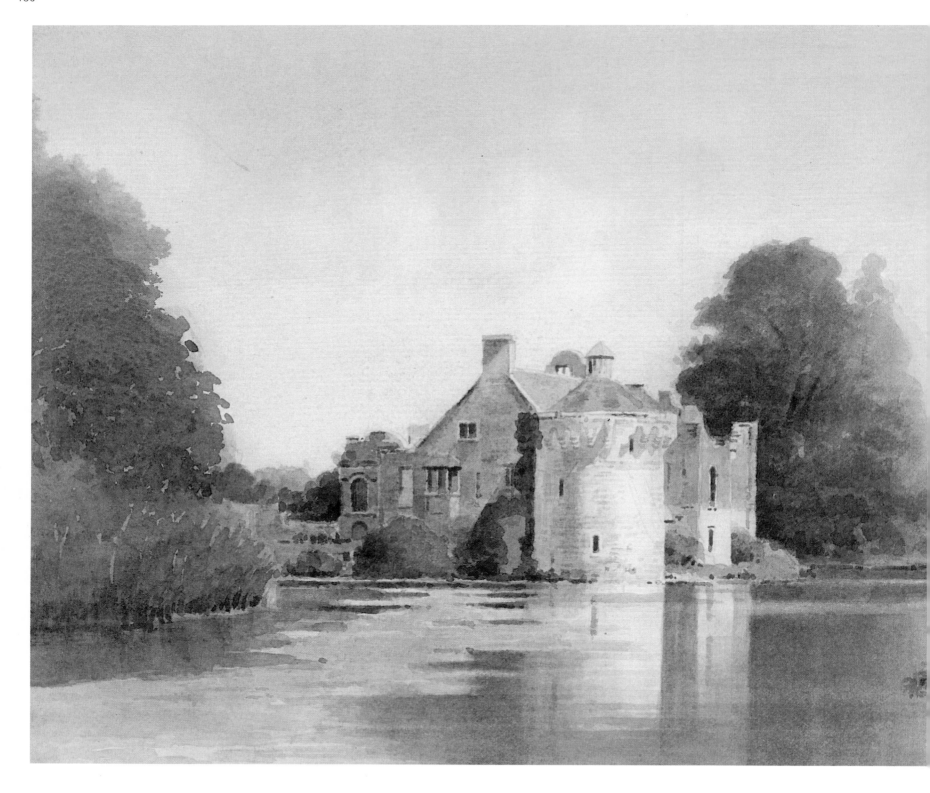

Scotney Castle
(34.5 cm x 22 cm /
13½ in x 8½ in);
Matthew Alexander

SCOTNEY CASTLE: WORKING WITH A LIMITED PALETTE

I wanted to demonstrate how a wonderfully rich and varied painting can be achieved using only a very few colors. A limited palette creates a natural unity and its practical advantage is that because your mixtures are less complex you can easily remember or work out how you achieved a particular color. The intention is not to match the colors of nature exactly but to orchestrate the palette in a way that creates a naturalistic impression.

Limited means exactly that and it is worth experimenting with the degree to which you add or subtract colors. Only two can create a surprising range of color variations and extremes in tonal range. Colors of vastly different temperatures — blue and orange are examples — allow a full range of warms and cools to be exploited and surprising mixtures can be created. Browns and siennas are more closely related and will create subtle harmonies and suggested, rather than obviously stated, temperature changes.

I worked with only five colors — raw sienna, burnt sienna, Prussian blue, magenta and sepia — and consistently developed the counterpoint between warms and cools, gradually building up surprisingly subtle variations from this basic range.

The method I used is based on the classic tradition of watercolor landscape painting exemplified by eighteenth-century artists like Thomas Girtin and John Sell Cotman. The range of colors available to them was relatively restricted by modern standards, but their paintings are rich in texture and tonality. Watercolor is often treated with exaggerated delicacy today; if you look at older examples you will often see how areas have been scrubbed at, washed out, blotted and reworked, so you should keep in mind that you do have a chance to make changes at every stage. I have included techniques like lifting-out, blotting-out and scratching-out in this project.

Materials
- 2B pencil; tissues; hard pencil-type eraser
- Paper: 90 lb hot pressed; stretched
- Brushes: ¾ inch flat; 2½ inch; No. 6; No. 8; No. 10
- Colors: Raw sienna; magenta; burnt sienna; Prussian blue; sepia.

1 Positioning the image

From the start I make the painting detailed and controlled.

The first step is:

A Draw the buildings and trees with a 2B pencil to develop an accurate guideline for the color.

I then dampen the paper before applying the first wash (illus. B).

B Tilt the board at a slight angle and use a 2½ inch brush to dampen the paper. Use clean water and apply it evenly so that the surface is wet enough to be receptive to the first delicate color washes; be careful not to flood the paper too rapidly.

2 Establishing color temperature

To set a warm base color for the whole image I apply the first color layer — an all-over wash of raw sienna (illus. A). This is loosely applied but I lift out the paint to retrieve the white of the paper while the color is wet (illus. B, C).

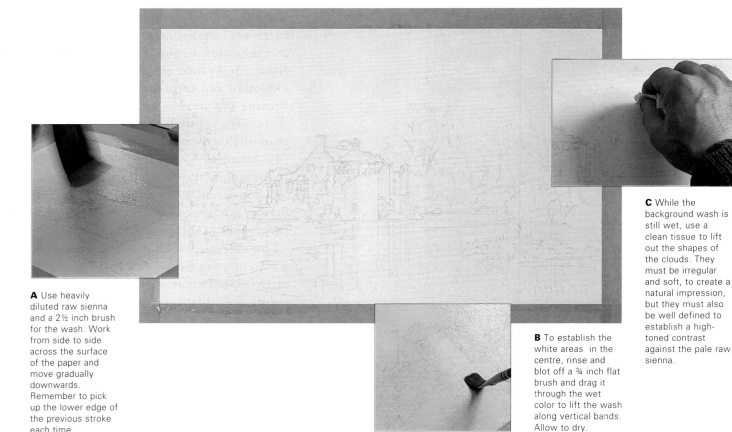

A Use heavily diluted raw sienna and a 2½ inch brush for the wash. Work from side to side across the surface of the paper and move gradually downwards. Remember to pick up the lower edge of the previous stroke each time.

B To establish the white areas in the centre, rinse and blot off a ¾ inch flat brush and drag it through the wet color to lift the wash along vertical bands. Allow to dry.

C While the background wash is still wet, use a clean tissue to lift out the shapes of the clouds. They must be irregular and soft, to create a natural impression, but they must also be well defined to establish a high-toned contrast against the pale raw sienna.

3 Blocking in the masses

I offset warm and cool colors. The first step is:

A Re-dampen the paper with a 2½ inch brush and clean water.

I then apply a Prussian blue wash to introduce a cool contrast (see main illustration). I work roughly to the drawing (illus. B).

4 Modifying the warm/ cool contrast

As the initial washes dry the color contrast becomes very faint and subtle. I begin to strengthen the depth of tone and the balance of shapes and pay more attention to the detailed outlines of buildings and trees, varying the color strength and edge qualities to develop space and form (illus. A).

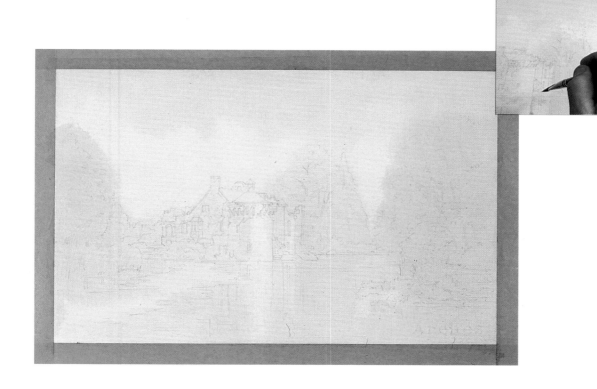

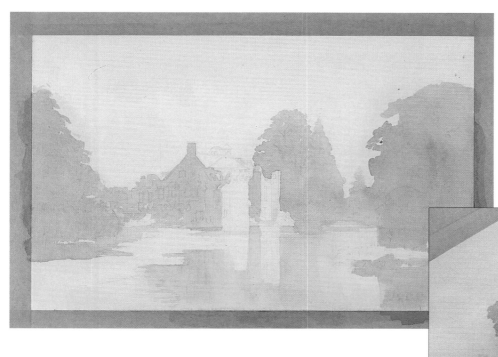

B Use a ¾ inch brush to add the Prussian blue. Mix a dilute wash — you will find that what appears to be a fairly strong color when you first lay it down softens and fades as it dries and becomes integrated with surrounding tones. This is most noticeable in the early stages, when the high tone of the white paper still dominates.

A Prepare a burnt sienna wash and use this and the Prussian blue to fill in the larger shapes with bold strokes. Use a ¾ inch brush. Then work into the detailed outlines with the edge of the brush. Let the colors flow together to produce separate color areas and occasional delicate mixes.

136

9 Singing the low notes

The full tonal range of the painting is established.

A Add sepia to all the darker parts in order to strengthen them and give impact to the linear detail in the trees.

I decide to darken the sky and also fine tune other details (illus. B, C).

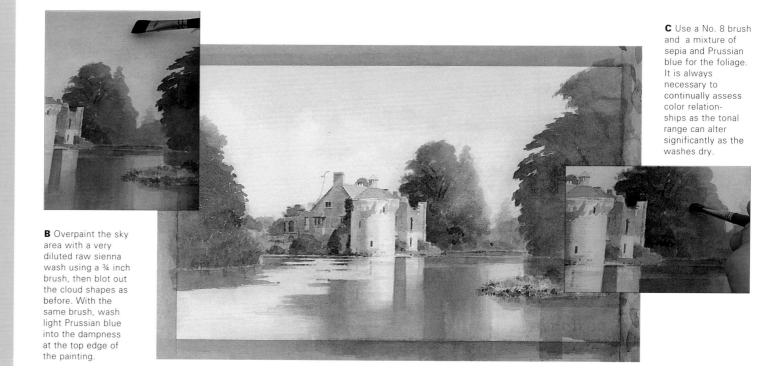

B Overpaint the sky area with a very diluted raw sienna wash using a ¾ inch brush, then blot out the cloud shapes as before. With the same brush, wash light Prussian blue into the dampness at the top edge of the painting.

C Use a No. 8 brush and a mixture of sepia and Prussian blue for the foliage. It is always necessary to continually assess color relationships as the tonal range can alter significantly as the washes dry.

10 Detailing for effect

I use subtle mixtures to modify the stronger hues.

A Mix Prussian blue with magenta and, with a No. 8 brush, overpaint the reflections in the foreground.

B Add a few vertical lines to the tower's reflection.

C Use sepia for the righthand tree and under the reeds.

I continue to refine the image (illus. D).

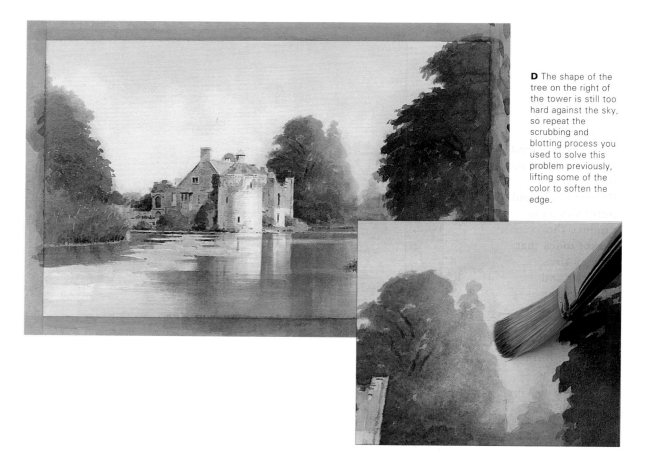

D The shape of the tree on the right of the tower is still too hard against the sky, so repeat the scrubbing and blotting process you used to solve this problem previously, lifting some of the color to soften the edge.

11 Realizing the image

The lighting particularly depends on the way I have preserved the highlights through each stage while deepening the tonal range, although I also let in some light at the last stages (illus. **A**).

The five basic colors have produced a surprising range and richness of color in the image. The impression of greenness is perhaps the most unexpected element as the limited palette used for this project contains no bright yellow or green. Nevertheless, it emerges strongly in the painting by contrast with the warmth of the russet and magenta mid-tones. Raw sienna, which is a slightly subdued yellow, also gains brilliance from its neighbouring colors and lights up the landscape.

A Use a hard pencil-type eraser to scratch out color from the tree to give the impression of sunlight shining through the foliage. You will have to rub very heavily into the surface, so make sure the paint is dry before you start. If the paper is damp it will lift and tear.

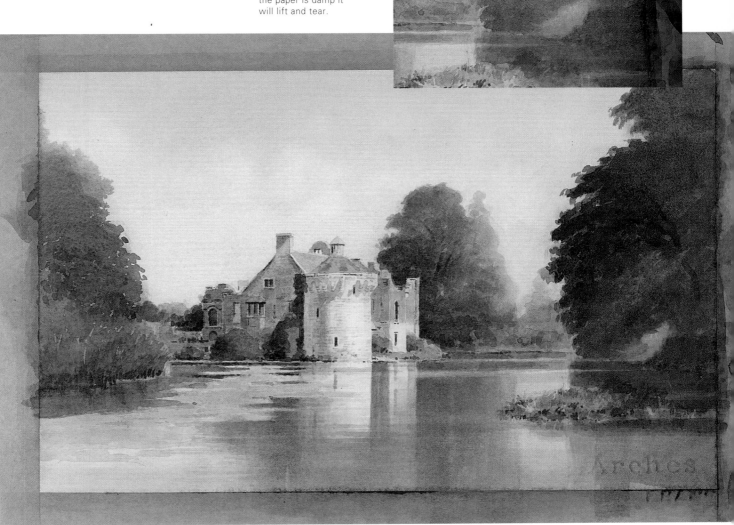

AFRICAN TOWNSCAPE: WET WASHES AND DENSE PIGMENTS

African Townscape
(61 cm x 80 cm /
24 in x 31½ in);
Gregory Alexander.

This townscape was inspired by visits to a remote town on a group of islands off the coast of Africa. Time seems frozen in Lamu — dhows and donkeys are still the main means of transport — and the Arab and Swahili influence is apparent in elegant Moorish arches and beautiful carving.

I made many sketches and took a variety of photographs during my visits but the tropical heat and other practical problems made it impossible to produce a large, considered work on the spot. I was therefore forced to re-construct the painting in my studio at home, using my sketches and photographs — and my memories of Lamu. This process enabled me to select only elements that are unique to the town: the decorative architecture and carving, donkeys and dhows and, of course, the people themselves.

I combined all these in a preparatory drawing which I later transferred on to my pre-stretched paper; I wanted to do as little rubbing out and changing as possible. I altered the scale of people to buildings and boats to emphasize the eastern nature of the subject and decided to surround the whole image with a painted representation of a carved frame: a kind of *trompe-l'oeil* effect which I denied by running a mast across it.

I worked wet-into-wet, flooding the paper with wet washes of warm reds and yellow ochres and spattering colors on to create a semi-haphazard effect as a counterpoint to the hard, rectilinear drawing. Later I added details. Some are soft and others, like the blue waves, are opaque and definitive.

This townscape is a good example of how painting is so often about giving value to different areas and finding contrasts of light and dark, warm and cool, wet and dry, thick and thin and general and specific.

Materials
- 1B pencil; aquapasto
- Paper: 140 lb Rough; stretched
- Brushes: No. 6; No. 8; No. 10; No. I6; No. 24; No. 26
- Colors: White gouache; Indian yellow; yellow ochre; raw sienna; permanent rose; alizarin crimson; Winsor red; cadmium red; emerald green; Winsor green; cobalt green; cerulean blue; ultramarine blue; cobalt blue; burnt sienna; raw umber; burnt umber; sepia; black.

When the drawing is completed the paper is dampened with lots of clean water to give a flooded surface for the wet washes that will come later. The pencil lines must be strong so that they remain visible as the painting develops.

1 Establishing a tropical ambience

Before applying the paint I made the drawing with a 1B pencil, pressing hard so that the lines are heavy and indented. It will be important to see the drawing as the painting progresses and faint pencil lines would be covered by strong washes.

I dampen the paper liberally with water using a No. 24 brush and then splosh lots of permanent rose into and around the centre of the painting to establish its hot, tropical ambience. I use the No. 24 brush with which I applied the water to do this. I lay the board flat as I will be working wet-into-wet until Stage 6.

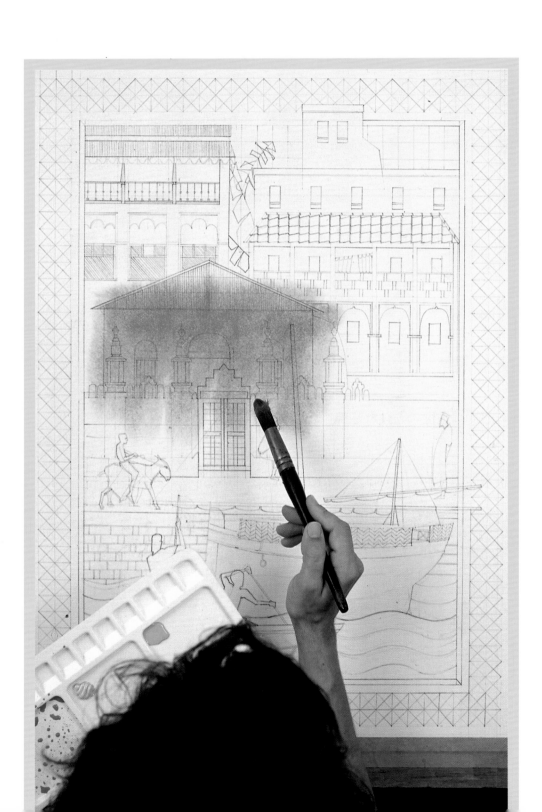

2 Filling the painting with color

I continue to establish a feeling of heat by applying yellows and red, and a pink wash of permanent rose over the buildings generally. I keep the painting fluid during this early stage in order to create a counter-point to the hard, rectilinear lines of the drawing. (Illus. A, B).

There is one final step in this stage:

C Apply cadmium red to the roofs of the buildings (see main illustration).

It is a big painting so I prepare lots of the colors I will be using and make sure the mixtures are saturated with pigment. The surface of the painting is very wet and the water will disperse the density of the paints. I apply the colors liberally, knowing that they will look a lot paler as the painting develops.

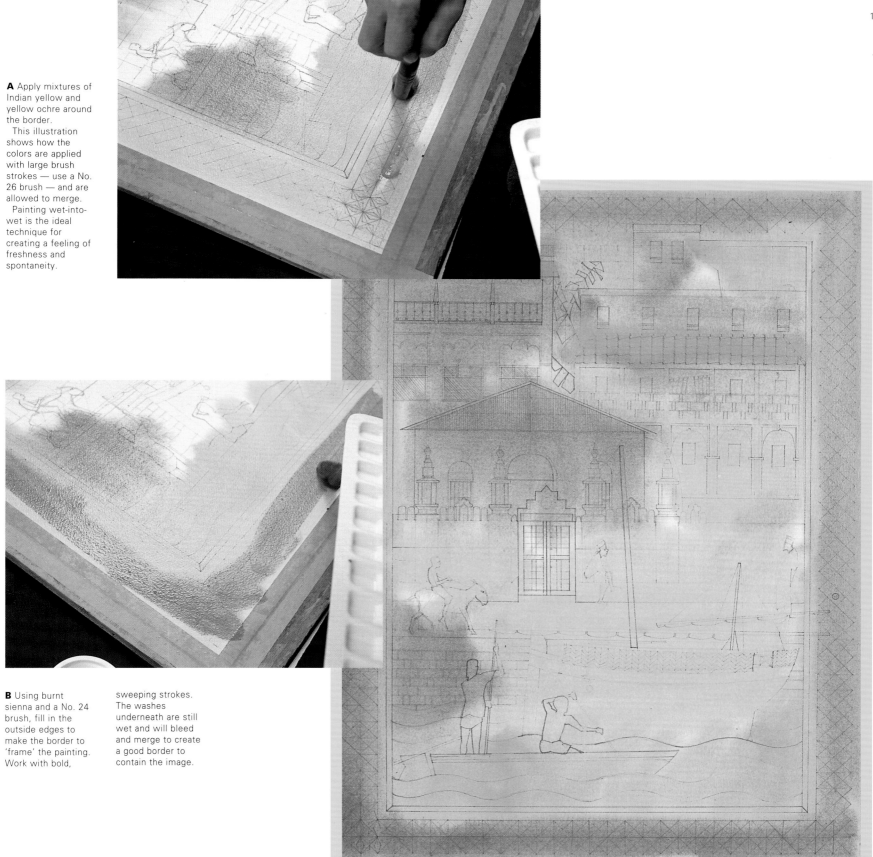

A Apply mixtures of Indian yellow and yellow ochre around the border.

This illustration shows how the colors are applied with large brush strokes — use a No. 26 brush — and are allowed to merge.

Painting wet-into-wet is the ideal technique for creating a feeling of freshness and spontaneity.

B Using burnt sienna and a No. 24 brush, fill in the outside edges to make the border to 'frame' the painting. Work with bold, sweeping strokes. The washes underneath are still wet and will bleed and merge to create a good border to contain the image.

3 Creating a visual reference

I allow spattered drops of alizarin crimson and yellow ochre to bleed and merge with the initial washes to create a silky feel that will provide a foil to the hard-edged details that will be added later (illus. **A, B**). The mottled, almost haphazard effect, adds a nice reference that is reminiscent of Persian or Indian miniatures. The painted border is already giving a sense of depth to the painting.

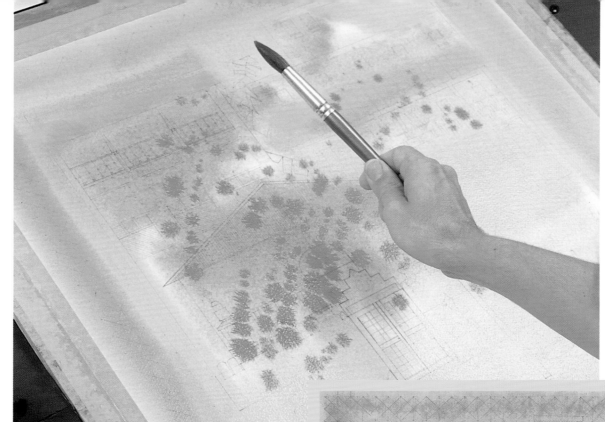

A Use a No. 16 brush to spatter alizarin crimson on to the painting. Concentrate on the areas you have already covered with permanent rose — the roofs and tiles — but also add the crimson to other parts that will have a red feel in the finished work.

Mix the color with plenty of water so that it is very wet and 'sloppy'. Apply the paint by holding your brush over the areas you want to spatter and allowing the paint to drop off.

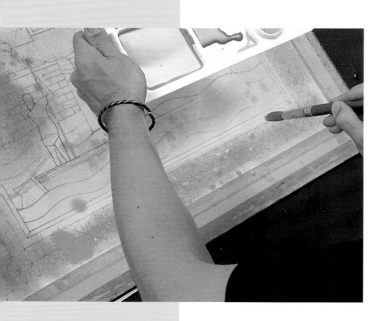

B Mix yellow ochre for the border area with lots of water and, still using a No. 16 brush, drop blobs of color around the edge of the painting. These will merge with the burnt sienna wash you applied earlier and will give the appearance of old, weathered wood to what will be the 'frame' of the picture.

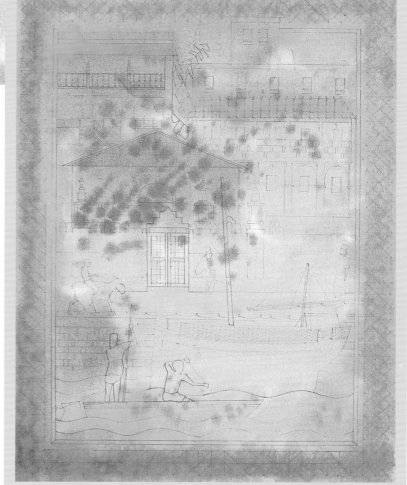

4 Bringing the images into focus

The colors are now beginning to come into focus in the same way that adjusting the lens of a camera starts to define an out-of-focus view. I allow the yellow ochre and alizarin crimson to merge with the previous washes and then make a start on refining the painting as a whole (illus. **A, B**).

There are two final steps in this stage:.

C Continue to add spatterings of yellow ochre and alizarin crimson to various areas of the painting in order to create the lush, rich, mottled effect characteristic of old and decaying buildings.

D Reinforce the area between the dhow and the buildings by applying raw sienna with a No. 16 brush.

A Use a No. 16 brush to paint the side of the dhow with burnt sienna. The painting is still wet and the color will bleed, but it should be applied with more control than before: the shape of the boat must be slightly more specific than previous shapes.

Up to now paint has been applied to general areas of the painting. Here, for the first time, it is necessary to fill in a particular area — the side of the dhow.

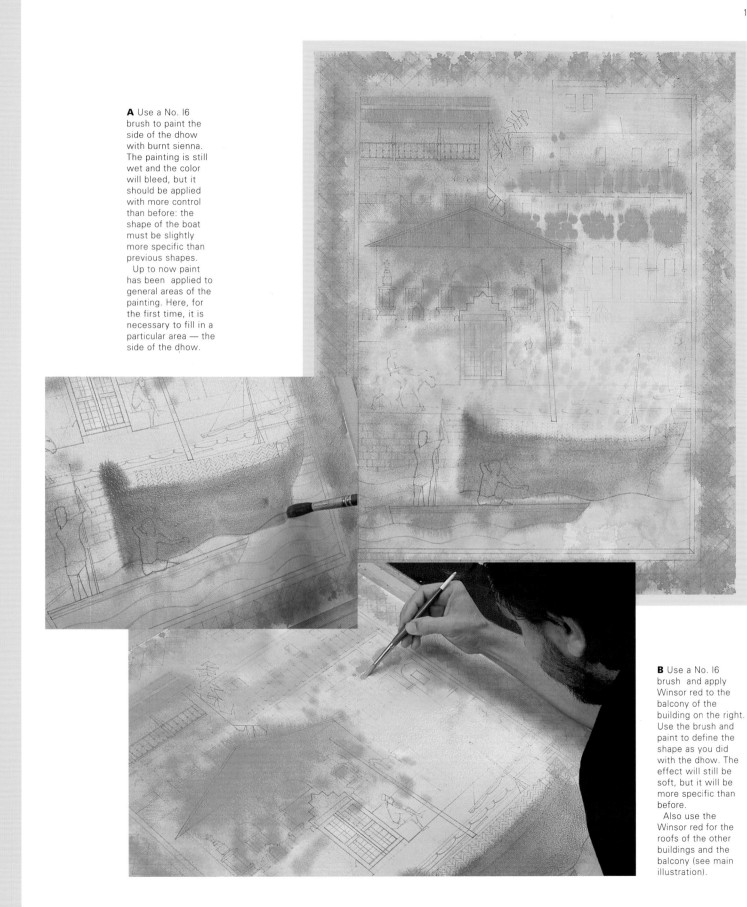

B Use a No. 16 brush and apply Winsor red to the balcony of the building on the right. Use the brush and paint to define the shape as you did with the dhow. The effect will still be soft, but it will be more specific than before.

Also use the Winsor red for the roofs of the other buildings and the balcony (see main illustration).

5 Introducing the cool colors

I introduce a range of cool colors to form a contrast with the warm ones that predominate in the painting. The images are now becoming even more specific but are soft-edged rather than hard: although the painting is drier than it was — damp rather than wet — the colors still merge into each other. (Illus. A, B, C, D). The spattered paint in the bottom righthand corner has dried to give the effect of an ancient manuscript.

E Use a No. 10 brush and burnt sienna to paint the mast and booms of the dhow and yellow ochre with a little cobalt green for the building in the middle ground.

F Re-paint the wall of the mosque using emerald green mixed with some ochre if the initial washes look too light. Use a No. 10 brush

A Use a No. 10 brush and Indian yellow mixed with a little Winsor red to paint the trellis pattern in the top righthand corner of the painting.
Follow the lines of the underlying drawing and apply the color with the point of your brush. The paint will bleed slightly and the soft appearance of the painting will be retained despite these rectilinear lines.

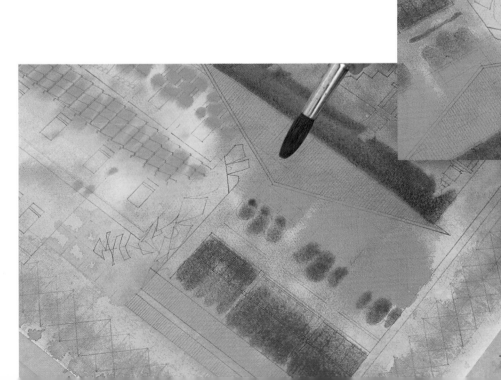

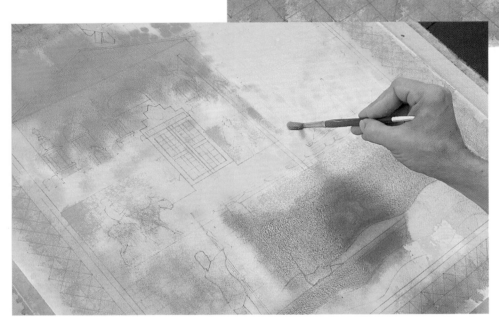

B Mix emerald green and yellow ochre and, still using a No. 10 brush, add this color to the wall in the middle ground of the painting. Try to apply the paint with short brush strokes, almost 'blobbing' it on. The painting is still damp so the color will bleed.
Use the same mixture of emerald green and ochre, and the same brush, to fill in the top of the dhow.

C Start to introduce the cooler colors — a mixture of permanent rose and ultramarine blue with a little cerulean blue — while the painting is still damp. Use a combination of these colors to paint in the shadows under roofs and arches and in the windows (see main illustration) using a No. 10 brush but vary the mixtures to make them bluer or more purple.

D Continue to add the cooler colors to the painting, trying to create as much variety as you think the image needs. Use a No.6 brush. Allow some shadows to tend towards green and some towards purple, rather than paintiing them all in the same color. The shadows under the arches in this illustration are cerulean blue mixed with a little bit of emerald green. Use the same mixture for the shadows in the chequerboard balcony fronts.

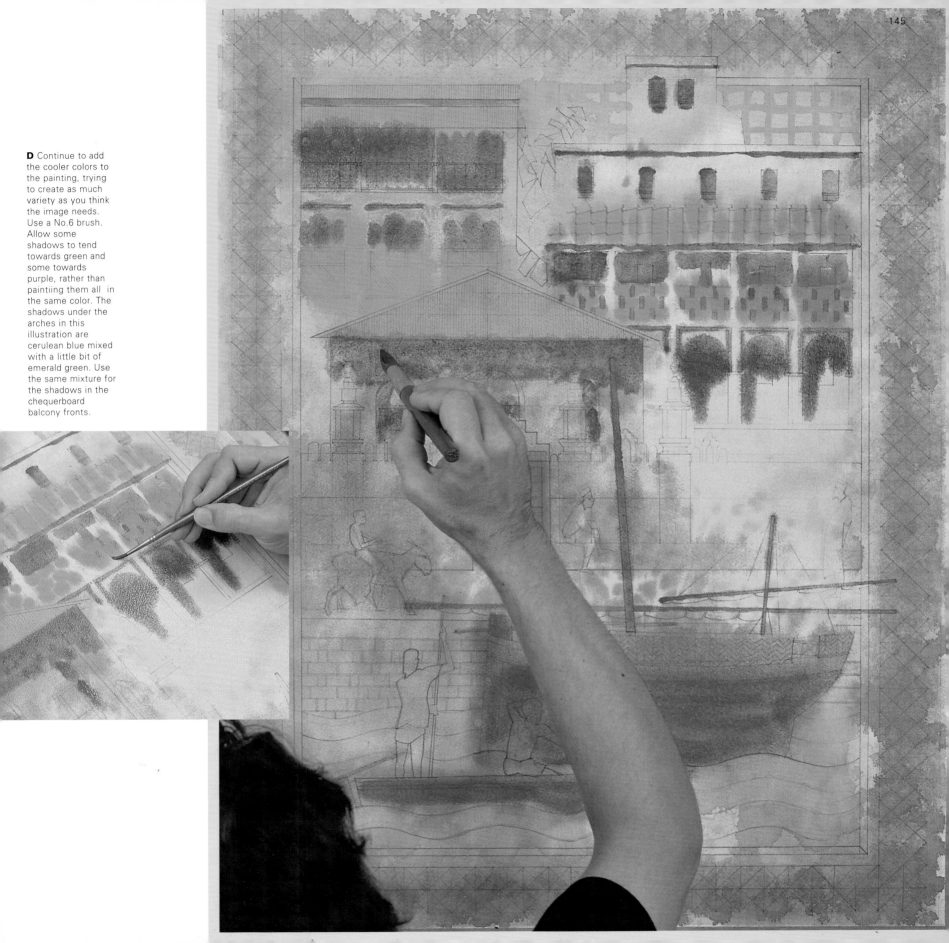

6 Defining and refining the details

At this stage I am able to relax and work more slowly. I allow the painting to dry, then stand it up and look at it from a distance. I can see that it needs more details so once it has dried I start defining and controlling — but with great care as any overworking could lose the beauty of the fresh and accidental qualities of the earlier washes. I also introduce dense blue waves to create a counterpoint to the washes. Contrasts like this exploit the potential of watercolor and it is always important to find them.

The view through the camera is now coming into focus (illus. A, B, C, D).

A When the painting is thoroughly dry use Winsor red mixed with a little alizarin crimson to paint the finished effect of the corrugated iron roof. Although this is basically the same color as the initial wash, the base red was applied when the painting was wet and will have become lighter and less dense as it dried.

Tilt the board at a slight angle from now on, and use the point of a No. 6 brush to resolve the pattern of the roof into a series of stripes.

Paint the screens above the roof using the same mixture with the addition of a little Indian yellow.

B Use a mixture of burnt umber and alizarin crimson for the wooden balcony decoration and railings on the building in the top lefthand corner of the painting.

Apply the color with the point of a No. 6 brush and follow the outlines of the drawing underneath.

You will be able to work more easily if you move around the painting when you apply color to the intricate decoration on the roof of the balcony.

C In a separate bowl combine white gouache, cobalt blue and aquapasto with some water to make the creamy consistency of the blue for the waves in the foreground of the picture.

Aquapasto is a thick, creamy medium that can be mixed with pigments to give textural variation to watercolor paintings.

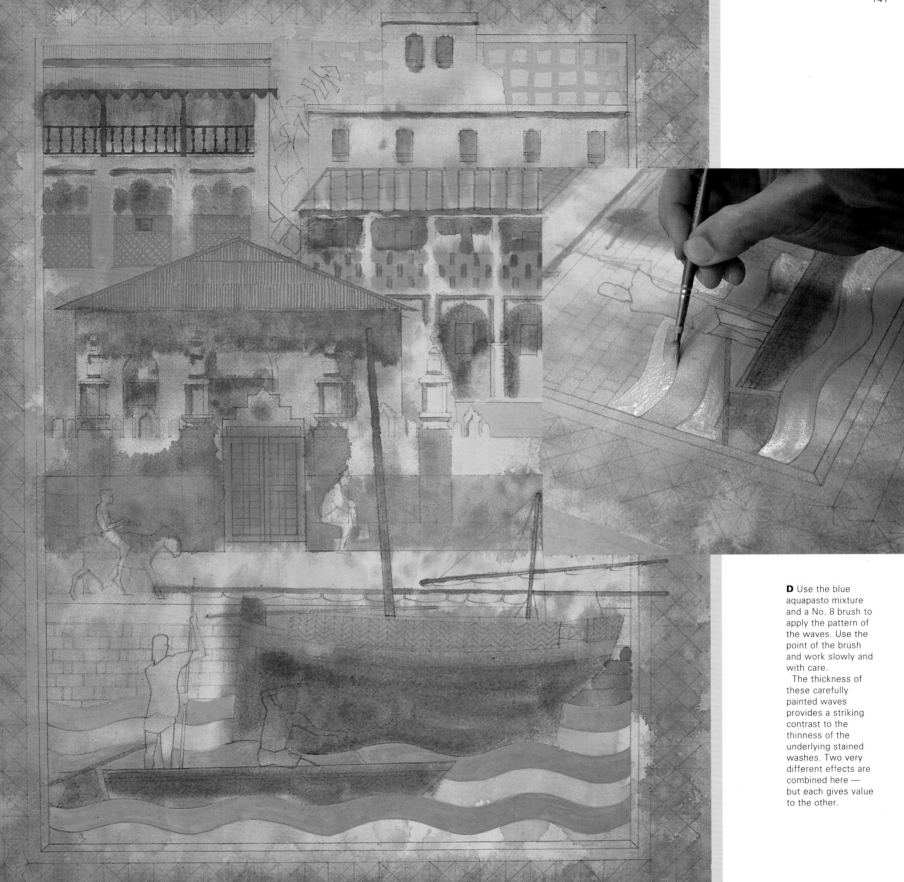

D Use the blue aquapasto mixture and a No. 8 brush to apply the pattern of the waves. Use the point of the brush and work slowly and with care.

 The thickness of these carefully painted waves provides a striking contrast to the thinness of the underlying stained washes. Two very different effects are combined here — but each gives value to the other.

7 Adding more color contrasts

I add more details to the painting: the green of the banana leaves provides a cool contrast to the warm reds and pinks that surround them and the figures have an almost statuesque quality.

Throughout this stage I am guided by the underlying drawing (illus. **A, B, C, D, E**).

There is one final step:

F Use raw umber mixed with a little Winsor green to paint the bar on the front of the dhow with a No. 8 brush. This creates the background for the decoration to be added in Stage 8.

A Mix Indian yellow and Winsor green to get varying degrees of dark green and, using a No. 8 brush, fill in the banana leaves between the two buildings at the back of the painting.

Focus on the shapes to create a sense of lush green, tropical vegetation. Use the point of your brush and keep within the drawn outlines. Try to vary the intensity of the greens.

C Paint the figures in two stages. First, fill them in using a dark blue mixture of ultramarine blue and alizarin crimson; then, go over them again with sepia. Use a No. 6 brush.

Add a touch of black to the dark blue mixture and carefully paint in the windows of the mosque and other buildings. Leave the bars of the windows unpainted.

Treat the figures very simply with not too much variation. They should be seen almost as silhouettes.

B Mix aquapasto with white gouache, a little permanent rose so that the white isn't too pure and very little water. The mixture must be so thick that it is dragged across the surface rather than being painted on. Then, with a No. 8 brush, apply the white to sunlit areas of the buildings at the back of the painting.

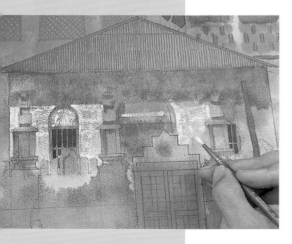

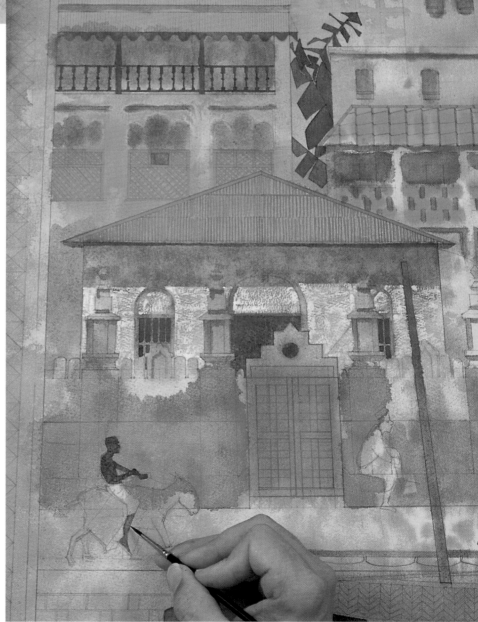

D Paint the sky area with the mixture of aquapasto, cobalt blue, white gouache and water that was used for the waves in Stage 6. Use a No. 8 brush and paint over the existing color in order to create a chequerboard effect reminiscent of motifs in early illuminated Arabian manuscripts.

The aquapasto mixture will be thick and hard-edged against the softness of the underlying wash, echoing the contrast between the blue waves in the foreground and the soft, stained colors against which they are seen.

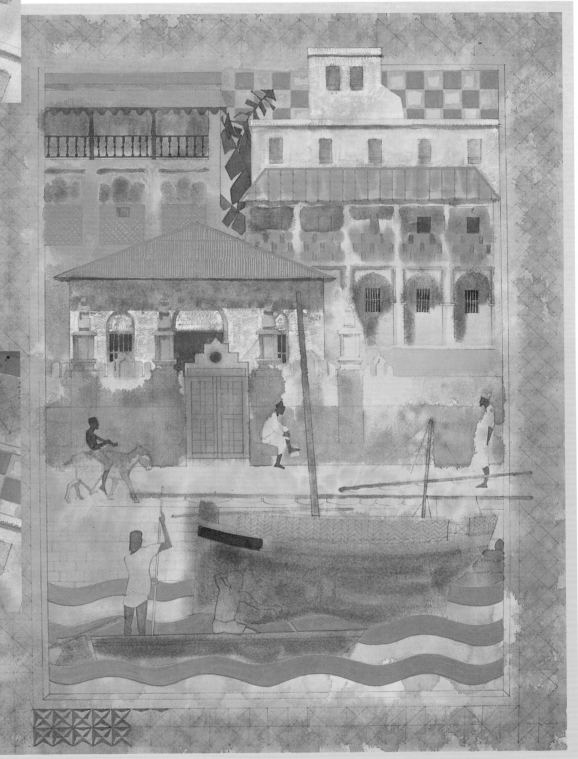

E The application of the thick, dry white mixture shown here is not really a 'classic' watercolor technique. However, its use in **B** shows how well it can convey the impression of crumbling stucco plaster on an old and neglected building, and underlines how important it is to keep pushing the limits of watercolor and experimenting with the medium. There are no rules — only what works.

8 Creating an atmospheric effect

I paint in the carving in the 'frame' to reflect the atmosphere of the town of Lamu with its Arabic and Swahili influences. To create an ambiguity that is both interesting and reminiscent of Arabian and Indian miniatures I then deny the realistic effect by painting the dhow's boom across it. (Illus. A, B, C)

There are two final touches, both of which create a feeling of depth:

D Paint the top left edge of the frame with a No. 8 brush and a mixture of sepia and burnt sienna.

E Use the same brush and a mixture of aquapasto, yellow ochre and a little water on the lower and right edges of the frame.

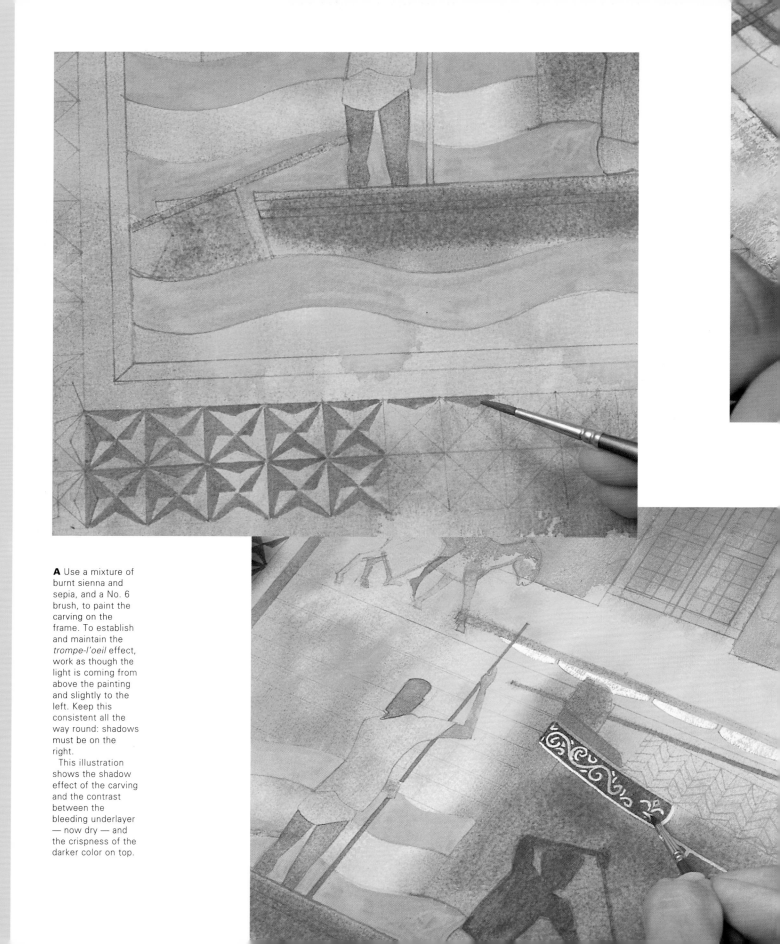

A Use a mixture of burnt sienna and sepia, and a No. 6 brush, to paint the carving on the frame. To establish and maintain the *trompe-l'oeil* effect, work as though the light is coming from above the painting and slightly to the left. Keep this consistent all the way round: shadows must be on the right.

This illustration shows the shadow effect of the carving and the contrast between the bleeding underlayer — now dry — and the crispness of the darker color on top.

C Make a thick mixture of aquapasto, white gouache and just a touch of yellow ochre with a little water to add a yellowish tinge. Then, using a dry No. 6 brush, paint the sails and boom. As in Stage 6, make sure you almost drag the color on rather than painting with it so that the underlying wash sparkles through.

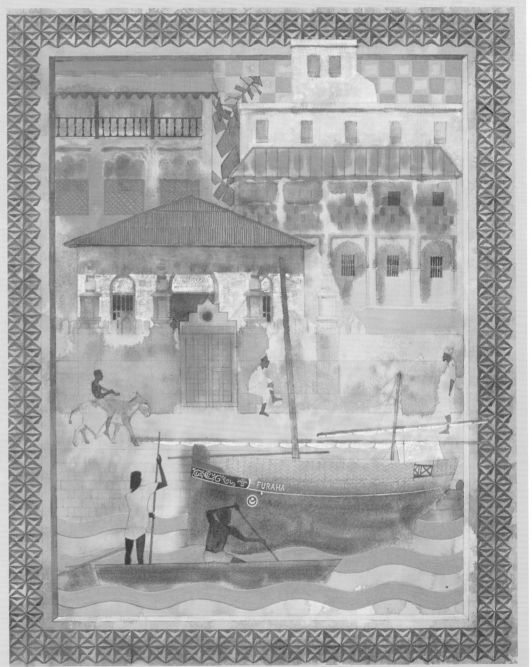

B Use a No. 6 brush and white gouache for the details on the front of the boat. The decoration here provides a nice reference to the place and adds to the ambience of the painting.

Also paint the figure of the boatman immediately under the decoration, using a No. 6 brush and sepia. The Stage 7 illustration shows how he was almost lost against the side of the dhow; filling the shape in with the darker color brings it into focus.

MOUNTING AND FRAMING

Because watercolors are inherently delicate they need to be framed and protected under glass and are usually mounted in white or colored board to provide a complementary border for the painting and prevent it coming into contact with the glass.

The central window in the board, called a mount in the UK, or a mat in the US, generally has a bevelled edge. Selecting the right board for a painting can be difficult as it is available in an enormous range of colors and tones. It also comes in acid-free and conservation qualities that will not yellow with age or damage the painting over a period of time. Always remember that its purpose is to enhance the painting and select the color accordingly. Essentially, the choice will be yours but over the years we have found that harsh colors or dark tones detract from watercolor paintings and that it is best to stick to light-tones in neutral colors.

Special equipment is available for cutting the bevelled window in the board and some of the tools can be very expensive. They achieve no more than can be achieved with a good straight edge like a steel ruler and a sharp-bladed Stanley knife.

Start by marking out the position of the window, either by drawing its shape or, preferably, by pricking the corners of the shape with a pin. As a general rule the border should be slightly deeper at its base than at its sides and top, all of which should be the same size. In other words, if the top and each of the sides are 2 ½ inches (7 cm) the base should be 3 inches (8 cm) or more. The border must not be too narrow as the purpose is to give the painting some space in which to breathe.

Put a second sheet of board underneath so that the blade can cut cleanly through it when you make the window.

Now place the ruler firmly on the board about 1/8 inch (3 mm) from where you wish to cut and angle the knife so that it forms a 45-60 degree angle. Push the blade of the knife into the board and press downwards as you pull the knife to the length of the required cut. Repeat this operation for the other three sides.

To further embellish the effect you can cut another mount, or mat, with a bigger window and place it over the first one to make a double mount. If the top one is a different color to the bottom one the margins of the first will create a frame within a frame.

Other decorative devices include wash-lining. To do this you will need a ruling-pen, which has adjustable flat and bowed shanks that allow you to control the gap between the points so that the thickness of the line can be varied. Use the pen to draw parallel lines around the sides of the window, some close together and some wider apart. A very dilute wash that harmonizes with the painting can sometimes be laid in a space between the lines. There are many ways of embellishing mounts, or mats, and a visit to a framing shop will give you an idea of the techniques available.

Like mounting, framing can involve specialized and expensive equipment. However, it is possible to achieve good results with a fine-toothed tenon saw and a mitre block. Lengths of finished moulding are available from most framing shops and simple, unfinished mouldings can be found in large do-it-yourself stores. Styles vary widely from slim, beaded mouldings to large, ornate, gold ones. You will also need a backing sheet of thick cardboard or hardboard and glass to protect the painting, both cut to the same size as the mounted piece.

Cut and mitre the moulding accurately so that the lengths match the sides of the mount board and then glue and pin them together. Make a 'sandwich' of the glass, mounted painting and backing sheet. Put the frame on the front then turn the 'sandwich' over and secure the whole package with small nails. Be careful to clean the glass thoroughly and remove any specks of dust from the painting and mount before doing this. Finally, seal the back with tape, screw in two eyes and link them with picture wire.

One word of warning: don't forget to sign the painting before you seal it in the frame.

GLOSSARY

Terms and Techniques

aquapasto
A creamy medium that adds textural variety to watercolor painting. It can be used with or without water.

asymmetry
The absence of symmetry in a painting. This is necessary to create a composition that has movement and vitality, but the elements in a painting must always be balanced so that the composition as a whole has equilibrium.

atmosphere
The prevailing feeling or mood created in a painting.

background
The part of a painting that seems to be farthest away from the viewer.

balance
An essential element in a successful composition. The shapes and masses, lines and color must be balanced to create a coherent and pleasing image.

bleeding
The merging of wet paints when they are applied next to, or over, each other so that they interlock and overlap.

blending
The technique whereby two colors or shades of the same color are brushed together with a clean brush and encouraged to merge imperceptibly together.

blotting-out
Using absorbent tissues to remove pigment from painted areas while the wash is still wet.

color wheel
A circular arrangement of the colors of the spectrum showing the primary and secondary colors; tertiary colors, made by mixing secondaries, may also be included.

complementary colors
Two colors that are opposite each other on the color wheel and visually completely different. Examples are red and green, yellow and purple and blue and orange. The effect of a color is intensified when its complementary is used nearby.

composition
The arrangement of the various elements in a painting in relation to each other so that they form a harmonious whole.

cool colors
Colors such as greens and purples in which blue is dominant. Coolness is, however, relative. Prussian blue and ultramarine blue are both cool but the Prussian blue seems comparatively warm when it is applied next to the ultramarine.

dry brush
A technique whereby paint is applied with the minimum amount of water on the brush to reveal traces of the paper or the underlying wash.

earth colors
Pigments made from naturally colored clays, rocks and earth. They include the siennas, ochres and umbers.

extending colors
Reducing the tone of a watercolor paint by adding water to extend the pigment.

flat wash
A wash in one color that is applied to the entire background of the painting or to selected areas.

foreground
The area in a painting that seems to be closest to the viewer.

gouache
Also known as body color. It was originally created using the same ingredients as transparent watercolors with white added to the pigments to make them opaque. Gouaches available in tubes today have clay-based pigments to give them opacity.

gradated wash
A wash in which one color progresses slowly from light to dark or in which there is a scarcely perceptible transition from one color to another.

granulation
A textural effect achieved by using pigments that are chemically heavy or less refined than others.

highlight
The part of a painting that has the lightest tone, often a reflection of the light source. In watercolors highlights are frequently created by leaving the paper unpainted.

lifting-out
Using a dry brush to soak up areas of wet paint to re-establish the tone of the paper after the first washes have been laid and create soft-edged shapes. The technique can also be used to correct mistakes.

limited palette
A term usually applied when a minimum number of colors is used for a painting.

masking fluid
A rubberized liquid that is applied to the paper surface and allowed to dry before the first wash is laid. It protects the paper from the pigments.

masking-out
Applying masking fluid to areas of the paper that are to remain white in the finished painting.

mass
An area of color, shade or intensity that is a significant element in the composition of a painting.

medium
A substance such as water-soluble gum arabic with which pigments are mixed to form paint. Also the material or materials used in a work of art.

middle ground
The area of a painting between the foreground and the background.

monochrome
A painting done in various tones, ranging from light to dark, of a single color.

ochres
Natural earth colors such as yellow ochre and red ochre. The term is also often used to define colors such as siennas and umbers that are within that range.

opacity
The extent to which a pigment is incapable of transmitting light and obscures the surface on which it is painted.

overlaying
Overpainting an area of dried pigment with another color to create a third 'transparent' color. Overpainting a cool color with a warm one, or a warm color with a cooler one, allows the artist to achieve a range of temperatures in a painting using only a few pigments.

palette
The flat piece of wood, metal, plastic, etc. on which paints are mixed. Also the range of colors that is available to, or characteristic of, a particular artist or school of painting.

pastels
Colored crayons made of ground pigment mixed with a binder such as gum acacia or gum tragacanth. Can be used in watercolor painting to emphasize and clarify parts of the image.

piece-to-piece
A method of painting in watercolor in which a small area of a painting is completed before the next one is started.

pigment
A finely ground powder, made from natural or synthetic substances, that is mixed with a binder to make paint.

primary colors
Red, yellow and blue — the three colors that cannot be obtained by mixing other colors. In theory, all other colors can be made from them with the addition of black and white.

pure color
A color that is unmixed with other pigments. Its tone is deepened by adding more of the same paint and lightened, in watercolors, by adding more water.

saturated color
Vivid or intense color. In watercolor painting saturation is achieved by using a high proportion of paint to water.

scratching-out
Using the side of a blade or its point to scratch white lines and highlights back into a dry painting.

secondary colors
The three colors that are formed by mixing the three pairs of primary colors: green (blue and yellow); purple (red and blue) and orange (red and yellow).

sgraffito
A decorative technique whereby the surface layer of a design is incised or cut away to reveal an underlayer of a different color. Although it is not a classical watercolor technique it can be adapted to create an exciting textural effect.

GLOSSARY

silhouette
An outline portrait or image filled in with solid color. It was named after Etienne de Silhouette, the French minister of finance in 1759, because it was claimed that this partial portrait symbolized his shallow nature.

spattering
Flicking pigment on to a painting to create an irregular pattern of fine dots that adds textural variety to the finished work.

sponge
Used to 'blot on' color; especially useful for adding texture and to create the impression of foliage.

squaring up
Changing the size of a drawing by transferring it to another surface. Squares ruled over the drawing are repeated, in a larger or smaller size, on another sheet of paper and each square of the drawing is copied on to the corresponding square on the new surface.

still-life
A painting of inanimate objects like flowers, fruit, etc. The group is arranged by the artist, usually indoors, and includes at least one man-made object.

symmetry
The arrangement of the elements of a composition so that one side of the painting is exactly like the other, creating a static image.

technique
The way in which an artist achieves a particular effect.

tertiary colors
Colors produced by mixing the secondary colors. Although they may tend to be dull in comparison to primaries and secondaries they can be as useful as these more vivid colors and can be used to sensitive effect.

tonal relationships
The relationship between light and dark areas of tone in a painting.

tone
The lightness or darkness of a color. In watercolor painting the dark tone of the paint when it is mixed with only a little water is progressively lightened when it is extended with more water.

translucency
The effect created when a pigment, or combination of pigments, transmits light either partially or diffusely.

transparency
The effect when a pigment or combination of pigments allows light to be freely transmitted.

trompe-l'oeil
A painting that gives such a convincing illusion of reality that the viewer thinks that the subject it represents is real.

warm colors
Colors in which red and yellow are dominant. However, warmth is relative: lemon yellow and cadmium yellow are both warms but when they are adjacent to each other the lemon yellow appears cool in comparison to the cadmium yellow.

wash
Dilute watercolor applied to an area of paper too large to be covered by a single brush stroke. The area may be as large as a sky or the wash may be applied selectively to smaller parts of the painting.

watercolors
Paints made from pigments that have been finely ground and mixed with a water-soluble gum that adheres to the surface when it is applied to paper. The gum also acts as a varnish which gives watercolor paintings their characteristic translucency. The transparency of the pigments allows the whiteness or tone of the paper to shine through to add brilliance and sparkle to the finished painting.

wet-into-wet
A technique whereby paint is applied to a surface that is already wet.

INDEX

Page numbers in *italics* refer to illustrations.